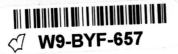

Tom Goodwin
San Antonio
1977

THE NEW YORK SCHOOL

The New York School

A CULTURAL RECKONING

BY DORE ASHTON

THE VIKING PRESS · NEW YORK

Originally published in England under the title *The Life and Times of the New York School: American Painting in the Twentieth Century.*

Copyright 1972 in all countries of the International Copyright Union by Dore Ashton
Published in 1973 in a hardbound and paperbound edition by
The Viking Press, Inc., 625 Madison Avenue, New York, N.Y. 10022

Published simultaneously in Canada by
The Macmillan Company of Canada Limited

SBN 670-50912-4 (hardbound)
 670-00368-9 (paperbound)

Library of Congress catalog card number: 72-80897

Printed in U.S.A.

Second printing June 1975

ACKNOWLEDGMENT
Random House, Inc.: From 'Age of Anxiety' from *Age of Anxiety* by
W. H. Auden, Copyright 1946 by W. H. Auden. From 'September 1,
1939' from *The Collected Poetry of W. H. Auden,* Copyright 1940 by
W. H. Auden. From *Man's Hope* by André Malraux, Copyright 1938
by Random House, Inc.

Contents

Author's note

My favorite philosopher is Gaston Bachelard. I like particularly his unbounded contempt for those who, like the psychoanalyst, 'try to explain the flower by the fertilizer.' Knowing about an artist's ambience does not 'explain' his work.

In this book I am not dealing with works of art, as I have in my other writings. Rather, I have pursued the problems that cultural historians have always raised in the hope of answering at least partially a simple question that occurred to me years ago: Why did painting take such a long time to make its force known in American culture? In trying to answer that question for myself, I have written a book that is not about art, nor about artists individually, but about artists in American society. It is, if you like, a close scrutiny of the components of fertilizer which, undeniably, has *something* to do with the flower.

ACKNOWLEDGMENTS

I wish to thank many for their specific and cordial assistance, among them Lee Krasner Pollock, Lillian Kiesler, Sally Avery, Rudolph Burckhardt, Charles Egan, Jeanne Reynal, Betty Parsons, Richard Roud, and so many others. I thank especially my two incomparable editors, Anthony Adams and Barbara Burn, and my friend, the photographer Denise Hare. The Guggenheim Foundation is responsible for the freedom needed to complete this book and I am most respectfully grateful.

DORE ASHTON
New York, N.Y.
September, 1971

List of Illustrations

Introduction

In the welter of criticism that accompanied the ascendancy of modern American painting there is little to justify the legend of the New York School. Yet, whenever the New York School is mentioned, we know what we mean. The fact is that at a certain moment enough painters seemed to converge in a loose community, with sufficient aggressive energy to command attention both in the American press and abroad, to constitute an identifiable entity. Yet a refined study of the period roughly spanning a decade from the early nineteen-forties indicates none of the usual attributes of a 'school' of painting.

Long after the image of a New York School had been shattered by subsequent circumstances, Harold Rosenberg, one of the major critics of the golden moment, contended that the group he himself had identified under the umbrella of 'action painting' could under no circumstances be regarded as a school. In *The New Yorker* of December 6, 1969, he wrote that style in modern art is determined not by place but by ideology, and his examination of the 'great flawed art of Gorky, de Kooning, Pollock, Rothko, Gottlieb, David Smith, Still, Newman, Hofmann, Kline, Guston, and a dozen others' indicated that they were 'individuals bewildered, uncertain, and straining after direction and an intuition of themselves.' Unlike the artists of the School of Paris, who were bound by the aroma of their ancient city regardless of their intellectual divergence, the New York artists lacked 'the ephemeral influence that binds responses together beyond the antagonism of minds.'

The art historian and critic Robert Goldwater took up an entirely different position in his article 'Reflections on the New York School' in *Quadrum 8*, 1960. For him the New York School had an indisputable existence; it had 'lived a history, germinated a mythology and

I

produced a hagiology.' He notes the prevalence of paradox in the artists' statements, in which the idea of individual uniqueness was always stressed, despite what he calls the 'gregarious intimacy' of their association during the peak period. Goldwater prefers to speak of the 'multiple individuality' of the New York School, and suggests that the 'results' of their attitudes—their works—are more homogeneous than critics think. The implication in Goldwater's assessment is that ultimately, from the distanced view of the art historian, the New York School will be seen to share the ideological and stylistic characteristics that generally constitute a school of painting.

Throughout these discussions centering on the New York School, which is generally presented as an epoch in which abstract expressionism predominated, there is a constant conflict between individuality and the will to cohesion. The variety of personalities who expressed themselves vociferously during the period (those who talked in cafeterias as well as those who held forth at the Artists' Club), makes an orderly classification almost a falsification. It is also true that those who knew the artists participating in the School of Paris always made it a point of honor to stress their individual differences. But in Paris, even after the Second World War, if you wanted to know what the constructivists were thinking you knew which café to frequent, and if you wanted a taste of surrealism, you could find your way to the appropriate café in Clichy and sit right down in Breton's court. While there was little intercourse among the various groups within the School of Paris, there were always nuclei which made definition conceivable.

In New York, there were certainly circles of artists and their sympathizers that never touched, or that intermingled only rarely, but the stamp of an ideology was never precise. For example, Stuart Davis was for a long time a good friend of Arshile Gorky. In a memoir on Gorky, he related that when Gorky had had a few drinks he would try out his native songs and dances, but that in Davis' circle, only jazz was admired. Gorky found little encouragement there and went instead to the *other* circles he frequented 'where they liked that sort of thing.'

Many were attracted to New York and its artists precisely because of its chaotic impression of a vital activity generated by no specific ideology. The composer Morton Feldman, recalling in a conversation with the author the late nineteen-forties and early fifties, says he was attracted to the idea of an art scene where everybody was totally different from each other: 'There were both bohemians (or

loft rats) and Right Bank guys. I was aware I was involved in a movement of some kind which was not just the Club. Personalities didn't seem to change the fact that there was a movement going on.'

But it was the personalities that everyone, including Feldman himself, stressed. He took comfort in the fact that the painters seemed able to believe in infinite options, and remarked that 'the charismatic element was fantastically important.' He arrived on the scene soon after Gorky's suicide, and says that he heard nothing about Gorky's work—only about the man: 'Or, I heard all about Hofmann, or an anecdote about de Kooning or Pollock, but seldom about the work.'[1]

The vague 'movement' that Feldman sensed and others attempted to describe did in fact take on definition when art historians and critics gathered together the various hints in the works and state-ments of the charismatic artists, and reflected on their implications. The nearest thing to a definition turned out to be a summary of the philosophic preoccupations of the artists involved. Eventually, abstract expressionism and the New York School appeared to be a set of attitudes that generated works which reflected a set of attitudes. From the inside—from the point of view of the artists, that is—the movement appeared to be an extremely complicated set of preroga-tives appropriated with a new-found zeal that could only be attri-buted to the peculiar circumstances of the post-war era. No single artist of this group voluntarily identified with the group, or accepted any of the sobriquets offered up by a succession of well-meaning critics. They did, however, accept the infusion of vigor that a com-munal activity sponsored, no matter how loose and ill-defined that activity was. Many of the artists were engaged in a surreptitious romance with the city itself, which became an almost mystical source of individuality. The 'loft rats' were proud of their penury, their bohemianism, and their absolute isolation from uptown city mores. Many of them took pride in their self-reliance, that old Emersonian ideal, and regarded survival as a sign of their artistic justification. The story that Willem de Kooning who, like everyone else, was starving during the early Depression years, refused a job decorating a department store and preferred to be evicted rather than sully his individuality and artistic integrity was often repeated. The streets of New York were de Kooning's 'place' (and the 'place' of all the others who felt the mounting heat of creative activity in the city to be a true inspiration). The dance critic Edwin Denby, de Kooning's close friend and most congenial memoirist, has told us how keenly

exhilarated the painter seemed to be by the atmosphere of the streets:

I remember walking at night in Chelsea with Bill during the Depression, and his pointing out to me on the pavement the dispersed compositions—spots and cracks and bits of wrappers and reflections of neon light. . . . We were all happy to be in a city the beauty of which was unknown, uncosy, and not small scale.[2]

Aside from the sense of place, and the indefinable sense of movement (movement toward many things, it is true, but movement nonetheless), what seemed to draw artists together in the nineteen-forties was their common need to denounce all rhetoric and elude all the nets cast by ambitious cataloguers and historians. The feints and dodges of many abstract expressionists are well documented in the proceedings of the Club (see p. 198), and in numerous memoirs. The idea was to have no part of the dogmas that had nourished the modern tradition. Rhetoric, verbal or visual, was suspect; for where there is none, there is no school, and if there is no school, there are no limits. Their rhetoric was that of no rhetoric, and no one exemplifies this better than de Kooning, who has shifted his ground and contradicted himself publicly with the deliberate intention of throwing off the rhetoricians. As Denby says about de Kooning's attitude toward theory: 'He grasped the active part and threw away the rest.'[2]

Painters did talk, however, but with the kind of exploratory rhetoric that always left an opening, as the visual rhetoric of the abstract expressionists makes very obvious. Most of those who did meet and occasionally made impassioned speeches were careful not to be caught with an exclusive point of view. Nearly all the New York artists made it a point to announce their admiration for certain European artists, most of whom derived from sharply divergent traditions. Pollock said on various occasions that he admired Matisse and Miró and Mondrian; Guston at one point spoke passionately about both Mondrian and Soutine; de Kooning also praised Mondrian, as well as a host of very different artists ranging from Ingres to Cézanne; and Rothko admired both Miró and, on occasion, Léger.

Athough at certain times some of the New York School artists appeared to be forging an ideology, and although there were even

1. Edwin Denby met de Kooning when his kitten strayed into the studio, starting their long, close association. This photograph, taken by Rudolph Burckhardt, shows Denby on the roof of his 145 West 21st Street studio in 1936, overlooking just the kind of urban street scene that excited the trio of friends.

some assertions on formal and stylistic matters, all this amounted finally to a series of evasions. If, for a couple of years, Newman and Rothko and Still repeated similar notions, they never committed themselves to a group of practical working tenets: their statements were always quasi-philosophical and related more to what can only be called the *Zeitgeist* than to any concerted progress toward a movement. Most analyses of the nature of the abstract expressionist evolution correctly begin with the nineteen-thirties, when this generation—born between 1900 and 1922—would have been quite young and very susceptible to the tremendous external pressures that followed the First World War. The rapid acceleration of social and economic change after 1918 mitigated many traditional American views of the role of the visual arts. The values inherited by this generation were quickly rejected, but many of the problems handed down from the late nineteenth century remained in the background.

One of the most complicated of these problems inherited by our first generation of international artists was the relative indifference of American society to their existence. As the experience of the W.P.A.* was to demonstrate, there were vast geographical areas in the United States where no living painter or sculptor could be found, much less a museum. Although culture, as conceived by Americans, had penetrated the hinterland in the form of public libraries, literary societies, and even music-circles, the plastic arts had, for various reasons, lagged far behind. One reason for this was that the artist who happened to be born in a barren cultural milieu usually moved as soon as possible to a metropolis, preferably New York.

Even there, the experience of the painter or sculptor was tinged with a lack of confidence in the importance of the visual arts. More than a century of turmoil had failed to resolve some of the basic conflicts of the artist with his society. For Americans an artist had always been valued for his functional role—whether as historian of manners and morals, flatterer of social status, or glorifier of national aspiration—and very rarely for his imaginative spirituality. The history of American painters who digressed from the motifs established by their patrons is a record of repeated cries of loneliness and

*W.P.A. stands for Work Projects Administration, a government agency, established in 1935 by President Roosevelt (and redesignated in 1939 as Works Progress Administration), which undertook extensive building and improvement programs to provide work for the unemployed. The Federal Art Project and Federal Writers Project were two of its programs.

despair, a story of flinty, determinedly reclusive eccentricity. Very early in American history the painter learned to accommodate the very few patrons who needed his services. John Singleton Copley found himself in difficulties when the conflict between loyalists and revolutionaries developed in New England, and wrote to Benjamin West in 1770 that the artist should remain apolitical, since political struggles 'were neither pleasing to an artist or advantageous to the Arts itself.'[3] And in the middle of the following century Thomas Cole testified to the exigencies of patrons when, toward the end of his life, he sadly wrote 'I am not the painter I should have been had there been a higher taste.'[4] While there was always a very small group of enlightened patrons in the United States, their enlightenment did not extend so far as to honor the imagination of the painter above all else. Walt Whitman's defense of Eakins' portraiture came in response to the unseemly demands of the so-called enlightened patrons. Until World War II, most wealthy patrons regarded the painter and sculptor as embellishments of culture, basically non-essential.

Since America had long since decided that the artisan and craftsman should keep his place, many artists had unconsciously accepted the condition for their survival and stressed the craftsman's neutral position. Others struggled to establish a professionalism on the European model, but few artists could really believe in their professional status. Each successive revolt, every attempt to create a national standard of professionalism, seemed to founder on the problem of patronage. The very first art academy in New York disintegrated when its founders—the wealthy patrons and *their* artists—demanded obeisance. The choice was almost always to be a dutiful artisan, a polite courtier, or a pariah. The frustration of America's serious artists can be attributed partly to the fundamental anti-intellectualism of the puritan culture on the one hand, and partly to the Brahmin suspicion of the handworker on the other. Although there have been many recent evaluations of puritanism, some of which have discounted its anti-intellectual bias and its utilitarian prejudices, there can be no doubt that America was strongly affected by the puritan suspicion both of the sensuous side of existence and of the heresies of imaginative intellectual life. Artists themselves very often reflected these tendencies, rejecting theory as frivolous and esthetic discourse as somehow deleterious to their pioneer sensibilities. The abstract expressionists often boasted of their working-class origins, and some of their number sought opportunities

B

to prove themselves in the world of physical work—the kind of 'real' work they associated with the wood-chopping, sweating, pioneer spirit.

Although literary men were themselves none too stable in American culture, they all too often shared the puritanical suspicion of the sensualist, and associated the artist or the manual worker with a lower order of civilization. The kind of camaraderie that now and then developed among European poets and writers and the adventurous artists of their generation was almost unknown in American circles after the Civil War. If the American painter felt isolated, as he repeatedly said he did from the very beginning, he was isolated not only from the public at large, but also from that segment of the public known as the intelligentsia—a condition peculiar to the United States. A cursory glance at the weeklies and periodicals read by the intellectuals from the Civil War onward into the nineteen-thirties proves how little the visual arts were considered vital to our civilization. When the *Dial* or *Vanity Fair* wished to show how cosmopolitan they were, they nearly always published the work of Europeans, or else took the advice of Europeans in their choice of material. At the height of its intellectual prowess during the years 1943–45, *The New Republic* published only two articles dealing with painting and sculpture, and both of those referred more to the sociological ambience than to specific plastic problems.

The caution with which the literati approached the artist, whose 'loft-rat' bohemianism was markedly different from the Greenwich Village literary bohemianism, can be traced in many forms. A highly sensitive poet, Randall Jarrell, never could overcome his secret distrust of the painter and an overwhelming desire to cry fraud whenever he encountered the language of the plastic artist in its most opaque abstraction. In one of his last works, a book of essays,[5] he examined 'The Taste of the Age' with considerable distaste, but lapsed into downright philistinism himself when he came to speak of the visual arts: 'Our society, it turns out, can use modern art,' he wrote, sneering at the restaurant that orders a mural by Miró, and conjuring up a president of a paint factory who goes home to contemplate two paintings by Jackson Pollock: 'He feels at home with them; in fact, as he looks at them he not only feels at home, he feels as if he were back at the paint factory.' Such lack of comprehension drove the poets themselves to Europe between 1900 and 1930, where they found personal fulfilment merely by rubbing shoulders with other poets, and sending back occasional poems to be published in the

8

struggling little magazines of America. The painters and sculptors who felt compelled to leave philistine America behind were doubly cursed, having been largely ignored both by the literati (with a few honorable exceptions grouped around Edward Stieglitz's magazine *Camera Work*) and by the public in general. Moreover, they found little response to their efforts to show their work. There was nothing for them comparable to the little magazine for poets, and the few inspired protagonists, such as Stieglitz, made little headway. When Adelyn Breeskin wrote a restrained foreword in 1965 for an exhibition detailing the early efforts of an American vanguard, *The Roots of Abstract Art in America, 1910–1930*, she noted that until 1920 the lack of encouragement did not seem to dampen the spirits of the early experimentalist. But,

in the story of John Covert, we find an example of the discouragement which many of the group then experienced. By 1923, due to lack of support, he had given up art altogether and gone into business. For others, discouragement brought a more tragic result. Alfred Maurer, Oscar Bluemner, and Morton Schamberg all were suicides. The cause, at least in part, was the frustration of general indifference to their art.[6]

The doctrine of self-reliance, sympathetically outlined by Emerson but quickly controverted by a lusty, expansive America, made deep inroads in American culture. Not only did self-reliance become a rationalization for self-interest, but it fed the basic antipathy to the non-productive member of society. Until very recently, even artists themselves doubted that they had a natural spiritual function, and almost never arrogated to themselves the right to philosophize. The ideal American—the go-getter, or the good-day's worker—lurked in nearly every painter's soul in those dark days before the late nineteen-forties, ready to do battle at the slightest hint of discouragement.

If the European vanguard artist could complacently regard himself as the enemy of the bourgeois and the stalwart upholder of intellectual criticism, his American counterpart seemed always to be beyond the pale of discussion. Once the European painter had accepted his inherited mantle as the enemy of bourgeois culture, he was free to concentrate on his own development within the ranks of the intelligentsia, where he had plenty of company. The American painter on the other hand could never find, as de Kooning once put it, a comfortable chair. To some extent the background against which he played out his internal drama served as a barrier to self-fulfillment. From Emerson's self-reliance to William James' pragmatism and John Dewey's instrumentalism, all American philosophic

doctrine tended to constrict the role of the dreamer. Practical consequences and action were the chief concerns of these anti-metaphysicians. The free-flowing discourse of the imagination, so essential to the nurture of the arts, was rejected the instant it appeared to lead to a body of theory (and theory, no matter how frequently modified, rejected, and overthrown, is still a vital part of the artist's equipment). William James, despite his rich intelligence, fed the native American utilitarian bias. Henry Bamford Parkes summarized James' contribution when he pointed out that

it was from the American past that James acquired the distrust of abstract theory that pervaded his pragmatist epistemology, deriving it partly from the suspicion of dogmas and intellectual absolutes that had always been characteristic of the Anglo-Saxon mentality, and partly from the added emphasis on practical utility the American had acquired during the pioneering experience. . . . Above all, it was from the American past that he acquired his vision of the universe not as a cosmic order in which everything had its appointed place but as a scene of battle between good and evil, in which nothing was predetermined and the future was always uncertain.[7]

If James himself, by a supreme effort of carefully cultivated will, could declare that he believed in his own 'individuality and creative power,' those who grew up in the pragmatic society he helped to develop were much less successful. If truth was to be judged by the practical consequences of action, what was the artist to do for his measure of truth? There were, at least until the nineteen-thirties, all too few practical consequences with which to measure anything at all, much less the truth. The artist was thrown back again and again on the shoals of pariahdom. His individualism, while it supported America's professed faith in the individual, was hardly noticed and became finally a pernicious kind of loneliness (later to be known as alienation). This pre-ordained loneliness was only one of the multitude of problems with which the generations of 1900–20 grew up.

Another distinct problem lay in the American painting tradition itself, which derived both its virtue and its weakness from its provincialism. As far back as Asher B. Durand, who came back from his mid-nineteenth-century pilgrimage to Europe saying he would trade it all for the signboards of New York, the American painter had attempted to find his strength in local realities. Throughout the history of American painting there is ample evidence of conflicting attitudes—but there is also a persistent rejection of the sophisticated imports from Europe as somehow less virile than the work of the pioneering American could be. The two recurrent tendencies were

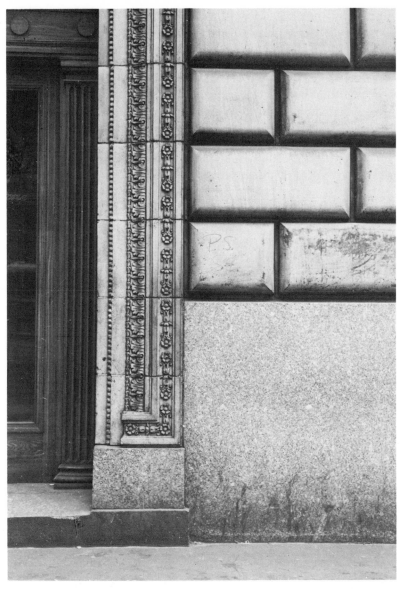

2. De Kooning and Denby were enthusiastic about Burckhardt's sober vision of the city during the nineteen-thirties. This typical Burckhardt photograph would have found little favor elsewhere since photography had been decisively consigned to social commentary.

represented on the one hand by the realists, who tried to deal with America's rawness in its own terms, and on the other by the romantics who, thanks largely to the resolute indifference of their society, projected themselves constantly into the uncertainties of both physical and spiritual existence. These contrasting attitudes can be found wherever you look in American art history. A neat juxtaposition occurs, for instance, in the decade between 1893 and 1903, when the majority of American painters had succumbed to the Genteel Tradition and were producing provincial imitations of European salon painting in an effort to win back the wealthy patrons who had abandoned the local artist.

But there were also major painters (although the robber barons were not aware of them) representing the two consistent American poles: Thomas Eakins, Winslow Homer, and Albert Pinkham Ryder. Eakins, pupil of Gérôme, advocate of scientific training for art students, experimenter with photography, and stern puritan, was, according to Walt Whitman, the only artist 'who could resist the temptation to see what they think ought to be rather than what is.' Eakins' puritanism, apparent neither in his life nor his pedagogy, was reserved for his art. His abhorrence of sensualism, so apparent in his remarks about the work of Rubens, for instance, was the probity of his art. Like Eakins, Homer detested artificiality. He wrote in 1880 that he wouldn't go across the street to see a Bouguereau because his pictures were false, waxy, and artificial. He thought of himself strictly as a realist, but his late works are infused with the romanticism of the solitary individual pitting his talents against the intransigent American elements. Ryder, who represents the epitome of American romanticism, made no pretence to objectivity, and worked out, instead, a genuine parallel to European symbolism in his moody landscapes. His relative unimportance in the nineteenth-century American scheme of things undoubtedly bolstered his inherent eccentricity.

The example of these neglected masters influenced the young painters at the turn of the century who started out again, as American artists had started out so often before, to relate themselves to their society. The obvious means had always been to accede to the public demand for illustration. The Eight, or the Ashcan School, began as newspaper illustrators (some were even war correspondents) and steadfastly maintained their interest in the passing American scene, even when they created their *succès de scandale* as painters. Their rebellion was aimed against the hypocrisies of the genteel academi-

cians in the interest of realism. The other rebellion—against American spiritual isolationism—occurred at the same time, and culminated in the Armory Show. Those who were most intimately affected by the travelling wonders of European avant-garde art were naturally the painters. Stuart Davis stated categorically that the Armory Show was the most important influence in his life, and others agreed. Stimulated by the profusion of new visual experience, the first small band of modern experimentalists made their largely unsuccessful bid for acknowledgment.

Out of their disheartening struggle, in which the demand for realism always obscured their existence and led directly into the social realism of the nineteen-thirties, the myth of the solitary genius drew sustenance. Many of the artists who gravitated to Europe during the nineteen-twenties and early thirties have remarked upon the complete absence of an artistic milieu in the United States, and above all, on the absence of verbal exchange and camaraderie among the painters. Paul Burlin once tartly commented that there was a total lack of discourse among artists in the first quarter of the century; and Carl Holty confirmed this observation, recalling that he went all the way to Germany in 1925 to study with Hans Hofmann in order to satisfy his need for contact. While these memories are probably exaggerated, it is undeniable that the American painters and sculptors in the first quarter of the century were isolated both from their society and from each other, and were perpetually hungry of spirit. The orgy of discourse that overtook America after the 1929 debacle had been pent up for a long time: it reflected the inherited problems clearly.

The contradictions with which the abstract–expressionist generation grappled form a significant chapter in their history. Implicit in the revolt against realism was the struggle to resist mass culture. For every one of their predecessors who had accommodated the rise of industrialism, there was now an antagonist. To those who were young in the late twenties, the idea of reportage was beneath contempt. The strong modern influence from Europe made old-fashioned realism seem hopelessly provincial: to be an illustrator was to renounce all aspirations to art. At the same time the artist who renounced the language of the masses suffered the shame of becoming *déclassé* and the anguish of the solitary traveler. If he were neither reporter nor flatterer, America had little use for him; yet, a longing to be acknowledged was never overcome. Until the myth of the artist as inspired soothsayer took root in the late nineteen-forties, the American painter

was almost always caught in his own conflicting desires to be wholly individualistic and, at the same time, a member of his society.

Until the Depression, then, there was little support for the artist's view of himself as a necessary functionary in a sound society. If there had been a point of contact between society and the artist's extreme isolation, many of the conflicts inherent in the early years of the century might never have erupted as violently as they did during the Depression. The absence of an artistic milieu—that median between society and the artist—was crucial. It was in the creation of such a milieu, in which the extraordinarily different temperaments of the abstract expressionist artists could find moral sustenance, that the nineteen-thirties mark a true art-historical epoch.

Greenwich Village-and Depression

Even in the twenties, the little towns throughout America usually had at least one piano teacher and often a circle of literary ladies subscribing to newly organized book clubs, but art was taught very rarely in the local high school, and if there were art classes, they were horribly debased. Mechanical drawing, even in the universities, was the nearest approach to art, and it was taught for obvious utilitarian reasons. These extreme conditions sent the determinedly artistic youth fleeing to the few large cities in America where there were usually a few art schools and some pretensions to visual culture. Most often, the would-be artist tried to get to New York, where a school such as the Art Students' League, with its open system allowing the student to choose his instructor, promised a grand initiation to sophisticated life. But even New York had its artistic limitations in terms of an audience. Murdock Pemberton, recalling his years in the twenties as an art critic for *The New Yorker*,[1] sarcastically outlined the taste of the time: 'Of course there was a national fondness for art expressed in the annual feed and coalyard calendar and the Maxfield Parrish boy on the swing.' Even Harold Ross, founder of *The New Yorker*, 'shared the average American's unconcern about art.' Toward the end of the decade Pemberton said he checked statistics and discovered that Americans spent $87 million on chewing-gum, $820 million on soft drinks, $5½ billion on cosmetics and knickknacks. His statistic on art was missing, but it is all too clear how trivial the sum would have been. Except for a few galleries, such as Daniels, Weyhe (where he first saw Calder's work), and the Downtown Gallery, there were few outlets for practising American artists.

Whatever artistic milieu that did exist, however, was in New York, and it was closely quartered with the literary bohemia that flourished

in Greenwich Village. Throughout the memoirs of the literary denizens of that hectic neighborhood during the twenties there are remarkably few references to painters and sculptors; but in the few memoirs of painters and sculptors, there are frequent references to Greenwich Village.

The myths that kept the Village alive during the Jazz Age are legion, but the most significant have been precisely located by one of the Village's most intelligent progeny, Malcolm Cowley. Cowley saw the Village as the site of a moral revolution, the most superficial aspects of which spread throughout the United States: the right of women to smoke, to use cosmetics, to neck, to bob their hair, to drive cars, and of men to drink as though there were no tomorrow and to buy on credit. For the provincial with talent the magnetism of Greenwich Village lay, however, in its system of ideas which Cowley summed up in *Exile's Return*, published in 1934. Prime among these was self-expression, which in Cowley's description reads as though it might have been written today: 'Each man's, each woman's purpose in life is to express himself, to realize his full individuality through creative work and beautiful living in beautiful surroundings.' Another important idea was that of living for the moment: 'Better to seize the moment as it comes, to dwell in it intensely, even at the cost of future suffering.' With that went the idea of liberty:

Every law, convention or rule of art that prevents self-expression of the full enjoyment of the moment should be shattered and abolished. Puritanism is the great enemy. The crusade against puritanism is the only crusade with which free individuals are justified in allying themselves.[2]

Cowley also referred to the concept of 'paganism' by which the human body was considered a shrine to be freely enjoyed, and which often drove artists to other parts of the world where they felt people had preserved their pagan heritage. He himself had gone out on the quest, and had returned in sober mood to the vastly altered America of the nineteen-thirties, where he fulfilled his intellectual duties as an editor of *The New Republic*.

The system of ideas Cowley outlined was, of course, congenial to the development of the visual artist who settled in the purlieus of the Village. When Arshile Gorky was twenty-one, he left New England for New York where he quickly established himself in a studio on Sullivan Street near Washington Square, right in the heart of the Village. His imposing presence seemed not to have been noted by the literati, though he was often in the little tea shops and

cafés frequented by the writers. Yet he, Stuart Davis, John Graham, Frederick J. Kiesler, and a score of others in the artistic vanguard were well aware of the literary and philosophical heroes of the day (Nietzsche, Spengler, Wells, Havelock Ellis, Freud, Schnitzler, Chekhov, Strindberg, Toller, Hauptmann, Dreiser, *et al.*).

For these pioneers there were a few sources of direct artistic stimulation which, meager as they were, proved indispensable for the development of an artist. Ideas were not enough; the artists had to see for themselves the living exemplars of that other culture in Europe where bohemia always included painters and sculptors, offering them equal rank with poets, writers, and hangers-on. In addition to the few modern galleries, certain museums were slowly admitting modern art. In 1926–27, Matisse won the Carnegie International prize and was given a thirty-six-year retrospective at the Valentine Dudensing Gallery. In 1926 the great scandal over Brancusi's fight with the customs officials helped to focus attention on the existence of modern art in America. Isamu Noguchi notes in his autobiography that in the same year, when he was twenty-one years of age, he had begun to frequent J. B. Neumann's gallery and Stieglitz's 'An American Place,' and he wrote that his life was transformed when he saw the Brancusi exhibition at the Brummer Gallery.[3] Little by little, artists were beginning to make inroads on the cultural psyche of New York. Like other intellectuals, artists were not completely fooled by the madcap atmosphere of parties and celebrations of life described by F. Scott Fitzgerald. Ever since 1919, when the Russian Revolution began to appear permanent, an undercurrent of fear and incomprehension had affected American life. There were increasing attempts to curtail civil liberties, many hideous miscarriages of justice (such as the Sacco–Vanzetti case), and a rising fear of the intellectual as a natural Bolshevik. If a few painters and sculptors could begin to make headway in galleries in New York, they were by no means certain of their role in the society that was rapidly learning to associate artistic liberty with radicalism. Moreover, they were reminded constantly of the terrors of American life in the journals they read in those days. Many artists read regularly in *The Masses* that in the twenties there were almost five million members of the Ku Klux Klan, a sinister parallel that had to be drawn with the rise of Fascism in Europe.

The mounting apprehension in Europe was quickly reflected in the bohemia of New York, where already the rapid social change from prewar mores had fundamentally changed what artists then as now

referred to as 'the situation.' When the stock-market crash came it was probably not a great shock to the artists. That was to come in the following two or three years when the meager sources of desultory income—dishwashing, housepainting, carpentry, or occasional teaching—were no longer available. Poor as bohemia had been, it had always managed to survive on the left-overs from the affluence of the nineteen-twenties. The Depression brought the artists into an entirely new context with their society. Some even regarded the Depression, which was bitterly described by many as 'the great leveler,' as the long-hoped-for cataclysm out of which a humanistic America might arise. From all accounts of the painters and sculptors who were young during the early years of the Depression, the sight of the breadlines and the general despair that settled soon after the crash was deeply traumatic. An artist in New York would have seen his 'place,' so cherished for its anarchic vitality during the preceding years, turn overnight into a quiet warren of dying spirits. The physical pangs of hunger were not nearly so great as the psychological shock that hurtled even the most thoughtful Americans into unprecedented confusion. Nothing, not even the vast literature of disillusion that characterized twentieth-century America, could have prepared artists for the reality of universal despair. This tremendous upheaval, bringing changes ranging from the most trivial details of life, such as what to eat for breakfast on a drastic budget, to the problem of what to do without paint and canvas, and how to preserve one's individualism in the midst of mass prostration, drove out all thoughts of continuity and structure. Accelerated social change was indisputably a major force in the shaping of the new generation of artists. (This holds true, I think, for all successive 'movements' in the United States, which have been consistently conditioned by the deep-cutting modifications each decade seems to have brought to the social and political situation.)

When the downtown New York artist stepped out of his door as the thirties dawned, his former exhilaration at just being in the center of whatever culture America had mustered was considerably diminished if he happened to live near one of the hastily improvised soup kitchens. The breadlines where silent, resentful, broken men filled the New York air with their dead quiet could not fail to depress him. If he walked in the Union Square district, he would meet the less transient members of this despoiled society—those who would bluster, those who would argue, those who proposed panaceas ranging from political overthrow to utopian life-insurance schemes. The

silence or the noise—both were profoundly disquieting. No artist, however deeply committed he was to art for its own sake, could have escaped entirely from the haunted eyes of his urban contemporaries.

There were some artists who had established an 'uptown' life, knew some of the liberal collectors, and frequented certain elegant art galleries. But even they would find the damaging evidence of what Edmund Wilson called the earthquake, those dreadful years from 1929 to 1933 when everything had collapsed. If they walked up Fifth Avenue in 1931, the artists could have seen what Mary Heaton Vorse described in *The New Republic*: a Fifth Avenue that had lost its glittering shine, when the 'shabby, shifting, ebbing men out of work' drifted uptown.

On a street corner near Fiftieth Street was a store which had been turned into a free restaurant for the unemployed. Well-dressed young ladies were cutting sandwiches for all who wanted to come in and get one. . . . There were men with well-brushed clothes, men who looked like old bums, young white-collared men, all engulfing enormous sandwiches.[4]

Outside, Mary Vorse reported the comments from people gaping through the windows, one of whom observed that it was to keep them quiet that they were fed, otherwise 'they'd break the windows and loot 'em and help 'emselves. An' what's to prevent 'em from takin' what they want? They's a million of 'em in the city; if they was to march they'd make a procession!'

Mary Vorse herself wonders what would happen and speculates that it would be tear gas, clubs, and arrests. In fact, one of the more familiar sights in the city during the worst days was the brutal confrontation of authority and the jobless. The violence, which had already in the twenties cost the lives of many striking workers and demonstrators, mounted steadily as the bewildered urban population lost its economic footing. Artists, as recent events in New York have amply demonstrated, are on the whole very responsive to the evidence of authoritarian brutality, and most of them did react in one way or another to the violence of the turmoil in which they and their fellows in New York were flung by the breakdown of America's economic system.

"Hell, it's not just about painting!"

One of the editorials in *View* magazine of 1943, a periodical that was assiduously read when the New York School was in formation during the early nineteen-forties, cast a look back to the twenties and thirties and found that

the two main themes of inspiration were the *unconscious* and the *masses*. The genuine artist, the pure poet, the authentic composer according to his political inclinations, believed either that his mission consisted in expressing the deeper feelings of the masses, or in giving form to his own dreams.[1]

The writer reviewed some of the conflicts that arose during that period and which still bedeviled the advanced painters. He spoke of their dependence on myth as escapist devices on the one hand, but on the other, he offers an exalted definition of the contemporary artist as a 'magician,' echoing a Rimbaudian conviction when he concludes: 'Seers, we are for the magic view of life.'

At the time this editorial appeared, Jackson Pollock, Arshile Gorky, Adolph Gottlieb, Mark Rothko, Clyfford Still, Barnett Newman, William Baziotes, and others were, in fact, deeply immersed in scanning distant archaeological horizons. Their quest had been prepared, as the *View* writer correctly noted, by the two most compelling issues of the previous decade: radicalism in esthetic views and radicalism in social ideas.

Radicalism had been inherited from the Greenwich Village sensibility analysed by Cowley in the twenties. Nearly all those liberated souls who clustered around the Italian restaurant tables and in the tea shops of the Village were inclined to the left politically. Certainly, during the nineteen-twenties, they were decisively committed to artistic radicalism. Now and then the painters-turned-political-

THE COP THE STOOL PIGEON THE LAWYER THE JUDGE

Otto Soglow

ALL RIGHT,
BOYS LET'S
DO OUR
ACROBATICS

DRESS REHEARSAL.

lawyers, they get military training, they marry or don't marry, as they wish. And it has all gone so far and it has all become so simple and natural that no one notices it any more, and is as surprised as this girl photographer was when a dumb American talks about it.
November 11.

Delegates have reported from China, Japan, Switzerland, Czecho-Slovakia, Hungary, Lithuania, France, Germany, Egypt, England, U. S. A., Poland, Roumania, Soviet Georgia, Ukraine and Russia.

There are other reports still to be heard. The stenographic report of the Congress will be issued as a book in Russian, English, French and German.

Meanwhile, how can I convey the sweep of it all? In these lands, so different in speech, tradition, history and culture, native groups of revolutionary writers have sprung up exactly as in our America, and in exactly the same spontaneous ways. It's strange and exciting to hear a Bulgarian poet protest against the New Humanists of Bulgaria, or a Chinese novelist condemn the Mandarin nonsense of his own bourgeois intelligentsia. It is stirring, somehow, to hear Egyptian and Hungarian and Japanese and Ukrainians call for proletarian themes, forms and purposes in literature—just as we do in the *New Masses.*

It satisfies one's deepest soul to hear that so many men and women are dedicated in every remote corner of the world to building up of revolutionary art and culture, at whatever cost.

Literature and art are two powerful ways of organizing the revolutionary masses for the great creative tasks of the Revolution. For those whose talents lie in this work, there should be no hesitations and doubts.

We must bring our young artists and writers closer to a revolutionary consciousness, for this will give their work strength and clarity. We must urge them to plunge into the realities, but we must not set up the false dichotomy of revolution versus art.

No, the conflict is between revolutionary art versus bourgeois art, and every artist and writer who comes to us must be stimulated into activity, not inhibited. Our criticism of each other must be accurate, but brotherly. We must all allow the petty-bourgeois Bohemian jealousies to enter our new world. In the presence, too, of this world movement, so spontaneous, inevitable and magnificent, the picayune chatter that has gone on in some quarters in America makes me ashamed.

There are some of the random reflections that came to me sitting at the Congress sessions today.
November 12.

An interesting discussion was begun by the German delegation, and everyone participated in it. It was our familiar *New Masses* discussion, the one that John Dos Passos started, as to the place of the petty bourgeois intellectuals in the revolutionary movement.

Here, too, one found surprises. The general line taken by the Congress was not the one taken by our leftists. The congress declared that it was of vital importance to enlist all friendly intellectuals into the ranks of the revolution. Every door must be opened wide to the fellow-travellers. We need them. We must not fear that they will corrupt us with bourgeois ideas. This fear is a form of insecurity and a sign of weakness. It is as if we doubted our own ability to keep on the main road.

But the Congress also declared that everything possible must be done to stimulate the proletarian writers. Beginning on the broad basis of workers' correspondence from mines, factories and farms, there must be nurtured a new literature written by the workers themselves. Yes, this is the great new historic thing; that this proletarian giant who has been dumb and blind for all the centuries should be urged to speak for himself. This reservoir of energy and passion must be tapped by the revolution.

These are the two main tasks, then, and neither negates the other; both are equally important, was the Congress line.
November 13.

Ernst Glaeser is only 28 years old, and has written two strong, beautiful novels that portray social conditions in Germany during and after the war. He has made a great success, is a kind of

3. Otto Soglow was widely admired by young artists during the nineteen-thirties for his unique political cartoons in *New Masses*.

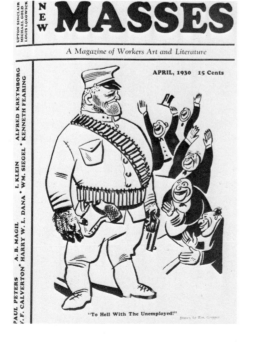

N E W MASSES

A Magazine of Workers Art and Literature

APRIL, 1930 15 Cents

"To Hell With The Unemployed!"

Drawn by Wm. Gropper

4. William Gropper's 1930 cover for *New Masses* indicated the early fears of new military adventures among the liberal and radical intelligentsia.

cartoonists converged. Political radicalism was a well-grounded tradition, going back to the days before World War I when the avant-garde included Robert Henri, a professed and literate anarchist, and John Sloan, a committed socialist who in 1908 ran for the Assembly and in 1915 for a judgeship, and whose teaching at the Art Students' League in later years often focused on political issues (although he concluded later that art must remain detached from politics). Shortly before the First World War Sloan had been involved in a celebrated quarrel that was to affect the development of his young colleague Stuart Davis. Sloan was the artistic director of the radical magazine, *The Masses*, to which Davis, Glenn Coleman, and Art Young contributed visual commentaries, based very often on their observation of the city, especially of the impoverished immigrants. Not long after Sloan arrived at *The Masses*, an ideological battle developed in which Max Eastman, John Reed, and Art Young insisted that only an art of 'ideas' had a place in the magazine, by which they meant an art fully captioned. Art Young, whose life, as he wrote, was dedicated to the destruction of plutocracy, was an uncompromising propagandist. Opposed to them were Sloan, Coleman, and the young Davis, who stood for 'pure' art (genre scenes that needed no captions). In the dispute that ended his cartooning career, Davis learned, as he said, to be forever suspicious of 'an art of ideas' and in fact, even when he was in the thick of political agitation later in the thirties, he never again brought his art and his politics together.

In 1926 *The Masses* became *The New Masses* and again was distinguished by its use of contemporary artists as cartoonists. The work of Otto Soglow, William Gropper, Adolph Dehn, and the stalwart Art Young was regularly seen by other artists; Soglow in particular was much admired. Their strong indictment of the military industrialists and American isolationists in the face of rising Fascism in Europe and the increasingly evident threat of a second world war, did much to pave the way for the political commentary undertaken by so many artists in the mid-thirties.

Tacitly, those in the avant-garde of painting and sculpture were political leftists, but few after Stuart Davis gave their artistic allegiance to anything except esthetic radicalism. The issue of modern art and letters was much closer to their hearts, even after the crash. While the followers of *The Masses* read Jack London and Maxim Gorky for their socialist content, the artists were very often studying the works of Ezra Pound, James Joyce, and even Gertrude Stein, whose legend passed homeward after World War I. When Arshile

5. Picasso's ineluctable presence is testified by this untitled drawing (1929–32) by Arshile Gorky. Photo: courtesy M. Knoedler & Co.

Gorky exhibited his paintings at the Mellon Galleries in Philadelphia in 1934, they were reviewed by Harriet Janowitz (a young critic who would later sign herself Harriet Janis) for the catalogue in distinctly Steinian terms:

He is a sheared beard voluntarily. Giving importance to spaces the object existing for them and impersonal keen the knife cutting rectangular proportion into disproportion with numerical interest the $5 + 7 = 10 + 2$ and paralyzed with surprise is quoting the equation. Before is laboring the archives through tradition for past intentions interred and bringing out. Potential is exclaiming construction in the personal to focus the lens of Arshile Gorky already arriving.

For these early experiments with the cubist idiom, drawn largely from Gorky's close study of Picasso but already, as William Seitz wrote in 1962,[2] showing Gorky's own achievement in the way 'the representational skin of cubism had already been peeled,' Gorky found a group of enthusiastic supporters. The catalogue also included comments by Stuart Davis, Holger Cahill, and Frederick Kiesler. Writing in a more orthodox style, but clearly awed by Gorky's esthetic daring, Cahill noted that he had an extraordinary inventive-

c

ness and added to American contemporary art 'a note of intellectual fantasy which is very rare in the plastic art of this country.' Kiesler, writing from his expressionist background, used a more exalted and modern diction, saying that Gorky was the spirit of Europe in the body of the Caucasus ready to shoulder down the doors into a land of his own. 'Unswerving, critical reason seeks the quintessence of Picasso–Miró drunkenly to absorb them, only to exude them again in deep slumber.'

Kiesler's stress on Gorky's exotic origin was inevitable. The circles of artists in New York in the late twenties and early thirties were often generated, or at least stimulated, by the energetic foreign-born. Gorky himself maintained friendships in several such circles. First there were the Russians, whose warmth and background related to Gorky's own. He was a frequent visitor to the studios of the Burliuks, the Soyer brothers, and Nicolai Cikovsky. David Burliuk and his wife Maryusa enjoyed great esteem in those early days for having been in the heart of the esthetic movements that preceded the political revolution in Russia. Burliuk was proud of having been one of the founders of Russian futurism and a great source of inspiration for Mayakovsky. Burliuk's reminiscences of the great days of Russian experiment, as well as his lasting commitment to the political revolution, were offered freely to anyone who cared to listen, and were published in his quaint periodical *Color and Rhyme*. The Russians who associated with Burliuk were joined by certain Americans, among them Isamu Noguchi (at that time not yet closely identified with Japan), and old Joseph Stella, who would sip tea in Burliuk's studio, or in Raphael Soyer's, and enjoy the constant intellectual discussions.

Much more important to the artistic lives of Gorky and many other vanguard artists was a Russian of a different stamp: John Graham. If charisma counted for much in those early years of groping, John Graham seemed to have had more of it than almost anyone around. His legend— for he did encourage others to elaborate his legend— was constantly revised by him and his admirers, but throughout its many variations, it remains. As time recedes, so Graham's legend grows stronger. His energetic presence, flitting from circle to circle, and from Europe to New York and back, seemed to have caused artists of very different viewpoints to converge. Admiring references to Graham's intellect, his personality, and his impressive cavalry-officer's bearing, occur again and again in archive notes. His history (which varies according to the source consulted) seems to be as

follows. He was born in Kiev as Ivan Dabrowsky. He studied law and then joined the cavalry in which he served during the First World War. He had apparently been a White Guard during the Crimean uprising and fled to New York when it was crushed. From the time he arrived, around 1920, to 1924 he studied painting at the Art Students' League. After his colorful advent at the League, Graham became an irresistible source of sophisticated esthetic information for other artists.

A poised and self-assured European, Graham easily moved from circle to circle, from Burliuk and Vasilieff, unreconstructed Russians, to the salty American Stuart Davis; from Willem de Kooning, whom he met shortly after de Kooning arrived, to Gorky, Kiesler, Milton Avery, Jean Xceron; and later to Lee Krasner, Jackson Pollock, and the other rising stars of the new generation. David Smith, who was a student of painting in the late twenties, more than once mentioned his great debt to John Graham and to another European, Jan Matulka, who also helped to dispel provincialism among his students at the League. In one of his journals, Smith indicates clearly how dependent the local Americans were on the knowledge and sensibility brought to New York by European modernists:

Being far away, depending upon *Cahiers d'Art* and the return of expatriates often left us trying for the details instead of the whole. I remember watching a painter, Gorky, working over an area edge probably a hundred times to reach an infinite without changing the rest of the picture, based on Graham's account of the import in Paris on the 'edge of paint.' We all grasped on everything new, and despite the atmosphere of New York, worked on everything but our own identities. I make exceptions for Graham and Davis. . . .[3]

Dorothy Dehner, Smith's wife during that period, emphasizes in a memoir of Graham the importance of his presence in their lives, while they were still students at the Art Students' League:

He brought the excitement of the French art world to us, a world he knew well from having lived and painted in Paris. . . . What he said was very much to the point, profound, flavored with caustic humor. He showed us copies of *Cahiers d'Art* and other French art publications of which we had been unaware. He knew the painters of that time as well as the writers Eluard, Breton, and Gide.[4]

She recounts that Graham introduced them to his collection of African sculpture which he 'handled lovingly,' at a time when such things in New York were regarded only as ethnic curiosities. When she and Smith went to Paris in 1935, Graham began 'whizzing us

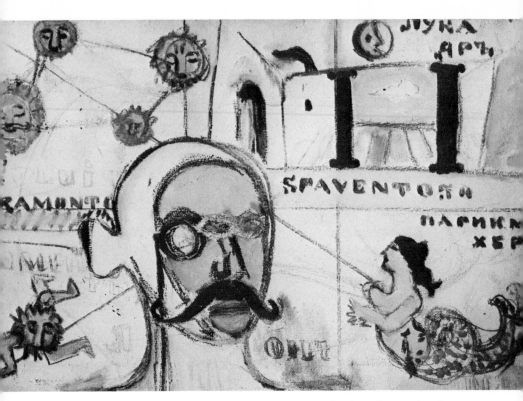

6. This undated painting by John Graham is presumed to have been painted after he turned away from cubism. The mixture of Italian and Russian words in 'Tramonte' harks back to the early Russian experiments in combining words and image, which were largely unfamiliar to the New York painters, who admired Graham's strange fantasy. Photo: courtesy André Emmerich

around Paris in a wild and wonderful journey that took hours,' and which included commentaries on art history as well as visits to no less than four exhibitions of African art. At that time, Graham had found an eccentric position somewhere between Marxism and Freudianism, and Dehner mentions his autobiography, fittingly titled *From White to Red*. His rapport with the surrealists was close, as she indicates by mentioning a visit to Paul Eluard's house where they saw Meret Oppenheim's *Fur-lined Teacup*.

Despite Graham's links with the surrealists in Paris, he seems never to have been wholly convinced that surrealism was adaptable to painting. He, and many other Europeans in New York, were thoroughly conversant with the movement, but seemed much more intent

on clarifying the interior tradition of modern painting, which they nearly always traced back to Cézanne. As early as 1921, when the Brooklyn Museum staged an exhibition of French painting which included fourteen Cézanne canvases and twelve by Matisse, many local painters had been overwhelmed. Jack Tworkov for one never forgot the impact of Cézanne, whose 'anxieties and difficulties' came to mean more to him than Matisse's liberty and sophistication. Gorky assiduously studied Cézanne, even copied him, and told his future dealer, Julien Levy, 'I was *with* Cézanne for a long time, and now naturally I am *with* Picasso!'[5] 'Naturally,' he had said. It *was* natural, most youthful painters of the period felt, to adopt the idiom of the modern masters. Their reverence—or at least the reverence that the rebellious students felt—was reserved only for artists proved in Paris. When Stuart Davis asked his young friend to write an article on his work for the magazine *Creative Art* in 1931, Gorky's highest praise came in the form of associating Davis with his own modern heroes:

This man, Stuart Davis, works upon that platform where are working the giant painters of the century—Picasso, Léger, Kandinsky, Juan Gris —bringing to us new utility, new aspects, as does the art of Uccello.[6]

To work in the modern tradition was indeed a struggle. Very rare were the critics, galleries or museums that took the least interest in such work, which is undoubtedly why the charismatic figure of a John Graham or a Frederick Kiesler assumed such crucial importance. Kiesler, for instance, had an indomitable fighting spirit that he had given full rein in his native Austria, while still a very young man. When he came to the United States in the mid-twenties, he arrived brandishing radical theatrical theories which had developed in Vienna but had been strongly influenced by the experimental theater in Russia. Kiesler's natural expressionism grew fervent when he met the cautious and often hostile atmosphere of New York. In 1926, he and Jane Heap compiled The International Theater Exposition in the Steinway Building, for which he wrote this rousing manifesto:

The theater is dead! We are working for the theater that has survived the theater. . . . The contemporary theater calls for the vitality of life itself. . . . The new spirit bursts the stage, resolving it into space to meet the demands of action.

Kiesler's idea of a 'space stage'; his designs for both theater and motion-picture houses; his constant theorizing and energetic pro-

posals, as well as his writings (often devoted to the young artists he encountered in avant-garde circles), kept him very near the center of esthetic life in New York. Diminutive and very gregarious, he had the strength of personality that is so important to the formation of a community. Moreover, like Graham and a few other resident Europeans, Kiesler was always alert to the latest news from advanced circles all over Europe, and he lost no time in spreading it. The preoccupations characterizing the art world just before the definitive cataclysm (which occurred only as the results of the 1929 crash became unavoidable two or three years later) are described in Kiesler's book.[7] Although informed by the activities of the Bauhaus and respectful to older modernist traditions, Kiesler's text seems to reach out in multiple directions, committing the reader to no single theory or style, but always enlisting him in the struggle against provincialism and philistinism. One can well imagine the heated discussions that found their outlet in this book, which surely must have been composed with the unwitting collaboration of the artists Kiesler knew.

The core of his argument was the conviction, nurtured by his European experiences, that 'the expression of America is the mass, and the expression of the masses, the machine.' He thought that Americans were gradually approaching the solution of a nation's most profound cultural problem, an art of its own, which he saw— as did many Bauhaus exponents—as a cooperation between public, artist, and industry. Nonetheless, the opening sections of his text were a plea for the proper understanding of contemporary art: Picasso for having taught that 'the quality of a picture consists in its harmony of lines, illusion of space and form, and colors'; Chirico for bringing together 'all kinds of objects in a natural illogical way, but he orders these things into a logical pictorial harmony'; Léger for the 'strong dramatic power that is the mark of the machine age'; Mondrian for being a master of asymmetric balance; Van Doesburg, for aspiring to the elementarist ideal of a 'cosmic emotion.' In discussing sculpture, Kiesler insisted that 'modern sculpture is abstract sculpture.' He reminded his readers that

every good piece of sculpture cannot be looked at from one side only, but from all around; flat modeling is merely a kind of applied painting. . . .

and he exhorted them to understand that Brancusi was more interested in the inherent beauty of his materials than in a realistic representation of nature. Oddly, he named the American Elie Nadelman, whose welded open sculpture is reproduced in the book, as one of the real founders of cubism who had influenced Picasso.

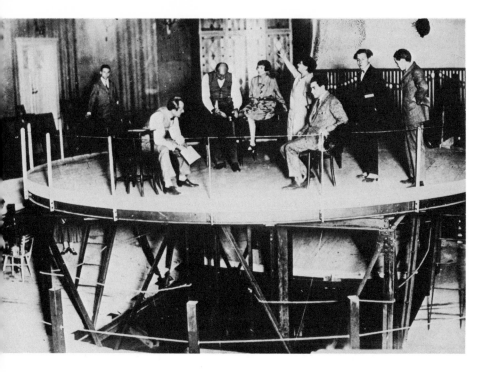

7. ABOVE: A theater-in-the-round designed by Frederick Kiesler in 1924 when he was director of the Vienna Theater Festival. Kiesler (center with arm raised) pioneered the movable stage which both revolved and went up and down. BELOW: Kiesler seen in the poster he designed for the opening of the Eighth Street Cinema in 1928, a Village event of considerable importance. Photo: courtesy Mrs Frederick Kiesler

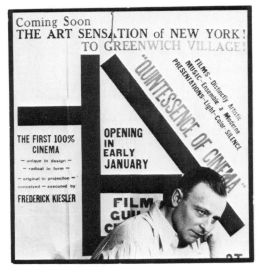

Kiesler's argument inevitably posited a kind of progress in modern art, which he regarded as moving more and more increasingly toward the architectonic. This was perhaps a reflex since he himself was at the time most interested in architecture and industrial design. His own Film Guild Cinema in New York had been the first experimental movie theater, with elaborate devices to enlarge the screen both in front of the theater and on the side walls.

Kiesler's book grew directly from a change of heart on the part of Americans during the late twenties. Modernism arrived from Europe vastly vulgarized and totally misunderstood. It was his mission, he felt, to correct all this through his writing and his projects. His friends among the artists were far less concerned, in those days before the depths of the Depression, with the social implications of modern art, but they undoubtedly shared his deep desire to improve the local taste. More important, they were prepared to examine the examples of painting, sculpture, stage design, and architecture from all over the world with intense interest. What Kiesler really did in this book was to draw together the *leitmotifs* that graced all the vanguard European and Russian publications from the end of World War I until 1929. Accordingly, his friends could turn the pages and see the work of Klee, Picasso, Matisse, Léger, Chirico, Thomas Hart Benton (in a rare abstract screen), Van Doesburg, Mondrian, Brancusi, Laurens, Gabo, Nadelman, Van Tongerloo, Bruno Taut, Mies van der Rohe (his Barcelona pavilion had been completed shortly before the book appeared), Oud, Mendelsohn, Le Corbusier, Malevich; also the theater designers A. Vesnin and Alexandra Exter, as well as Kiesler himself.

Not that references to the European avant-garde were entirely absent from New York during the nineteen-twenties: Marcel Duchamp's efforts as a documentarian of the modern tradition had succeeded when he and Katherine S. Dreier founded the Société Anonyme in 1920 (Wassily Kandinsky was vice-president and Duchamp himself secretary). Over the decade a small group of artists and students was exposed to symposia and exhibitions at the Société's gallery at 475 Fifth Avenue, and could see at the Brooklyn Museum, in 1926, a large international show which presented for the first time the work of Miró, Mondrian, and Lissitzky. In 1931, the Société claimed, as 'artists we have put on the map in New York,' Archipenko, Campendonk, Burliuk, Léger, Klee, Ernst, Eilshemius, Stella, Storrs, Villon, Miró, Kandinsky, Mondrian, Ozenfant, and Schwitters, among others. Downtown, the student of modernism could

view the Gallatin Collection housed from 1927 to 1942 in New York University, with its large and well-selected group of cubist paintings by Picasso, and scores of other abstract works from many countries.

What Kiesler recognized as a change of attitude toward a modern idiom was certainly a minor phenomenon in relation to America's own young modernist artists, but it was a beginning. Studio talk continued to focus on the major figures of the European avant-garde, even in the lean years of the Depression. Lee (Lenore) Krasner, who later married Jackson Pollock, recalls that her earliest introduction to the artistic vanguard while she was still a student was the School of Paris.

De Kooning was the big artist. At that point, the center of art for Gorky, de Kooning and myself was the School of Paris. We used to go to shows at the Matisse and Valentine Dudensing galleries all the time.[8]

The dialogue begun in the late twenties continued well into the thirties. When Edwin Denby met de Kooning in the mid-thirties, he described him as a young painter cheerfully in earnest who readily talked and listened, sitting forward on his chair. De Kooning's great enthusiasm was Picasso. It can be taken for granted that in countless lofts there were similar conversations, that Picasso thoroughly dominated those who wished to enter the magic circle of modern art, and that commitment to 'the new spirit' in esthetics was the deepest commitment made by those fledgling painters about to experience the Great Depression.

This alignment, which the editorialist for *View* generalized by speaking of the unconscious and the artists who sought to give form to their own dreams, often brought with it considerable conflict. The American artist, who was in fact a pariah and often doubted his right to be an artist, was never entirely comfortable with the doctrine of art for art's sake. The unspoken need to be acknowledged by society as a professional was at least as strong as the need to be distinguished from the 'true professionals,' the Europeans. The same artists who assiduously studied *Cahiers d'Art*, or listened to Graham's latest account of what Picasso was up to, often had moments of total rejection, in which they would praise, as did David Smith, the coarseness and directness of their own tradition, or speak deprecatingly of French cuisine in painting. Many artists in the Village suffered from episodes of extreme ambivalence (and continued to express it well into the nineteen-fifties).

At issue was the value of the sole historical distinguishing mark of the American artist: his isolation and loneliness. Individualism as an

institution acquired in artistic circles a kind of hallowed legend, fed by both writers and painters. Long after the young literary lights had ceased to be charmed by E. E. Cummings, for instance, the artists were still deeply respectful. Cummings brought into high relief a stubborn American tradition with which painters could identify. He insisted again and again that it was good to be an artist, that the artist was motivated by love, and that, above all, he was prepared to withstand ostracism and was, in fact, an artist almost by virtue of it. Long after his sensational success among the pioneers of the twenties, and his temporary eclipse (for political reasons) in the thirties, Cummings reiterated his articles of faith in a moving series of autobiographical lectures, 'Six Non-Lectures,' given at Harvard in 1952–53. His essential belief he stated by quoting from Rainer Maria Rilke's *Letters to a Young Poet*:

Works of art are of an infinite loneliness and with nothing to be so little reached as with criticism. Only love can grasp and hold and fairly judge them.

Cummings' defiant individualism, bred in serenity at Harvard, was echoed by other non-conformist American writers, some of whom found favor with painters, who are almost always more literate about literature than writers are articulate on painting. The same suspicion of theory and elaborately stated esthetics that persisted in so many artists could be found in these writers. They include Edward Dahlberg, whose work was beginning to be known in New York by the late twenties, Henry Miller, who had also at the same time enjoyed a *succès d'estime* in vanguard circles owing to the banning of his books, and William Carlos Williams. All these resolutely unconventional writers were at once proud of their lonely isolation and eager to see in it something potentially viable, expressive of their being *American* writers rather than any other kind. Dahlberg wandered about Europe and wrote of the America of his childhood; he lived the desperate expatriate life of the nineteen-twenties while searching the historical horizons of America for clues to his identity. When Edmund Wilson reviewed *Bottom Dogs*, published in 1929, he said it represented the back streets of all American cities:

Dahlberg's prose is primarily a literary medium, hard, vivid, exact and racy, and with an odd kind of street-lighted glamor. . . . We read the book, at any rate, with wonder to see how the rawest, the cheapest, the most commonplace American material may be transmuted by a man of talent . . .[9]

That very material, so illuminated by Dahlberg, was to the author

himself, as it was to Henry Miller, a source of constant consternation. Dahlberg's conviction that America had gone wrong—as once Emerson had said it had, when even before the Civil War 'we reckoned ourselves a highly cultivated nation, [when] our bellies had run away with our brains'—led him to highly colored diatribes against machine-age ethics:

We are a stygian silent people, and it may be that we are the inheritors of the obituary forest, and the great bison tracts of the Platte. We are bleached and spectral Redmen still looking for our inceptions. The big, paranoic cities have made us more solitary and rude . . .[10]

For the writer, he felt that

Sunset has fallen upon American letters, though it is less than a hundred years ago that we had a meadowy, daybreak verse . . . We were an agrarian people, smelling of the harvest and orchard and of good, savory cattle stalled and colonized together. Now we are becoming city untouchables, and manufacturers are making enormous profits out of deodorants and mouthwashes . . .

In other essays, Dahlberg reveals his sacred mistrust of the analysts and cataloguers of art, hating academics as the bane of American vitality, hating, in fact, the genteel tradition that so goaded the men of the twenties. At the same time, he attacked William Carlos Williams who reflected 'the cult of the frontier mind.' Dahlberg asks: 'But who wants to read these American anchorites on bleak ravines and desolate scrub-pines just to be more inhuman than one already is by nature?' Williams, Dahlberg felt, went too far in his hatred of the old European culture. 'He thought that the ancient civilisations could not be seeded here, which is a frontier perversion.' Dahlberg's insatiable hunger for wisdom beyond the frontier, with its distinctively moralistic American note, is very close in character to the appetite for millenial themes that was to gnaw at the vitals of the New York School painters.

His suspicion that America had fallen into decline when it lost its agrarian character was commonly endorsed in the nineteen-twenties. At the moment when certain groups within the vanguard were exhilarated by Machine-Age rhetoric, others were loudly denouncing the pernicious, demoralizing effects of technology. 'It must be remembered,' writes Matthew Josephson, 'that at that time intellectuals and liberals held the fairly consistent view that undirected industrialism was the curse of American life; that we were being turned into barbarians bent only on accumulating money and

33

material things, and that the development of a true culture in such a brutalized society was an impossibility.'[11]

The tenacity of the individualistic bias, at once persecuting and solacing the artist, emerges in many statements later made by the men of the New York School generation. Often they were born outsiders, like Clyfford Still, bred not in the urban chaos, but in those silent, artistically forlorn hinterlands. Still was born in North Dakota, and knew Dahlberg's 'great bison tracts of the Platte' very well. Throughout his life he has exhibited the same angry, moralistic and quirky traits found in Dahlberg's writings. Although he was pleased for a time to be part of a movement, to share experiences with other painters, and to win acknowledgment in the great metropolis, Still was always careful to maintain his position outside of society. In fact, his fanatic and extravagant statements are nearly always designed to alienate sympathy.

The great enemy of logical systems, Still bears out certain of the pragmatic principles of Henry James, who, as Santayana maintained, regarded eternal vigilance as the price of knowledge— perpetual hazard, perpetual experiment in order to keep quick the edge of life. Still's eternal vigilance is against the encroachment of standardized mass democracy. His individualism verges on Brahminism, when he sardonically remarks that 'they,' meaning the masses, will like anything; that museums 'represent collectivism'; and that 'they' will use anything if you let them. Inevitably, he contrasts collectivism with the lonely pioneer image. Reminiscing about a youthful stint as a worker in Canada, he proudly relates how he rode horseback at night for five miles 'in order to bang out Brahms in Alberta and to look at magazines that came once a month.' He likes to recall his farming experiences when 'my arms have been bloody to the elbow shocking wheat.'[12]

Combined with this pride in manual work, which is found also in statements by other artists such as Pollock, Gottlieb (who worked his passage to Europe on ships), and de Kooning, who was at one time a house painter, Still felt a puritanical and stern obligation to justify the life of an artist. In his case, and in many other artists', the justification lay in investing painting with moral overtones. 'Hell, it's not just about painting—any fool can put color on canvas,' he says, adding that painting is 'a matter of conscience.' These strictures developed by Still and his companions in the rise of the New York School, were carried to great lengths when the rhetoric of abstract expressionism found its outlet in the magazines of the forties.

There was a dangerously narrow line between the yearning for integration with America and the unwillingness to be entrapped by its provincialism. Always during the twenties and thirties the political dangers, exemplified in numerous persecutions of 'bolsheviks' and celebrated breaches of the Constitution, worried the artistic community. The moment the concept of an 'American art' was broached, scores of reactionary journalists and entrenched special-interest groups sprang forward to denounce modern art. A progressive young artist, being trained in those years before the deep Depression, always sensed the risks in identifying with America as an ordained American artist. That the risk was real is evident in the literature of the period. One of the early books about progressive American art, written by Sam Kootz in 1929, insistently warned against chauvinism. Kootz feared what he called '100 per cent. Americanism' being brought to art as its reason for being, and he denounced the recent search for the Great American Painters.[13] Again, in 1943, Kootz warned about chauvinism, which he still saw as a prevalent attitude, even though 'we happen to be, geographically, the art center of the world today.'[14] Among artists he mentions in his book are Milton Avery, Byron Browne, Peter Blume, Stuart Davis, Paul Burlin, John Graham, Morris Graves, Carl Holty, and Adolph Gottlieb—nearly all of whom had sought the rudiments of their styles in traditions elsewhere than America.

The situation, then, for the young artist entering the thirties, was uneasy, to say the least. If he looked to Europe or, as in the case of Mark Tobey, to the Orient for his inspiration, he was in danger of missing the essential sense of rootedness. If he remained within the canons accepted by the small but vociferous established cultural institutions, he was in danger of sinking into hopeless provincialism. The New York artists were already keenly aware of the coming dilemmas and had begun to draw together. A significant indication occurs in Ben Shahn's autobiography, when he bitterly recalls his early commitment to great social causes and his first paintings based on the Dreyfus case: 'I felt, and perhaps hoped a little, that such simplicity would prove irritating to the artistic-élite-guard who had already, even at the end of the twenties, begun to hold forth "disengagement" as the first law of creation.'[15]

What Shahn saw as 'disengagement' and what the editor of *View* saw as the expression of the personal dream, or the unconscious, was regarded by artists of varying temperaments as the truth to modern art required to maintain their integrity. Not that all were

totally disengaged. It is often forgotten that the older abstract expressionists had, almost without exception, once been exposed to an earlier kind of expressionism that found fertile ground in the melting-pot of New York. Many of the vanguard variants on European modes in America had had a distinctly expressionistic stamp, even in the first generation of Hartley, Dove, and Marin. During the late nineteen-twenties, the Art Students' League had a full complement of faculty and students involved with a sentimental elucidation of certain expressionist principles, such as the observation of contemporary life in terms of emotion rather than literal depiction. The old veteran Max Weber, who had begun with Matisse and Rousseau, experimented with cubism, and had finally emerged as an emotional anecdotalist, held forth at the League, where Mark Rothko, for one, studied with him. At the same time, other artists, familiar with the aims of the original German expressionists, were gaining ground through such enterprising dealers as J. B. Neumann. Neumann's early activities in propagating the German expressionists were well received by a circle of New York artists, many of them Russian born. It was he who exhibited Weber, the moody, quasi-primitive paintings of Benjamin Kopman, and eventually Rothko, as well as the heroes from Europe, among them Paul Klee (his first American showing), Max Beckmann, Ernst Kirchner. He had opened his 'New Art Circle' in 1924 on Fifty-seventh Street, boldly painting his motto on the entrance, 'To Love Art Truly Means to Improve Life.' Unceasingly, Neumann tried to improve the esthetic life of Fifty-seventh Street with both exhibitions and his idiosyncratic publication *The Art Lover*, in which each month he reproduced such rarities as ancient sculpture, European woodcuts, African sculpture, and even works of the newly esteemed colonial and Indian cultures of the Southwest.

Expressionism, moreover, was directly affecting another art—the theater. There were several experimental theater groups familiar with innovations both in the Soviet Union and in Germany. Kiesler, as already noted, was a full-fledged expressionist when he arrived in New York in the early twenties. The theories of such Russians as Tairov and Meyerhold were familiar to intellectual bohemians. Several artists were more than casually interested in the theater, particularly Mark Rothko who actually performed.

Emphasis on emotional value was all the more significant in view of the special receptivity in America to Freud's theories. His first widely read book, *On the Interpretation of Dreams*, was first published in New York in 1915. Chroniclers of the subsequent fifteen years

never fail to remark on the extraordinary success the Freudian view of existence found in the United States, and long before Freud had convinced his medical colleagues in Europe of the soundness of his interpretation he had found staunch supporters in America. Literary enthusiasts were actively linking their favorite writers with Freudian theories. James Joyce, for instance, was immediately perceived to be a stream-of-consciousness exemplar of Freud's speculations, and lesser literary experimentalists were forgiven their weaknesses if they could somehow hint that underlying their grammatical transgressions lay the workings of the unconscious. Already in the bohemian circles of the immediate postwar period Freud was as potent a subject as cubism, Ezra Pound, and Joyce's *Ulysses* (then being published in installments in *The Little Review*). Matthew Josephson described the effect of Freudianism on Greenwich Village mores when he spoke of a friend who used to go on Saturday nights to dances at the Rand School, a socialist adult school which attracted Village girls with socialist leanings. 'I would ask some girl there to dance with me,' he confided to Josephson, 'and then bring the conversation around to the subject of Freud's teachings, warning her about the evil effects of sexual repression and offering to interpret her dreams.'[16] Well into the nineteen-forties, the interpretation of dreams in social situations was a common sport.

As the twenties edged closer to the dreadful thirties, there was a noticeable drop in high spirits. This depression was experienced well before the Depression and it settled upon many artists and writers who, seeing America drifting toward the vilest bull-market values, evading the implications of the rising Fascism in Europe, and smugly rejecting its artists and thinkers, found little to hearten them. Eliot's 'The Hollow Men' was a substantial document and found confirmation in the artists' communities. The despair that drove some painters to literal or figurative suicide, that periodically descended on the young rebels was well nourished by the increasingly ugly society. (Barnett Newman often described how, even in his college years and the immediate postwar period, the artists he knew would now and then give up entirely, finished forever with the manifold struggles an American intellectual had to undertake.) It wasn't only the Sacco–Vanzetti case, or that of the Scottsboro boys, that affected so many sensibilities; there were other, more intimate conflicts that grew to unbearable proportions and finally exploded in the tremendous upheaval of all values, artistic as well as social, during the Depression.

This could be seen in high relief on the west coast. Artists who spent their youth in Southern California, among them Philip Guston, Herman Cherry, Reuben Kadish, and Jackson Pollock, all remarked on how isolated they felt and how meager the artistic fare was for ambitious young painters. Not only did they share the onus of living in the heartland of popular culture where materialism was the most cherished tradition, but they also had to face the fact that there were almost no patrons and very few institutions interested in painting. The cinema reigned supreme.

Young intellectuals shared the general interest in radicalism, accented on the west coast by the existence of those strong anarchist tendencies that were the heritage of the IWW* (or Wobblies) and of the occult philosophies that found their natural home in Hollywood. Philip Guston remembers his boyhood partly in terms of the bizarre phenomena of numerous cults—among them 'The Blue Triangle,' which was just across the street from his home. Jackson Pollock, who was seventeen in 1928 when he started high school, was immediately exposed to Theosophy and the teachings of Krishnamurti. His other interests are reflected in a letter to his brother in 1929 when he mentions that his school thinks of him 'as a rotten rebel from Russia.' In the same letter, he writes that he became acquainted with Rivera's work through a number of Communist meetings he attended after being ousted from school the previous year, and that he had the issue of *Creative Art* featuring Rivera. In that same issue he would have read a manifesto by Orozco, 'New World, New Races and New Art,' which begins: 'The Art of the New World cannot take root in the traditions of the Old World nor in the aboriginal traditions represented by the remains of our ancient Indian peoples.'[17] Orozco goes on to point out that already the architecture of Manhattan had presented a new value, which painting and sculpture must follow, and states finally that

the highest, the most logical, the purest and strongest form of painting is the mural. In this form alone, it is one with the other arts—with all the others.

It is, too, the most disinterested form, for it cannot be made a matter of private gain; it cannot be hidden away for the benefit of a certain privileged few.

It is for the people, it is for ALL.

* International Workers of the World.

8. Philip Guston's 'Conspirators,' painted c. 1930 and later destroyed, reflects the deep preoccupation he and many others had with political issues. His reference to the hooded Ku Klux Klan members was to be picked up again almost 40 years later when he painted a group of satirical, critical pictures featuring hoods. Photo: courtesy Philip Guston

D

A few months later Pollock went to Pomona College, where Orozco had just completed his first American mural, and in the fall he went to New York and enrolled in Thomas Hart Benton's painting class. There Pollock immediately came into contact with Orozco who was (in October 1930) doing his mural along with Benton at the New School for Social Research.

Guston remained in Los Angeles and was there in 1932 when Siqueiros came to teach at the Chouinard Institute. Long before the W.P.A. got started with its mural project, the interest of American artists in the Mexicans had been stimulated by publication of their various American projects, and in some cases, by direct contact with the Mexican artists. Orozco began the conquest at Pomona; in 1930, Rivera was at work at his mural for the San Francisco Stock Exchange.

Despite an indigenous bohemian tradition, San Francisco was slow in its reaction to painting and sculpture. Off-beat writers such as Kenneth Rexroth, and much later Henry Miller, could easily find a small yet enthusiastic public, but painters had a hard time. When the Mexicans burst upon the scene, they stirred up so much controversy and touched upon so many milieux, including the richest and most snobbish, that their effect was pronounced. In a memoir of the San Francisco painter Yun Gee, a youthful genius who was using the contemporary idioms of France even before he went there in 1927, the late John Ferren wrote:

In San Francisco the Mexicans then ran the roost. Rivera was good and more 'modern' one could not be. The words 'modern art,' now that the battle is won (lost again—won again, etc.) signify nothing today. Then they did, and the blank stare, apathy or violent rejection were real. One or two elders who had seen a Matisse encouraged Yun (I remember they gave a party for Matisse when he came through on his way to Tahiti but we weren't invited). MacDonald-Wright was somewhere about, but he was painting sexy Orientalia. . . . The omniscient Kenneth Rexroth was friend and counsellor. Beyond that—silence.[18]

The ironies inherent in the bourgeois acceptance of Mexican revolutionary rhetoric were not lost on the young artists in Los Angeles. Siqueiros was warmly received by the movie colony and, according to Fletcher Martin, it was at the home of a producer that he made his only outdoor mural in the area. The mixture of fairyland revolution and Hollywood venality made many of the young painters uncomfortable. Hollywood, at that time, was regarded by sophisticated members of the artistic community as fatal to the creative arts. People sighed over the loss of good writers who went to Hollywood and were never heard from again; Lillian Hellman in her autobio-

graphy recalls her sojourn there in the early nineteen-thirties with obvious distaste. She loathed the illiterate standards of studio moguls, the grinding routines gifted writers had to pursue, and, implicitly, the seduction of money:

If you were a writer who earned five hundred dollars a week you didn't see much of those who earned fifteen hundred a week. . . . It took me years to understand that it had been a comic time, with its overperfect English antiques that were replacing the overcarved Spanish furniture and hanging shawls; the flutey, refined language . . . and over our own fireplace in the ugly house there was a portrait of a lion whose eyes lit up if you pressed a button.[19]

She remembers, too, Nathanael West's and Dashiell Hammett's interest in the netherworld of failed spirits that haunted Hollywood then as now, and regards West's *The Day of the Locust* as the best book ever written on Hollywood.

But glamour, invented by Hollywood, is glamour, and some of the world's greatest figures passed through Los Angeles even before the rise of Hitler, and many of them (so unaccountably) decided to stay there. Charles Chaplin in his autobiography recalls a stream of significant visitors, among them Gertrude Stein who lectured him on movie plots ('They are too hackneyed, complicated, and contrived') and Albert Einstein, who spent an evening in Chaplin's home politely discussing the possibility of ghosts. 'At that time,' Chaplin wrote, 'psychic phenomena were rife and ectoplasm loomed over Hollywood like smog, especially in the homes of the movie stars, where spiritualist meetings and demonstrations of levitation and psychic phenomena took place.'[20]

Against that background of glitter and humbug, especially prevalent in Los Angeles, it is easy to understand the fervent rebellion of the young artists who yearned to put their talents to the good cause of social revolution. What came to be known as 'the big wall' of the Mexicans seemed a vital antidote to the corruption they condemned in society. Unquestionably, Siqueiros' presence served as the great moral impetus. When he came to Chouinard 'he formed a team consisting of himself and six assistants whom he called "Mural Block Painters" and set them to paint a mural. The surface at his disposal was small and irregular; an outer wall six by nine meters broken by three windows and a door. As the cement surface cracked almost immediately, Siqueiros decided to use spray guns, used for applying quick-drying paint to furniture and cars.'[21] Watching Siqueiros at work, both at the school and at film director Dudley

Murphy's house, reinforced the convictions that Guston and his friends had aired sporadically at meetings of their John Reed Club. A chilling story recounted by Guston suggests the climate in which they worked. The members (all in their teens or early twenties) decided to paint a portable mural. When it was completed, a group of American Legionnaires stormed their clubhouse, shot out the eyes and genitals of the figures on the mural, and then destroyed the rest of the place with lead pipes. Soon after, Guston left for Mexico.

The big wall represented to the young artists more than a mere escape from bourgeois influence. Many of them saw parallels between their own situation and that of the Mexican revolutionary who had to seek an identification after so many years of Spanish domination. The problem of self-identity was perhaps even more compelling for the American artist than the social problems he sought to depict in his murals. Like William Carlos Williams, who searched for a sense of locale in 'In the American Grain' and who wrote with equal fervor of the gods of the Indians and the gods of the Anglo-Saxons, painters who were unwilling to be shaped either by American chauvinist standards or by totally European values turned to the Mexicans who seemed to be able to plumb their own heritage and to integrate with their society. 'The reaction against European painting was very very strong at that time' (around 1930), Herman Cherry maintains, pointing out that the strongest figure representing the reaction was Thomas Hart Benton.[22] Pollock found his way to Benton, but others attempted to establish sympathetic American tradition by doing what the Mexicans had done: turning back to the American Indians. Artists' colonies in the American Southwest flourished from the nineteen-twenties, drawing generation after generation of wistful artists who sought a non-European tradition with which to identify.

Even before the twenties, there had been Americans foraging for an identity they could not find in Europe. The highly sophisticated painter Paul Burlin, who was well-known to the young New York School for his peppery tongue and his accurate art-historical critiques, had gone to the Southwest during World War I. His commentary on his initiation to a truly American tradition is worth quoting in full since it was an experience many others sought during the following decades, right up through to 1950:

In truth the American Southwest was practically the beginning of my interest in painting. My introduction to the art of the Indian stirred up strange conflicts. I was ignorant of the Indian and knew nothing of his

work. And since I didn't know him I feared him. . . . I travelled to distant places to learn; I heard his chants; I saw strange ceremonial rites in remote parts of New Mexico. I was entranced with his witch doctors and the whole aspects of the metaphysical propitiation of the forces of nature. Mayan architecture and sculpture overwhelmed me. I wished to understand these configurations that were indigenous to the character of the land. How could I translate them? What ethnic brotherhood brought about these two-dimensional designs on utilitarian objects? Why was a bowl decorated in this abstract fashion? By contrast, all other picture-making seemed like story-telling trivia. These disturbing factors, none of which had anything to do with 'representation' were the vague beginnings of an esthetic credo . . .[23]

Artists and the New Deal

Throughout the nineteen-thirties the W.P.A. was a central fact in the lives of nearly all the abstract expressionist painters. To them, the decade of the thirties represented the Project, and the Project meant the establishment of a milieu for the first time in the United States. If one conscientiously examines all the statements made subsequently by the major artists of the forties and fifties, the obvious value the W.P.A. had for them was that of artistic community. They often point out that the artist, like everyone else, was starving and the Project was a meal-ticket; that for the first time in their lives they could devote all their time to their work; that it coincided with their interest in a reformed society. But the most compelling force that emerges is their sense of having found each other. From the days of the Project onward, there would be the median between artist and society that had long sustained the European artist: an artistic milieu. How important this was can be judged by the defensive statements of the few artists who either didn't qualify because of income, or preferred to remain independent. The sculptor Isamu Noguchi felt bitterly isolated when he was excluded, and Barnett Newman claimed: 'I paid a severe price for not being on the project with the other guys; in their eyes I wasn't a painter; I didn't have the label.'[1]

As soon as the Depression began to make significant inroads in daily life patterns the government began moderate programs of relief, even in the arts. The Hoover administration did allocate some funds to states that initiated their own programs, although President Hoover himself, like most of his fellow citizens, gave no weight to the arts. Henry Billings, an artist on the mural project, regards the Roosevelt regime as the first to be even faintly aware of the arts as a necessary part of civilization, and points out that when Hoover

answered an inquiry by the French government for an exhibition to include American art, he said that as far as he knew there were no decorative arts in the United States at this time.[2]

The struggle to establish the arts as legitimate areas for subsidy was long and complicated, and as the most authoritative author to date, William F. McDonald, makes clear, was at least partially effected by the mounting pressures from artists themselves.[3] His well-documented book brings to light on a large scale the conflicts that had bedeviled the individual artist in his private ruminations. As he points out, the main figure in the Roosevelt administration charged with realizing the various arts relief programs was Harry Hopkins, a keenly intelligent, refined man who had served his apprenticeship in the settlement-house days of social progressivism. To Hopkins, the arts remained civilizing instruments for the social reformer. His aim was the total infusion of culture on a mass scale. When the prototype program of federal subsidy got under way under the Civil Works Service in 1934, McDonald stresses that it was largely on the level of extended community services:

Orchestras, bands and chamber ensembles were formed to give free concerts in libraries, museums, hospitals, schools and over the radio. Artists were employed to produce murals and posters and to assist teachers in the public school. . . . Five portable theaters on trucks were constructed to give plays in public parks during the summer, and trained teachers of the theater gave instruction to 175 groups of 2,500 persons in amateur theatricals.

Moreover, the classes for adults in New York City started with fifteen teachers and 150 students and within a year had 3,500 students and 60 teachers. These efforts in community service, he remarks, gave the professionals the idea to press for subsidy. (The organizations formed to make pressure groups were legion and the quarrels extensive.) And they also kept alive the inevitable conflict between the art-for-art's-sake professionals and the social reformers.

At the time the final version of government subsidy, the Works Progress Administration, was brought before Congress it was estimated that more than half the artists in the entire United States lived in New York. By 1931 artists had already begun to feel the mounting despair and began to form active groups. Various schemes were proposed. A group of New York artists, seeking to find a direct market and to bypass the few dealers who remained, looked to Paris where an artists' aid committee had formed to trade their art for 'anything reasonable.' This barter plan was tested without notable

success in 1932 by the American Society of Artists. Others attempted to organize outdoor exhibitions, festivals, community shows, and other projects in order to reach a rapidly dwindling middle class that might sustain the painters and sculptors for a few months longer. By 1934, however, the College Art Association estimated that there were more than 1,400 artists in New York city urgently in need of relief. The idea that artists could be employed by the state occurred to several members of Roosevelt's inner circle, but it was most forcefully presented by his old school friend, the painter George Biddle, who wrote on May 9, 1933:

There is a matter which I have long considered and which might interest your administration. The Mexican artists have produced the greatest national school of mural painting since the Italian Renaissance. Diego Rivera tells me that it was only possible because Obregon allowed Mexican artists to work at plumbers' wages in order to express on the walls of the government buildings the social ideal of the Mexican Revolution.

The younger artists of America are conscious as they have never been of the social revolution that our country and civilization are going through and they would be eager to express these ideals in a permanent art form. . . .[4]

Not long after, the first federally sponsored program, the Public Works of Art Project, got under way with the painter Edward Bruce at its head. It lasted only a year but according to Mildred Baker, one of the W.P.A.'s directors, over 3,700 artists were employed, producing between them more than 15,000 works. Closer to Biddle's idealistic hope of inaugurating a school of mural painters was the Treasury Department's program next undertaken by Bruce which specifically sought to employ artists for murals and sculptures in public buildings (one per cent of the construction costs being set aside for the purpose).

Edward Bruce's interest in his projects was always geared to the idea of public service, both to the artists and to the public at large. When he commented on the effects of the first programs, he noted that

the receipt of a check from the United States government meant much more than the amount to which it was drawn. It brought to the artist for the first time in America the realization that he was not a solitary worker. It symbolized a people's interest in his achievement. . . . No longer was he, so to speak, talking to himself.[5]

This view is confirmed by a number of artists such as Herman Cherry who, recalling the W.P.A. in California, felt that 'the recognition of the artists gave them dignity.'

The early programs proved inadequate. The relief rolls were crowded with artists who found it hard to qualify for government-supplied, categorized jobs and often fared worse than the blue- and white-collar workers. In 1935 the Works Progress Administration established Federal Project I, under the general direction of Jacob Baker, with Holger Cahill directing the art project. By November 1, 1935, there were 1,499 project workers in eleven states, of whom 1,090, or 78 per cent were concentrated in New York City. By November 13, 1935, there were 1,893 with 1,129 in New York City, and by 1936 there were more than 6,000 artists employed by the W.P.A. The quick and effective organization was largely due to the extraordinary zeal and sympathetic personality of Holger Cahill. The choice of Cahill as administrator may well have been the decisive factor in the importance the W.P.A. was to assume for professional artists. He had long been known to them as an open-minded, sensitive missionary for modern art. In his own youth he had taken his first step as organizer and modernist by forming an obscure group called Inje-Inje, named after a South American tribe whose only language was that single word. John I. H. Baur describes the movement as only half or perhaps three-quarters serious, with a tinge of Dada in its proposals, but nevertheless regards it as 'one of the most significant manifestations of postwar unrest in this country, its mixture of constructive and destructive elements more characteristic of America's underlying optimism than was the more thoroughly nihilist spirit of Dada.'[6]

Cahill moved easily between the artists' studios and the world of museums, having been trained early in the Newark Museum in New Jersey, one of the few American museums that had acknowledged the importance of contemporary art. His friendships were numerous, especially among the vanguard artists in New York. He quickly adapted, however, to the pressing ideas of the time, as can be seen in his introduction to the 1934 survey of American art circulated by New York's Museum of Modern Art to some one hundred small institutions. 'American art is declaring a moratorium on its debts to Europe,' he enthusiastically proclaimed, 'and returning to cultivate its own garden. . . . The Olympus of the observer, detached from the actualities of daily living, has been blasted out of existence.'[7] His exhilaration at the thought that art would now be related to daily life never prevented Cahill from understanding those artists who could not see themselves in a social missionary role. When Gorky exhibited in 1935 at the Guild Art Gallery in New York, it was Cahill who

47

wrote the foreword, as he did for several other artists in that circle. Cahill's personality, then, made it possible to organize the various divisions—such as the easel and mural projects—with great flexibility. He had excellent judgment and chose directors throughout the country who could cope with the unceasing flow of problems both from the government side and from the artists. The most difficult problems came from hostile legislators and the power of the Hearst press. Cahill said years later that the Hearst press was after him all the time, and a supervisor of the New York easel project, Rollin Crampton, recalled that the F.B.I. was always coming round to ask who was reading *The Call* (a socialist newspaper), and to look for reds. Not the least of Cahill's problems derived from the demeaning system of the means test, which forced artists to prove their need, and from the original guidelines set up in Washington by which artists were required to put in their hours like so many other employees of the state. With amazing skill, Cahill put into effect an extremely elastic system which permitted artists to work at their own speed and check in as infrequently as possible. The time-clock was banished in Cahill's department: easel project painters were required only to report back from time to time with a minimum quota of work. There are many amusing and pathetic stories about how solicitous artists were for their fellows who couldn't or wouldn't submit even a minimum of work. Pollock was one of the artists well protected by his friends, who would come to his studio and, despite his protest ('Who would want *that?*'), select some small work to present to the local supervisor for his $94 a month. Burgoyne Diller, one of the most diplomatic and sympathetic supervisors, personally visited artists who had not checked in to cajole and persuade them to meet their minimum obligation. Throughout the project, there were well-chosen artists who carried out Cahill's instinctively just directives with a patience that often reached saintly proportions. Under such circumstances, in which the fine arts were in the hands of the people committed to fine art—the artists—it is not surprising that an artistic milieu developed.

The troubles Cahill faced from the non-artistic world were legion. As McDonald says,

The opposition, which expressed itself in political channels through the states and the Congress, assumed popular form in the pages of the press . . . The masters of the fourth estate, applying the sound military principles that an enemy's line is most easily broken at its weakest point, concentrated their fire upon the white-collar—particularly the arts—

48

program. [The press] was able to create in many communities an attitude of contempt for cultural projects. In some instances, as early as 1934, to actual investigations . . .[8]

Throughout the brief life of the federal art projects there were threats from the political right. Sensing that the increasing hostility in Congress could boil over with very unpleasant consequences, Roosevelt apparently decided not to make a stand for the arts' projects when the controversies grew fiercer in 1936. Lewis Mumford took up the standard and wrote an impassioned letter which was published on December 30, 1936, in *The New Republic*. Mumford lectured the President on the social importance of the arts, of which he implied Roosevelt was unaware. He pointed out that the dispersion of works of art throughout the country had brought new meaning into the lives of ordinary citizens: 'Industry does not supply these needs; it never has and, since the motive of profit is lacking, it never will. Private philanthropy is too puny to endow them. Nothing short of the collective resources of our country as a whole has proved competent to bring the fine arts into the lives of everyday Americans.' Then, pointing to the economic dilemmas that undoubtedly motivated Roosevelt's moves against the funding of the projects, Mumford presented what was certainly the prevalent liberal attitude:

To dismiss the workers on the arts projects and dismantle the projects themselves will not 'release' a large body of people for commercial or industrial employment. There has never been a place in our present industrial system for the artist, except as a flatterer of the rich and idle, or as a mere servant of business enterprise. . . . Now that the community itself has devised appropriate ways for patronizing and encouraging the arts and giving them a permanent public home, it is time that art be taken for what it is—a realm like education which requires active and constant public support.

Even if the painters and sculptors on the projects in New York squabbled among themselves, fought for better wages, and engaged in considerable picketing activity, they were, when threatened by the philistines, a united front, wholeheartedly defending the principle of federal aid to artists and all its wholesome, cultural byproducts. The pressure from the Right, in fact, probably had a salutary effect in metropolitan circles. The burgeoning community of artists was thrown together for self-defense, if for nothing else. Much of the initial hostility was focused on New York, which was regarded then, and still is today, as an almost alien outpost of foreign influences. On the prairies and in the deep South, the mere mention of New York

would call forth angry denunciations of its radical politics, art, and literature.

Inflamed by the Hearst press, the average citizen was especially incensed by the more visible subsidized arts, the theater above all. The theater project, as originally conceived, was seen by Harry Hopkins as an extension of his social-service philosophy. When he went out to open the new University Theater in Iowa City in 1935, he revealed his idealistic bias in a speech at the opening:

What part could art play in the program? Could we, through the power of the theater, spotlight the tenements and thus help in the plan to build decent houses for all people? Could we, through actors and artists who had themselves known privation, carry music and plays to children in city parks, and art galleries to little towns? Were not happy people at work the greatest bulwark of democracy?

But Hopkins' gentle notion of the uplifting character of the theater was never shared by the director of the project, Hallie Flanagan, a spirited and highly cultured woman whose interest in experimental theater was keen. Through her, a great many small theater companies performed works of the radical European tradition, as well as home-grown expressionist manifestoes. The most embarrassing experiments, at least as far as the government was concerned, were undertaken with great panache by the New York contingent, which originated the inflammatory 'Living Newspaper.' Taking their material from actual news accounts, the dramatists of the Living Newspaper did not hesitate to do precisely what Hopkins had called for: spotlight the tenements and demand decent housing for everyone. However, they did it with an 'agitprop' roughness that immediately called the wrath of the legislators down upon them and ultimately destroyed the theater section altogether. McDonald thinks it was naïve of Flanagan and her supporters to believe that the theater projects could continually and spectacularly express a social philosophy opposed to that of a substantial element in Congress.

Surprisingly the theater and music projects were important models in relation to the painting projects, for they were drawing on professions that had already been unionized. Both the drawbacks and the advantages of professional organizing were highlighted in the controversial theater set-up. On the Theater Project, for instance, union demands forced the supervisors to take on people with previous professional experience, making it difficult for small theaters in the hinterlands to function. In the art project, on the other hand, Cahill made very sure that 'professional' standards rested on the

applicant's ability to produce objects of professional merit, not on his professional position in the field. As a result, the young, unknown aspirant with ability, or even a not-so-young but independent artist such as Willem de Kooning, was able to get on the project without difficulty. This important distinction certainly abetted the rising consciousness of professionalism amongst the painters without constricting their ranks (this was especially important to the less orthodox artists since the few artists' organizations that existed were invariably esthetically reactionary). The function of the W.P.A. in the lives of the artists was well summarized by one of its beneficiaries in San Francisco, Ben Cunningham:

The whole activity was one which the artist himself controlled. Peripheral institutions—museums, galleries, the press—had little or no jurisdiction. In retrospect, the feeling then was that art was something to experience directly, for excitement and satisfaction, rather than to evaluate in terms of the latest verbal label and fashion. . . .[9]

The continuity of the artistic life, which many experienced for the first time on the project, proved to be the catalyst that was to change the diffident American painter into a professional who would finally see himself as an equal in the world of modern art.

9. Lee Krasner, seen with one of her paintings c. 1938, was already friendly with the small vanguard including de Kooning, Gorky, Graham, and Kiesler, and the critics Rosenberg and Greenberg, by the time she met and married Jackson Pollock. Photo: courtesy Lee Krasner Pollock

A Farrago of Theories

Professionalism, the newly discovered lode in the crisis period of the Depression, brought with it the need for talk. Not only did painters and sculptors now have time to talk and visit and sit around each other's studios, but they also had the increasing need to cope with the barrage of rhetoric they encountered everywhere. The habit of discussion, which the older artists so often felt lacking in America, grew up in studios along with the problems—political, social, and esthetic—engendered by the Depression. Things moved swiftly in the thirties, and each new controversy stirred an uncommon amount of contention.

Any attempt to assess the situation of the New York School cannot ignore the astonishing outburst of talk that occurred during that period. Many of the problems the artists of the forties and fifties continued to examine fitfully throughout their careers were broached then, though some had been touched upon only cursorily. The talk took place almost everywhere. Lee Krasner recalls that she and Harold Rosenberg, having been assigned as assistants to the muralist Max Spivak, who had little need for them, sat around his Ninth-Street studio all afternoon, talking and talking. Others point to the many cafeterias downtown where for the price of a cup of coffee you could sit and argue all night. For example, in the first issue of the radical artists' magazine, *Art Front*, the New China Cafeteria on Broadway, near Fourteenth Street, advertised its appealing low prices with the slogan 'Where Comrades Meet.' Union Square was surrounded by convenient, low-priced eating places which the artists frequented, comrades or not, and indulged in what had become a New York obsession: talk.

Union Square was, in fact, for many New Yorkers the epitome of urban life, the heart of a turbulent city. It was fashionable to like

53

the square for the very qualities that social reformers condemned—
crowds and chaos and visible poverty. This affectionate attitude
cultivated by young artists and intellectuals (some of whom would
soon turn to social realism) can be sensed in Alfred Kazin's descrip-
tion of the square in 1935:

> The place was boiling as usual, with crowds lined up at the frankfurter
> stands and gawking at the fur models who in a lighted corner window
> perched above the square walked round and round like burlesque queens.
> . . . There were . . . the usual groups in argument before the Automat,
> the usual thick crowd pouring round and round the park in search of some-
> thing, anything, that might be in the stores. There was always a crowd in
> Union Square; the place itself felt like a crowd through which you had
> to keep pushing to get anywhere. . . .[1]

He speaks of the 'everlasting circle in Union Square of people
clasped together in argument,' and again of the 'eternally milling
circle of radicals in argument,' and he clearly felt exhilarated by the
constant sense of something occurring through talk.

The kind of discussion that might have affected the choices made
by painters when they came to make the stylistic decisions that
released them from tradition was held on too many different levels
to analyze thoroughly. There were artists who turned away from
street politics and others who were assiduous readers of the political
weeklies; there were artists who concentrated on the inherent prob-
lems of their craft, or on the history of painting, and others who
were easily diverted to the problems of society. At most levels, the
discourse was punctuated with Marxist allusions, and the most
dedicated of the young artists on the project would have been
exposed many times to highly intellectual discussions based on the
quickening of interest in Marxism that occurred in the mid-nineteen-
thirties.

The trajectory of thought from science-and-society to myth was
swift. By the early forties, the Marxist dialectic was all but eclipsed.
Yet it was in those earlier bull sessions, where Freudian, Jungian, and
Marxist ideas on art were explored, that most of the attitudes repre-
sented by the New York School were nurtured. The *leitmotifs* of the
richest kinds of discussions in those days were wittily synopsized by
Harold Rosenberg a few years later in 'Breton—A Dialogue.'[2]
Rosenberg, who had been a voluble young poet with his own coterie
among the young writers of the day, would have been the prime
mover of many of the discussions he satirizes in the dialogue—
discussions that were held up to the time of his writing it in 1942. In

10. William Gropper's back page of the March, 1930,
edition of *New Masses* includes a list of books which
shows the range of avant-garde political and cultural
interests.

Read the NEW MASSES

Drawn by William Gropper.

the dialogue, which takes place in 'a comfortable room,' unlike the uncomfortable places such discussions filled in the lean years, Rosenberg draws three proto-typical characters who emerge from the thirties—Rem, Hem, and Shem, all left-wing intellectuals. They are dicussing André Breton's call for a New Myth. Hem argues: 'We need a new myth and a new communion. Without beliefs man cannot act.' His orthodox Marxist opponent, Shem, disagrees: 'The desire for a new myth is reactionary. Society must be organized by science.' Rem, standing halfway between, and probably representing the cautious stance of many painters, maintains that a new life cannot be brought about by science alone, though it will depend on science. 'It requires a primordial upheaval, a fundamental revolutionary rejection of the past, and is therefore a matter of feelings and objective conditions, as well as of knowledge.' As they talk on, Rem and Shem and Hem become interchangeable, raising erudite but ordained arguments that lead only to further confusion. Rosenberg's thrust at his own caste, the intellectuals, has the force of the era in which he is writing, which had developed a certain scepticism to them, especially among painters. Yet, as ironic as Rosenberg strives to be in this short exposition, he does not succeed in masking the serious and healthy origins of such dialogues. A decade earlier such questions had been taken by him, as all other intellectuals, with the utmost seriousness.

As for the questions posed by those whose eyes were focused on what they felt to be the inherent tradition of modern art—they too were inevitably tinged with the experimental dialectics the new leftism introduced in New York discourse. In its most profound exposition, the Marxist-influenced analysis of art history is represented by Meyer Schapiro. He studied drawing at the National Academy and was remembered by Raphael Soyer as 'a bright boy in knee pants' at the time. A few years later, Soyer encountered him again, this time at a meeting of the John Reed Club, which had been founded in New York in 1929 and had spread rapidly throughout the cities of the United States as the Depression deepened. It was primarily a Marxist study group, although the members of the New York section of artists often discussed more immediate esthetic problems. 'One of his statements has remained with me,' Soyer wrote. 'I don't recall in what context he made it, but it was probably in criticism of the Club's philosophy of social realism—"No *Kapital* on art has yet been written." ' Soyer then mistakenly claims that Schapiro and others were soon to formulate a dogma of their own, preaching the 'truth' of non-objectivism.[3]

In fact, Schapiro trod warily among the modern dogmas and never completely accepted the theory that supported the ascendancy of pure abstraction. Soyer and the other social realists at the time bitterly resented his professional distance from their impassioned hatred of esthetes and ivory-tower painters, as the abstract painters were so often called. They did not understand Schapiro's breadth of interest, and missed, in his writings, what any close reading reveals: that the foundation of his attitudes toward modern painting remained buttressed by the dialectical modes of thinking typical of the Marxist. Intelligence, deep intelligence, shone through his essays of the period, together with a remarkable objectivity. But when Schapiro's work of the thirties is carefully analyzed, two important considerations appear to have shaped his thought. The first is his conviction that the modern artist's rejection of history as such (his interest in primitive art, for instance, represents for Schapiro a retreat into the non-historic) is unhealthy; the second is that the correct reading of modern art history must place it in a general historical context, or 'in society.' Approaching impressionism from this point of view, Schapiro associates the 'pleasure' aspect of painting with the horror of capitalist individualism, so that in painting moments of esthetic pleasure, the impressionists satisfied the *rentier* class. This Marxist analysis of a movement in painting jibed very well with the puritanical bias sustained in America. The whole sensuous or playful aspect of modern painting seemed to him decadent. Although he was too sensitive and too wise to attack modern painting, he found little justification for the 'absolute' painting divested of 'content.'

'If modern art seems to have no social necessity,' Schapiro wrote in 1936,

It is because the social has been narrowly identified with the collective as the anti-individual, and with repressive institutions and beliefs, like the church or the state or morality, to which most individuals submit. But even those activities in which the individual seems to be unconstrained and purely egoistic depend upon socially organized relationships.[4]

He goes on to show how inextricably the modern artist's endeavor is locked into the culture by discussing the nature of the society for which these artists' works are destined, and indicates his reservation in relation to 'esthetic' individuality:

The general purpose of art being esthetic, he is already predisposed to the interests and attitudes, imaginatively related to those of the leisure class, which values its pleasures as esthetically refined, individual pursuits. . . . His frequently asserted antagonism to organized society does

not bring him into conflict with his patrons, since they share his contempt for the 'public' and are indifferent to practical social life.

Attacking the egoistic artist even more sharply, Schapiro accuses him of passivity toward the human world and an incorrect attitude to 'the apparent anarchy of modern culture' which he seems to welcome as an assurance of his individual freedom. The other kind of artists—those concerned with the world around them in its action and conflict 'who ask the same questions that are asked by the impoverished masses and oppressed minorities'—win Schapiro's admiration since, as he concludes, 'in a society where all men can be free individuals, individuality must lose its exclusiveness and its ruthless and perverse character.'

This was, to my knowledge, Schapiro's strongest Marxist formulation. A year later, writing in the *Marxist Quarterly* of January–March 1937, his tone is far more moderate. He shows that he understands how certain artists cannot ask the same questions that the oppressed masses ask, and that he understands the intrinsic merit of abstract art. Yet, the burden of his argument remains—to place art within society in such a way that its individual movements and manifestations are symbolic of its social and political matrix. His most inflected language occurs precisely when he is attacking the modern artist for his retreat from practical life and, above all, from history. Historical materialism accounts for much of Schapiro's theorizing here. For instance, he is quick to link the vogue for primitive art originating at the end of the nineteenth century with colonialist imperialism, not sparing the artist who, he hints, is essentially a dupe of capitalist culture:

The preservation of certain forms of native culture in the interest of imperialist power could be supported in the name of the new artistic attitudes by those who thought themselves entirely free from political interest.

The modern artist, he sarcastically notes, considers it the highest praise when his work is described in the language of magic and fetishism. For him, the arts of primitive peoples without recorded history acquired the special prestige of the timeless and instinctive, 'on the level of spontaneous animal activity, self-contained, unreflective, private, without dates and signatures, without origins or consequences except emotions.' Such attitudes, Schapiro notes with distaste, played into the hands of the imperialists: 'A devaluation of history, civilized society, and external nature lies behind the new

11. The installation of the Museum of Modern Art's 'Cubism and Abstract Art' exhibition in March, 1936, already indicates the strong interest in surrealism. Photo: courtesy The Museum of Modern Art

passion for primitive art.'

Schapiro's main point in this discussion of the 'Nature of Abstract Art' is to blast the 'pretension that art was above history through the creative energy of personality of the artist.' His pretext was the catalog written by Alfred Barr for a very important exhibition at the Museum of Modern Art, 'Cubism and Abstract Art,' in 1936. This exhibition, which brought together for the first time in New York nearly all the significant movements of the century in coherent sections, was of prime importance to the artists. For many, it was the catalyst that served them as once the Armory show had served Stuart Davis. As a gauge of the unfavorable climate in which the exhibition took place, Barr's preface begins very defensively by stating that the show was conceived in a retrospective, not controversial, spirit and

that it was confined to abstract art in Europe because the Whitney Museum had had a large exhibition of abstract art in America only the year before. He also wrote specifically that he wished the text to be considered as a series of notes without any pretensions to originality or inclusiveness. In spite of Barr's diffident overture, the show and its catalogue were roundly castigated in the press from both left and right. On the left, criticism ranged from the crude denunciations of those committed to 'agitprop' art to the extremely sophisticated and intelligent remarks of Schapiro. On the right it was the same old story: ignorance and chauvinism giving vent to a derision that had not changed since the 1913 Armory show.

Schapiro's respectful attack on Barr rests on what he considered Barr's essentially non-historical point of view, which led Barr to exclude the nature of the society in which the art arose. 'The history of modern art is presented as an internal, immanent process among the artists,' Schapiro says, catching Barr in the simplistic statement that modern change in art was the 'logical and inevitable conclusion toward which art was moving.' Paradoxically, Schapiro, in many situations a dialectician accepting the historical determinism of Marx's theory, here becomes the upholder of the opposite view, denying that there can be a strict and mechanical determination growing from the modern art dialectic, and pointing to the many contradictions in the history of art. One of his most significant observations is the contention that Barr's view is 'common in the studios and is defended by some writers in the name of the autonomy of art.' Here he was correct, for many artists accepted the idea of an interior history of their discipline, which was not always paralleled by social and political history and which often seemed to gather its own momentum and respond to its own generating ideas in an auto-nomous way. Schapiro, and the artists who yearned to participate in a new society, a socialist society, saw this attitude as a reactionary one conditioned inevitably by capitalist circumstance:

The notion that each new style is due to a reaction against a preceding one is especially plausible to modern artists, whose work is so often a response to another work, who consider their art a free projection of an irreducible personal feeling, but must form their style in competition against others, with the obsessing sense of the originality of their work as a mark of its sincerity.

This observation, though made as an accusation rather than an impartial report, was accurate enough. There are many testimonies from artists to the fact that the modern imperative of originality

weighed heavily on them and, in some cases, brought them to despair. Far from being non-historical in attitude, most progressive painters were keenly aware of the obligations of history, and seriously debated both the interior history of modern art and its relationship to modern society. The luxury class to which Schapiro keeps referring was not operative during the Depression, and becomes a strawman for his argument. Rather, the modern painters in America were faced with the esthetic and social issues in their most fundamental form, since 'society' in the form of the W.P.A. was in many instances supporting them, while the *rentier* class as patron had been all but obliterated in the Crash.

Every time the artists in New York cast their eye on the European vanguard, especially the titan Picasso, they seemed to suffer their condition of historicism keenly. There is a story, apocryphal perhaps but significant nonetheless, that in the mid-nineteen-thirties Gorky called a meeting in his Union Square studio of eight or ten artists, and disconsolately announced, 'Let's face it, we're bankrupt.' The shadow of the School of Paris brought gloom to the artists, and, he said, the only thing they could do would be to work on a collective work: 'You're good at drawing, you draw it; you're good at composition, you design it,' and so on. The group, which included de Kooning and Lee Krasner, met only twice, but as Krasner remarks, it reveals the frame of mind.

The sense of bankruptcy experienced by the most progressive painters was also a source of considerable discussion. Each of the new modes from Europe was eagerly tested, and then abandoned when the personal conflict characterized by Schapiro as the false need for 'originality' intervened. Even an intrepid student of modern idioms such as Gorky had his moments of self-doubt and came in for a lot of raillery from his friends. They teased him about his adoption of the styles first of Cézanne, then Picasso, then Miró. One of the Gorky legends, for instance, tells of a friend who pointed out to Gorky that, in recent work, Picasso no longer had that clear edge, and his paint dripped. Defiantly Gorky responded: 'When *he* drips, *I* drip.' But the implications bothered him, and, indeed, all the artists in his circle.

It must have been very tempting to join those ardent advocates of radical social change in their digression from the interior history of modern art. Some of the most vigorous talk occurred in the artists' meetings and organizations that arose as the emergency deepened. As McDonald points out, the artists under financial stress began to

realize somewhere around 1932 that unlike the musicians and theater people, they had no well-organized means to pressure the government for relief. Within a year, the idea of an Artists' Union gained sway and drew very broadly from the ranks of the artists. Those who were not joiners by nature nevertheless found it hard to stay away from the often stormy organizational meetings. By November 1934, the Artists' Union and the Artists' Committee of Action had not only pulled together a large organization with Stuart Davis at its head, but also commenced publication of *Art Front*, a news and criticism vehicle which appeared with Davis' proclamation that it was 'the crystallization of all the forces in art surging forward to combat the destructive and chauvinistic tendencies.' The first issue announced a mass demonstration for 'Jobs and Immediate Relief for all Artists,' and demanded a government project that would differ from P.W.A.* in that there would be no discrimination against artists' styles and 'complete freedom in the conception and execution of the work.' To reinforce their demands, the artists had demonstrated in front of the Whitney Museum. The first issue also contained letters from well-wishers, among them Lewis Mumford, who praised the Union for its campaign for a municipal art gallery because 'it will help take art out of the sphere of mere connoisseurship and wealthy patronage,' and one from Max Weber, who saw the newspaper as a weapon against Nazism, Chauvinism, and Fascism creeping into the life of art and artists.

Far from being an orthodox left-wing organ, *Art Front* managed to maintain a lively, open position. It never succumbed to chauvinism, then epitomized by the new enthusiasm for the American scene-painters, Thomas Benton, John Steuart Curry, and Grant Wood. Although it was frankly activist politically, *Art Front* maintained considerable latitude esthetically. It was consistently against the intrusion of Americanism in artistic issues and frequently carried sharp commentaries by Stuart Davis on the subject. In the issue of February 1935, for instance, he attacked Curry and Benton; and when, in April, Clarence Weinstock reviewed the Whitney show of American abstract painting, expressing some reservations about the absence of 'meaning,' Davis answered categorically in the May issue:

If the historical process is forcing the artist to relinquish his invidualistic isolation and come into the arena of life problems, it may be the abstract artist who is best equipped to give vital expression to such problems—

* P.W.A. = Public Works Administration, the first federal project.

because he has already learned to abandon the ivory tower in his objective approach to his materials.

The struggle against American-scene painting was stepped up in 1935 (when for about a year Harold Rosenberg was an editor), when even the visual material was enlisted in the fight. Yasuo Kuniyoshi contributed with a cartoon making fun of the new social realism, which showed an art class very carefully drawing an Esso gas pump (thirty years later, perhaps no one would have got the joke). By 1935, a lot of contention within the ranks of organized groups began to disturb Davis' initial dream of 'social solidarity.' The innumerable splinter groups among the leftist political groupings succeeded in tearing asunder whatever basic agreement there had once been. The quarrels were legion; friendships were often terminated by political disagreement. Studios were no longer so often the site of discussion but rather of terrific arguments. Many painters, desiring the time and peace of mind to work, had already begun in late 1935 to understand what Davis later said about himself:

In 1934, I became socially conscious as everyone else was in those days . . . this meant meetings, articles, picket lines, internal squabbles. . . . Lots of work was done but little painting.[5]

But most young artists at that point were to wait a little longer before they extracted themselves from the meetings, articles, picket lines, and internal squabbles. The great event of 1936 was too alluring to resist: the conference of the American Artists' Congress held at Town Hall and the New School for Social Research on February 14, 15, and 16. The idea came from the American Writers' Congress that had been held in May 1935, sponsored by such influential writers as Theodore Dreiser, Waldo Frank, Josephine Herbst, Erskine Caldwell, and Malcolm Cowley. They had proposed that the congress be devoted to exposition of all phases of a writer's participation 'in the struggle against war, the preservation of civil liberties, and the destruction of fascist tendencies everywhere.'

When the artists came together to organize their own congress, they found the problem complicated by the fact that their strong feelings about the nature of each other's art inevitably influenced their attitudes to each other's social and political views. Davis was, by all accounts, the most effective single factor in the actualization of the program. Working with such diverse figures as William Gropper, Niles Spencer, and Peter Blume among many others, Davis managed to pull together an organization with members from all over the

United States. When the congress took place, it was attended by three hundred and sixty artists from the United States, a delegation of twelve from Mexico including Orozco and Siqueiros, and many guests from schools, colleges, and other artists' groups. At the meeting they voted to form a permanent organization 'to achieve unity of action among artists of recognized standing in their profession on all issues which concern their economic and social security and freedom, and to fight War, Fascism and Reaction, destroyers of art and culture.' The troubled history of that organization in the next few years indicates the accuracy of Schapiro's insistence that the arts cannot be detached from history; the Moscow trials and the Nazi–Soviet pact subsequently demolished the artists' solidarity.

But, in 1936, spirits were still high, and many politically unaffiliated artists could sympathize with the aims of the organization. Among some 400 signatories of the call for the congress were Ivan Le Lorraine Albright, Milton Avery, Ilya Bolotowsky, Paul Burlin, Adolph Gottlieb, John Graham, Carl Holty, Karl Knaths, Yasuo Kuniyoshi, Theodore Roszak, Lincoln Rothschild, Ben Shahn, James Johnson Sweeney, Max Weber, Isamu Noguchi, and J. B. Neumann—a group that covered the spectrum of many esthetic and political views.

During the congress, a great many significant issues were raised, and, at least in the closed sessions at the New School, were very carefully examined. They were issues that no artist, not even the most dedicated ivory-tower painter, could have failed to take into account at that particular moment. Overshadowing the proceedings was the consciousness of approaching war, and the unanimous desire to salvage culture in an atmosphere of increasing right-wing hostility. As Stuart Davis remarked in his opening speech, the increasing activity of the Hearst press, which didn't flinch at calling artists 'Hobohemian chiselers,' was a direct menace. Lewis Mumford in his address stressed the international character of their problems, flatly stating that they were meeting in the midst of what was plainly a world catastrophe. He prophesied the coming war, and focused on the events in Italy and Germany to underscore his view that depression and repression go hand in hand. The seriousness of the international situation was stressed by nearly all the speakers.

To their credit, the organizers early recognized some of the decisive issues that would continue to wrack American culture. For instance one of the papers delivered at the congress was a scholarly examination by Aaron Douglas of 'The Negro in American Culture,'

in which he raised all the issues that are today exhaustively discussed. Douglas indicted racism, and pointed out that anyone who wanted to know more about the nature of fascism had only to ask the Negro to whom the 'lash and iron hoof of Fascism has been a constant menace' ever since Emancipation.

Another paper, on 'Race, Nationality and Art' delivered by the wood engraver Lynd Ward, took on the problem of chauvinism in historical and scientific terms, implicitly attacking both spiritual and political isolationism. 'In Germany in 1927,' he said, 'six years before Hitler came to power, there was already established a nationalist movement in art whose slogan was "Only German Art". It distributed graphic work in which a blond hero was shown demolishing temples labelled French modernism, American jazz and so on.' This movement, he maintained, was due to the pressure of economic forces and offered a false solution to the problems of the artist. As for the implications for American artists, Ward argued that there was a growing emphasis on race and nationality in art: 'We have many appeals for an "American art" in which the concept of America is very vague, usually defined as "a genuine American expression" or "explicitly native art." ' Indirectly attacking the regionalist view, he concluded that 'just as the nationalist appeal in German art accompanied the rise of fascist reaction, a nationalist appeal in this country will inevitably contribute to a corresponding political movement.'

Although there was a decidedly political cast to most of the discussion, the rhetoric of the Artists' Congress was fairly free of Marxist clichés, unlike the Writers' Congress, which critic Kenneth Burke admonished in his paper on revolutionary symbolism. The nature of the artists' and writers' dilemma was stated all too clearly in Burke's speech, which was met with considerable hostility in the hall. Speaking cautiously and with unaccustomed diffidence, Burke felt compelled to remind his listeners that

in the last analysis, art strains towards *universalization*. It tends to overleap imaginatively the class divisions of the moment and to go after modes of thought that would apply to a society freed of class divisions. It seeks to consider the problems of *man*, not *classes of men*.

At the same time, Burke acknowledged that some kind of social commitment was required of the artist. He made an embarrassing gesture toward his listeners by saying that he recognized that his statement bore the tell-tale stamp of his class, the petty bourgeoisie, but added that he only dared to make it because it was important to

65

12. During the exciting months in 1936 when Siqueiros had his open atelier on Union Square, he was photographed with two young artists, George Cox (left) and Jackson Pollock.

enlist the allegiance of this class. He proposed, as some sort of compromise, that the imaginative writer seek to propagandize his cause 'by surrounding it with as full a cultural texture as he can manage.'

The lameness of Burke's speech—Burke was customarily a keen critical thinker, eminently capable of bringing a full cultural texture into play—indicates the difficulty with which serious American artists were faced. The painters had identical problems, as even the revolutionary Siqueiros pointed out in his speech at the congress. In a curiously moderate statement, Siqueiros mentioned that the newest generation of Mexican painters had abandoned their recent tradition in mural art and had occupied themselves with 'formal problems independent of social content.' He seemed to accept their move, recognizing that they were nevertheless sympathizers with the revolution and suggesting that they had broken away in order to create works revolutionary in content as well as form. Finally, he pointed out that 'differences of esthetic opinion do not prevent us from uniting solidly on the all-important question of the defense of culture against the menaces, Fascism and War.'

It may well be that Siqueiros' moderation was inspired by political considerations, since at that particular moment in the hectic history

13. Milton Avery, whose quiet lyricism affected many of his friends among the painters. Photo (dated 1950) by Lee Sievan, courtesy Mrs Milton Avery

of the nineteen-thirties there was considerable agitation for a Popular Front attitude which would permit intellectuals of all shades on the left to collaborate. But it might also have been Siqueiros' contact with his young admirers in New York that softened his attitude toward formal experiment. One of those admirers was Jackson Pollock who had worked in Siqueiros' experimental workshop at 5 West 14th Street. In an article by Siqueiros' wife, which Rodriguez says was obviously written in collaboration with her husband,[6] the goals of the workshop were described: it was designed to carry out the most exhaustive experiments with modern materials and tools and to examine artistic development of subjective elements intervening in creative artistic work. Apparently, the investigation of the 'subjective elements' was liberally undertaken, and would certainly have carried participants beyond mere propagandist exercise (although many May-Day floats were executed in the workshops). Francis V. O'Connor stresses the experimental experience in his description of Pollock's sojourn: 'Among the many experiments was the use of spray guns and air-brushes along with the latest synthetic paints and lacquers, including Duco. The spontaneous application of paint and the problems of "controlled accidents" occupied the members of the workshop.'[7]

The experience of Pollock and that of many of the others who were to make history as the New York School, was manifold, and the

intersecting interests must be understood. Those who flocked to the congress to listen and dispute very often kept up a constant dialogue among themselves concerning the seemingly antithetic social and esthetic commitments. Pollock had already taken a sharp look at the modern artists who interested him, and very shortly after he was to look even more closely at Picasso. The same Milton Avery who had signed the call for the congress, and who undoubtedly was present when it occurred, quietly pursued his romantic course of simplification, always with the deepest respect for Matisse, a thoroughly non-revolutionary painter if viewed in the context of 1936. His visitors, among them Rothko, Gottlieb, and Newman, would certainly have discussed the issues raised at the congress, but they would just as readily discuss the specific leaders of the School of Paris in which they were deeply interested. Similarly, de Kooning and Gorky were seeing John Graham constantly, and Graham's conversation went far beyond the local preoccupations. De Kooning, in fact, remembers Graham with great affection for donning his chamois gloves and, in his straightest cavalry officer's guise, marching on May Day shouting 'We want bread!'

Something of Graham's eccentric approach to the crisis can be gleaned from just such reminiscences; it can be even more accurately deduced from his numerous writings during the period, which reflect the full range of his inquisitiveness and his volatile intellectual temper. Whatever Graham said or wrote usually made its way outside of his inner circle of acquaintances, but was most valued by the artists he had befriended, among them Smith, de Kooning, Noguchi, and Pollock. (De Kooning remembers that Pollock, who probably met Graham in 1937, once lent him an article by Graham and un-characteristically insisted on getting it back. O'Connor suggests that Pollock had read Graham's article on primitive art and Picasso which created a stir when it was published in the *Magazine of Art*.) Like Davis, Graham in 1935 insisted that abstract art by its very nature is revolutionary. With a few twists of verbal logic he was able to convince his friends that it was all right to be a modern abstract artist and not a provincial realist. An example of his agility occurs in *Art Front* of January 1935, in which he is reviewing a surrealist exhibition:

It is, as all abstract art, truly revolutionary since it teaches the unconscious mind—by means of transposition—revolutionary methods thus providing the conscious mind itself with material and necessity for arriving at revolutionary conclusions.

His own historical determinism shows in his conclusion that those who think abstract art is just a passing phase are mistaken. Rivers do not flow backwards.

Graham's greatest admiration at this time was reserved for Picasso, as the article Pollock was said to have admired indicated. For the sake of a clear exposition of Picasso's position in history, Graham invents a strange historical background. The article begins: 'Plastically and esthetically, there are only two basic traditions operating in our day: the Greco-African and the Perso-Indo-Chinese.' The Perso-Indo-Chinese provides a family tree for Van Gogh, Renoir, Kandinsky, Soutine, and Chagall while the Greco-African includes Ingres, Picasso, and Mondrian. In the article Graham puts forward his particular interests which included at that moment Tlingit, Kwakiutl, and Haida carvings from the Pacific Northwest, as examples of the powers of the unconscious. Children and other primitives qualify also. Picasso, Graham stated, carries these values into modern art. More important, 'he delved into the deepest recesses of the unconscious, where lies a full record of all past racial wisdom.' Several years before Barnett Newman was to forge a philosophy of art drawing on those same Pacific Northwest traditions, Graham was busily introducing his young colleagues to the values inherent in primitive art. And, as his reference to 'racial wisdom' would seem to indicate, to a Jungian vision of creativity.

The mélange of eccentric, and often original, thoughts which Graham delivered so impressively to his friends, was brought together in a strange book published in 1937, *System and Dialectics of Art*.[8] Although there are ample dialectics of a rather loose construction, it shows relatively little system. The liveliness of the book reflects above all Graham's propensity for rich studio talk and his inspired idiosyncrasies. It is a fine compendium of the preoccupying problems shared by Graham and his modernist friends, and a close reading supplies a catalogue of many of the assumptions that were the basis of later developments.

In the very beginning Graham announces one of the prime tenets of abstract expressionism. Art, he says, is essentially a process. He then makes a number of statements concerning the nature of abstract art, many of which were at the time they were written considered incontrovertible truths. He regarded painting as a purely two-dimensional proposition. He stated repeatedly that 'a *painting* is a *self-sufficient* phenomenon and does not have to rely upon nature.' 'Abstraction,' he maintained, 'is the evaluation of form perfectly

understood.' And, in direct contrast to a critic such as Schapiro, he insists on the hegemony of pure form:

Form (both in nature and art) has a definite language of great eloquence. . . . In regard to the plastic arts, there are men endowed with *absolute* eyes who can evaluate every form seen in nature, understand its language, meaning, reproduce it, transpose it, revaluate it, abstract it.

These pronouncements were literally articles of faith for the small band of painters looking with Graham toward Paris.

His Jungian concept of culture emerges frequently in such statements as '*In general* races and nations develop culture in proportion as they have a free access to the racial past afforded by folklore.' To fortify his views, he included a chapter on Negro art. Marxist statements, somehow tacked on to the organic flow of his thought, often seem out of context and less thoroughly digested than his more cogent views on the interior history of painting. He blames the capitalist system for a variety of woes borne by the artist, such as the difficulty human beings have in understanding 'pure art.' He says the capitalistic system of education has pulverized the mental capacities of children into an analytical compound instead of building them into synthetic, constructive units. And like Nietzsche, Graham seems wary of science, asserting that it is a literary concept of life while art is a formal concept. The artist, especially a great artist, is the enemy of bourgeois society and a hero to posterity, he claims, citing Socrates, Galileo, Rembrandt, and Poe. Here, the romantic myth of the nineteenth-century artist is revived and made viable for the burgeoning New York School; added to it for good measure is the assertion that the history of art is 'the successive confession of personalities in regard to their epoch.'

This was a very different approach from Schapiro's, and as Schapiro had pointed out, an approach congenial to many artists at that time. The artist, as a witness to his time through the response of his deepest feelings, was to become the ideal of the artists' community within a few years.

Graham also took up the most troublesome problem of all—that of the identity of American art. He relieved his listeners by stating simply that American art is the art produced by American artists in America: 'The subject matter has nothing to do with the nationality of art, it rather obscures it.' All art produced in America, he stated, bears the strong, unmistakable stamp of precision or speed, and he names a number of young outstanding painters, among them Matulka, Avery, Davis, de Kooning, and David Smith.

70

Among the ideas Graham was building upon in 1937 was his theory of 'minimalism'—an idea picked up some thirty years later and promptly credited to him. Minimalism, he explained, is the reducing of painting to the minimum ingredients for the sake of discovering its ultimate, logical destination in the process of abstracting. Painting begins with a virgin, uniform canvas, and if one works ad infinitum it reverts again to a plain uniform surface (dark in color), but one enriched by process and experiences. When minimalism reappeared in the American lexicon, it had radically different premises. Graham's notion of minimalism was more nearly the traditional modern idea of reduction. His emphasis on the process and 'experience' that feeds the final painting was precisely the concept picked up by Rosenberg and fashioned into 'action painting.' Graham's one prophetic statement was perhaps his concluding thought that 'future art does not have to be painting or sculpture, it may be an art unthinkable to us now, perhaps a collective art, perhaps a highly individual art.'

Even in *System and Dialectics of Art*, in which Graham so emphatically posited his faith in the meaning of pure form, there are contradictions, which lay the ground for his subsequent volte-face and the denunciation of his idol Picasso. His very emphasis on meaning and his straining to discern it in the pure forms of primitive art is a weakness in the fabric of his faith. Artists sharing his concerns were equally perturbed by the difficulties in bringing form and meaning together without compromising with topicalism, regionalism, American scene-ism. Even those intellectuals writing analyses of art in society demonstrated considerable confusion on these grounds. It was widely sensed that myths, so important according to the psychoanalysts, were essential to culture, but the scientific materialism they professed to be the only approach to the ills in society seemed to present insuperable difficulties. The confusion is glaringly evident, for instance, in the October 1937 issue of *Art Front* where A. L. Lloyd wrote on 'Modern Art and Modern Society':

The bourgeois artist can find no theme he can acknowledge as valid. . . . This curious circumstance is largely due to the historic decay of myth, and it is the decay which has so materially contributed towards widening the gap between economic and spiritual production. . . . As Marx pointed out, the role of myth is to express the forces of nature in the imagination. . . . Only an autochthonous mythology, a mythology coming from the same soil, the same people, the same cultural superstructure of the same economic order can be an effective intermediary between art and material production, despite the bourgeois superstition that any mythology,

even one personally transformed into a kind of private religion, can form such a link . . .

What Lloyd referred to as a bourgeois superstition was undoubtedly gaining ground with many artists. Within the subsequent five years, one artist after another declared himself liberated from the toils of dialectical materialism and linear history via personally transformed myths. Among the artists who got out from under Marxist rhetoric as a result of the resurrection of hemispheric myths were Rothko, Gottlieb, Still, and Newman. In the days when artist's unions and left-wing talk filled lower New York, Newman was busily engaged in extracting himself by means of the profession of anarchism. Although many painters seemed to solace themselves in the studio with home-brewed philosophies of personal freedom, Newman's doctrine was apparently formed early through his structured reading in philo-sophical anarchism and his exposure to the remnants of the American anarchist tradition. As Thomas Hess has pointed out,[9] Newman was a product of New York, unlike many of his confreres, and had been educated in the highest tradition of C.C.N.Y. (City College of New York), a college widely known for its large numbers of brilliant students. His intellectual curiosity was enormous, and probably far more stimulated through reading than is usual for a painter. Since Newman was clearly a classical gadfly, enjoying discussion and hungry for intellectual exchange, his views were known to a good many of his artist friends during the thirties. Undoubtedly his natural predisposi-tion to a doctrine of personal freedom went down well with those painters who were finding the dogmatic rhetoric of the United Front very uncomfortable.

Since Newman was a real New Yorker (not the child of the wilder-ness, as Still, or of the depressed coal mines, like Kline, or victim of the Cossack's whip, like Rothko, or son of prairie farmers, like Pol-lock, or bona fide European, like de Kooning), he partook of the submerged American tradition of anarchism which was further nourished by his readings of the Europeans. That tradition began early, with certain of the utopian communes expressing the critical bases of all anarchist thought. Josiah Warren, for instance, flatly demanded nothing less than absolute personal liberty. What, he asks, is liberty, and who will allow me to define it for him? No one can define liberty for another: 'Each individual being thus at liberty at all times, would be *sovereign of himself*. NO GREATER AMOUNT OF LIBERTY CAN BE CONCEIVED. ANY LESS WOULD NOT BE LIBERTY!' He considered the only grounds for true liberty 'disconnection, disunion,

individuality.' The mutual aid practiced in Warren's utopian settlement, New Harmony, Pennsylvania, was intellectually defended by some of America's most important thinkers, among them Henry David Thoreau.

Absolute anarchism was the most attractive doctrine for Newman. Hess quotes him on the nineteen-thirties:

> My politics went toward open forms and free situations; I was a very vocal anarchist . . . even learned to read Yiddish so I could follow the anarchist newspaper.

His almost dadaist approach to free situations was demonstrated by his running for mayor of New York City on a platform demanding, among other things, playgrounds for adults. The implications of his effusive individualism were to be helpful not on the political or civil plane but, rather, on the esthetic level when at last the upheaval of the thirties subsided. Shortly before his death he reasserted his romantic anarchism in a foreword written for Kropotkin's *Memoirs of a Revolutionist*.[10] From this essay it is apparent that Newman was a dilettante anarchist; an anarchist by nature rather than by profound political formation (although he had read the books), and that the single most powerful appeal anarchism held for him was in its rejection of organized, theoretical doctrine. It was this obsessive need to have done with all rules and institutions that was to make him a valuable resource for his fellow artists.

Probably Newman's distaste for the numerous political doctrines being explored during the thirties was shared by more artists than wished to admit it. 'In the twenties and thirties,' he writes in the foreword to Kropotkin, 'the din against libertarian ideas that came from shouting dogmatists, Marxist, Leninist, Stalinist, and Trotskyite alike, was so shrill it built an intellectual prison that locked one in tight. The only free voice one heard was one's own.' For Newman—vital, obstreperous, combative talker that he was—the only free voice continued to hear till the very last was his own. His foreword renewed his assault on dogma, which throughout his life he saw wherever he looked. Anarchism was good because it offered a creative way of life, as he says, which makes all programmatic doctrine impossible. He admired Kropotkin because he was intoxicated with the love of personal freedom. This love Newman turns to artistic account, claiming that the artist alone can break out of the prisons of dogma. Moreover, he enters his plea against historicism, the great enemy of the creative imagination, via anarchism:

What gives the artist hope is that, although he is surrounded by the art critic-theoreticians and the art historians—the *Kunstwissenschaftler*—the artist can create if he has it in him to do so because the dogmatists among art critics and art historians do not know that they are operating in a mirage and that there is no such thing as 'art history.'

All the same, there were some serious artists, among them acquaintances of Newman, who were attempting to sort out the history of modern art and to understand the rather doctrinaire attitudes that had originated the various forms of abstract art. These artists, although unwilling to accept absolute laws for modern painting, nonetheless probed its history for basic principles. To the general din of discussion in the nineteen-thirties they added heroic, night-long sessions in debating the issues implicit in the works of the cubists, the constructivists, and what were sometimes called at that time the 'non-objectivists.'

ℰStudio Talk

Around the time of the Artists' Congress, some of the artists who
had come to know each other on the W.P.A. began meeting inform-
ally in the studio of the sculptor Ibram Lassaw. They included Ilya
Bolotowsky, one of the Russian contingent in New York, Byron
Browne, de Kooning, Gorky, Carl Holty, and George McNeil. They
were irritated with the Museum of Modern Art for having omitted
Americans from the 'Cubism and Abstract Art' exhibition, and they
felt that the Whitney show the year before had not properly represen-
ted local abstraction; eventually they began to discuss the possibility
of presenting their own exhibition. By all accounts their organiza-
tional meetings were stormy and difficult; during one of them,
according to George L. K. Morris, Gorky stormed out slamming the
door behind him and de Kooning soon followed. But others who
were later to be identified with abstract expressionism remained to
help found the American Abstract Artists. As had happened with the
Artists' Union, the factional fights within the organization ranged
over all the political and esthetic problems imaginable. According to
Lee Krasner, the members fought all the time. Carl Holty, one of the
staunch founders, remembers most of all the long nights when they
sat around on banquet chairs talking endlessly, flaring up and calming
down, trying to contain the inevitable personality clashes and the
bitter exchanges between Trotskyites and Stalinists. Holty himself
became angry when John Graham who, he said, 'had more culture
than the whole crowd'[1], was rejected for membership.

Despite the endless contention, members enthusiastically planned
for the first exhibition. The minutes for a meeting in 1936, for in-
stance, mention the idea of creating a gigantic street construction for
promoting their work, and the artists discussed having a 'portable

abstraction' for street advertising. They also felt that prices on the works that were to be exhibited in the Squibb Building in April 1937 should be kept 'reasonable'—between $100 and $200.

A general prospectus issued by A.A.A. in 1937 stated the purpose of the organization: To unite American abstract artists; to bring before the public their individual works; and to foster public appreciation of this trend in painting and sculpture. To keep as broad a base as possible for the many artists, the members stressed in their statement that a 'liberal interpretation' would have to be placed upon the word 'abstract.' In addition, the founding members were, for the most part, fervent internationalists, detesting the expressions of Americanism, whether from right or left, and looking to Europe for a model of their own organization. Holty emphatically states that the French *Abstraction-Création* movement and the British *Circle* were the prototypes for the American Abstract Artists. Their internationalism would be further expressed as membership grew. Within less than five years the organization could boast the presences of many distinguished Europeans in their shows, including Léger, Mondrian, Albers, Glarner, Moholy-Nagy, and Richter.

It was a measure of the general sophistication of left-wing journalism that the critic and painter Charmion von Wiegand, then associated with both *Art Front* and *The New Masses*, commented favorably on the first exhibition. Although closely identified with political activism (her husband was Joseph Freeman, one of the most important writers in the proletarian movement), von Wiegand wrote on April 20, 1937, in *The New Masses* that the exhibition was not only significant, but also that it reflected the important tradition stemming from Mondrian, Hélion, Kandinsky, and later Picasso.

Respect for this tradition was reiterated when the group published its first yearbook in 1938. The editors, feeling the pressures of political history, stressed their belief that they could do nothing better than 'emphasize that the contemporary must respect the interpenetration and concatenation of all culture.' Throughout the book one finds allusions to history and pleas that art of the past be seen as the source of the ultimate reduction in modern art. George L. K. Morris, one of the most eloquent members, referred to a continuous opposition to Renaissance, fauve, and impressionist principles: 'For fifty years, through both single and concerted efforts, the basic problems of art have been attacked from the inside.' He went on to speak of Cézanne, Seurat, and their cubist heirs, whose 'vital steps have proved a direction, and not as we were once informed the end of a road and

an era.' Morris, like most of his friends in the organization, wished to believe that 'the path has been cleared for later artists who are finding for themselves that they must strip art inward to those very bones from which all cultures take their life.' Even Ibram Lassaw, whose voice heralds the change in attitudes that were to distinguish the abstract expressionists, and who opened his statement in the year-book by insisting that the present-day artist must work as though the art of the past had never existed, found historical reasons for his beliefs. He regarded the invention of printing on a mass scale and the development of photography as historical developments that stripped painting and sculpture of superimposed tasks: 'In view of these developments, artists are beginning to realize the limitations of time-honored laws of art, so-called, and even the various media.'

Another writer, Frederick Kahn, pointed out that since 1910 'the liberating movement seems to accelerate, when with cubism in France the new era began to dawn and dadaism threw a monkey wrench in the old machinery.' All the essays show a strong awareness of the forward flow of modern art, of its interior formal history, and of the inevitable historicism attaching the linear sequences of movements. A number of artists attempt to make a case for the social value of abstract art, reflecting a mounting pressure in the thirties for a rapprochement of artist and society. Most of these half-hearted attempts to reconcile the two viewpoints fall short of the clarity achieved when formal problems alone are approached. The individualism they assume to be inherent in the abstract artist is put forward as a revolutionary value, but without much conviction. These artists in a group, and many outside the group, could not then, still less later, convince themselves that the autonomy of art was the supreme value; as Americans, they craved rationales and meanings. They could not, like Matisse, accept the simple meaning of sensuous satisfaction.

Even less susceptible to an Apollonian view of painting were the numerous artists who were developing figurative or semi-figurative paintings in the expressionist tradition. Both Gottlieb and Rothko, for instance, were deeply moved by the work of Milton Avery, but nevertheless could not themselves reach the simplicity and joyous clarity he had already achieved before 1940. Many years later Rothko wrote of the 'instruction, the example, the nearness in the flesh of this marvelous man,' saying of his memorable studios that the walls were always covered with an endless and changing array of poetry and light:

Avery is first a great poet. His is the poetry of sheer loveliness, of sheer beauty. Thanks to him this kind of poetry has been able to survive in our time. This—alone—took great courage in a generation which felt that it could be heard only through clamor, force and a show of power.[2]

At the time, he was painting somber underground visions of the city, especially the subways, while his friend Gottlieb tended to paint close-valued, faintly distorted visions of interiors, such as 'The Family,' reproduced in *Art News* of December 19, 1936. These two resisted the pull to American-scene illustration but nonetheless sought in their works some tragic communication. Around 1935 they frequented the studios of some dozen others and finally formed a loose group called 'The Ten' which, as one member (Joseph Solman) repeated, 'challenged the supremacy of the silo.' They had their first show in 1936 at the Montrose Gallery. Listings in the catalogue were Ben-Zion, Ilya Bolotowsky, A. Gottlieb, Louis Harris, Jack Krefeld, Marcus Rothkowitz (Rothko), Lou Schanker, Solman, and Nahum Tschacbasov. In other shows in the subsequent four years the group varied, including at times John Graham, Ralph Rosenborg, and Lee Gatch. Their objectives were more or less announced in 1938 when, as 'The Whitney Dissenters,' they refused to show in the Annual, and wrote a broadside in which they spoke of The Ten as 'homogeneous in their consistent opposition to conservatism, in their capacity to see objects as though for the first time. . . . It is a protest against the reputed equivalence of American painting and literal painting.'

The increasing interest in expressionist variants was remarked by Jacob Kainen in the February 1937 issue of *Art Front*. He noted a 'stirring,' a reappearance of expressionists who: 1, attempt to reduce the interpretation of nature or life in general to the rawest emotional elements; 2, have a complete and utter dependence on pigment; 3, show an intensity of vision. The best organized group of young expressionists, functioning in New York was The Ten, he reported, praising Gottlieb and Rothko (Rothkowitz) for their 'usual sober plasticity, keeping everything simply emotional,' and also mentioning Louis Harris, Lee Gatch, Ben-Zion, and Joseph Solman. Significantly, he linked expressionism with the mounting fear of war, warning that 'we are closer to chaos than we think.' It is probably safe to speculate that the artists he writes about were keenly aware of the political dangers in the late thirties, and that their expressionism was a response to the rising hysteria as the war drew close.

Outside of the groups such as The Ten or American Abstract Artists or the Artists' Union, there was another very important source

of discussion, and that was the studio school of Hans Hofmann. Hofmann's role in the formation of American vanguard painting and sculpture has been variously assessed. It has been pointed out, for instance, that the dozen or so major figures of the New York School never studied with Hofmann. (But how could they have? They were nearly all in their middle twenties or early thirties, beyond the age of apprenticeship.) It has also been said that since he himself emerged as a painter in the United States only after 1940, his influence was relatively minor. On the other hand, his school at 52 West Ninth Street in 1936, and at 52 West Eighth Street from 1938 until 1958, was by all accounts a magnet that drew visitors constantly. Many of the evening sessions during which Hofmann offered impromptu lectures, were attended by the artists in the neighborhood who would then move on to the local cafeteria to continue the discussion of painting as painting. For Hofmann's approach was consistently esthetic—he maintained the professional European's confidence in the autonomous character of his art. The existence of his studio school on 8th Street helped to sustain the spirits of many young artists bewildered by the excessive rhetoric of the various politically oriented groups. It brought to America, for the first time, the highly professional, imperturbably art-for-art's-sake urbanity so keenly missed. Hofmann, the very model of a maestro, never for a moment doubted the power of art to survive all temporary digressions, and it was this conviction that buoyed up so many serious young artists. In addition, Hofmann ran a real atelier which looked and smelled like one, an atelier in which the student found the wide painting culture rarely available elsewhere. At that time in fact, the only freely run school was the Art Students' League, where Hofmann himself had once taught. But even at the League during the late thirties, when such figures as Yasuo Kuniyoshi and George Grosz were the stars, there was rarely the broad general discussion that went on constantly at Hofmann's. Each teacher at the League had his *aficionados*, and each studio reflected his views, but the broadest implications of modern art history were rarely probed in the consistent, effervescent way they kept emerging at Hofmann's.

Hofmann's professionalism (as he once said, 'abstract art, in my opinion, is the return to a professional consciousness'[3]) was not lost on a number of influential figures in the New York art world; the most important of these was probably Clement Greenberg. It was in Hofmann's studio that Greenberg heard the first authoritative discussions of the strictly interior problems of painting. It was there,

where he had first come as a friend of Lee Krasner, that he learned how to formulate his image of cubism, which was to be so important in his development as a critic. While critics do not create the idiom of painting, they do translate it. In Greenberg's case, these intense studio talk sessions were to make a profound impression when it came time for him to assume his role as one of the first spokesmen for the new painting. The lessons of picture analysis Greenberg learned in Hofmann's studio school are really the fundamental tools of his trade. They can be overheard in much of his subsequent criticism.

Those lessons were always delivered in the quaint, utterly idiosyncratic language Hofmann developed to overcome his poor ear for English. Sometimes students memorized his phrases without ever knowing exactly what he meant (years later certain of his favorite axioms were decoded by means of teamwork on the part of his former pupils). Nonetheless, with exuberant gesture, consistent enthusiasm, practical demonstration, and unceasing verbalization, Hofmann did manage to purvey the principles of modern European art, and he was probably the only teacher in America who could have done so. His popularity with his students was unparalleled. As Harold Rosenberg has recalled, they spoke of him as a 'Cause'; their devotion was not only to the man, who was a large, genial, fatherly figure but also to the grand culture which he made accessible to them. As Larry Rivers, one of his later pupils, put it:

Aside from his theories of art like 'push and pull' he made art glamorous. . . . He had his finger on the most important thing in an artist's life, which is the conviction that art has an existence and a glamorous one at that.[4]

Ironically, the modern doctrines that Hofmann made available to his listeners were usually milled in his own queer imagination, and they emerged as a rather patchwork mélange of theory culled from many divergent European studios. What the Americans didn't know was that the principles Hofmann expounded were barely considered by their counterparts in Europe, who had long ago assimilated them and took them for granted; the kind of talk Hofmann gave his students, which they in turn developed, was the conversation they might have encountered in hundreds of studios in Paris many years before. By the time they were exposed to it, through Hofmann's eclectic and rambling personality, such talk was considered elementary elsewhere. But for the Americans it came fresh, and was, to say the least, inspirational. At last they could enter the mainstream. Perhaps Hofmann's curious way of bringing together diverse tenets of modern painting and his sometimes simplistic attitude were all for the best. He

opened many avenues of inquiry, and left the Americans free to develop their own variants of modern art culture. American innocence has its value, and many imperfectly understood principles were to be fashioned into viable painting modes in the years to come. In the late nineteen-thirties it would have seemed to a young European a curious phenomenon for his counterpart in America to be exhilarated at the discovery that a painting can—indeed must—be a two-dimensional illusion, a principle already enunciated in France in the late nineteenth century; and he would have been amused to watch the excitement generated by such simple analyses of abstract pictorial dynamics as Hofmann's famous 'push-and-pull' theory or his admonition to respect the picture plane. The grammar of painting —a subject almost unknown in the United States—was Hofmann's major gift to his students.

The salient features of Hofmann's teaching derived from his own rich background. It must be remembered that by the time he settled permanently in the United States he was already in his fifties and had had wide experience of the various movements affecting the artistic life of Europe. His early exposure to impressionism came in Munich in 1898 when he saw exhibitions at the *Sezession* gallery. In 1903 he made his way to Paris, where he sketched in the same class at the Grand Chaumière as Matisse, where he met Delaunay, Braque, and Picasso and became friendly with several fauve painters.

He watched the emergence of cubism in Paris, and later, returning to Munich, acquainted himself with the lyrical abstraction of Kandinsky and Klee. His early encounters with burgeoning movements were extremely important to him. Out of his three youthful enthusiasms—fauvism and Matisse, cubism, and German and Russian expressionism—Hofmann was to build his catholic philosophy. Having begun life as a scientist, as he often reminded his students, he had a natural tendency to Aristotelian order and was far more prone to systematizing than most of the artists he studied. His isolation of the principles of these three modern tendencies was to prove his salvation since it made of him a teacher and helped him to survive the various dislocations imposed on so many Europeans in the twentieth century.

When Hofmann expounded theory to his students, he would often make aphorisms. 'You must give the most with the least,' he would say; or 'the object should not be of prime importance, there are things bigger to be seen in nature than objects.' Those 'things' were natural forces, invisible tensions which lent Hofmann's pedagogy something

of the cosmic preoccupation that informed Kandinsky and Klee. In his lexicon, 'tensions' were translated into the 'push-and-pull' formula with which he urged his students to synchronize their development of form and color. Undoubtedly the principles he discerned in cubism were the cornerstone of his theory. And certain of the 'laws' that he believed existed in pictorial structuring were clearly derived from the rhetoric that grew up around the cubist movement (although its originators would vehemently deny that there were any 'laws' possible in art). To understand some of the judgments later made by such a critic as Greenberg, it is worth examining some of Hofmann's pronouncements (his views on pictorial space, for example, are echoed in Greenberg's earliest criticism). In an essay titled 'The Search for the Real in the Visual Arts' Hofmann wrote:

Pictorial space exists two dimensionally. When the two-dimensionality of a picture is destroyed it falls into parts—it creates the effect of naturalistic space. . . . The layman has extreme difficulty in understanding that plastic creation on a flat surface is possible without destroying this flat surface. . . . Depth, in a pictorial, plastic sense, is not created by the arrangement of objects, one after another toward a vanishing point, in the sense of the Renaissance perspective, but on the contrary (and in absolute denial of this doctrine) by the creation of forces in the sense of *push and pull*. . . . Since one cannot create 'real depth' by carving a hole in the picture, and since one should not attempt to create the illusion of depth by tonal gradation, depth as a plastic reality must be two dimensional in a formal sense as well as in the sense of color.[5]

His emphasis on the plane decidedly derives from cubist doctrine: 'A plane is a fragment in the architecture of space. When a number of planes are opposed to one another, a spatial effect results. . . . Planes organized within a picture create the pictorial space of its composition.'

When it came to color, however, Hofmann's theory leaned toward fauvism (he condemned tonal gradation for example) and to Klee and Kandinsky. For instance, he uses Kandinsky's musical diction:

Color is a plastic means of creating intervals. Intervals are color harmonies produced by special relationships, or tensions . . . Just as counterpoint and harmony follow their own laws, and differ in rhythm and movement, both the formal tensions and the color tensions have a development of their own in accordance with the inherent laws from which they are separately derived.

Further extensions of German theory occur in Hofmann's insistence on empathy. He used it in a special way, not wholly compatible with Worringer's original definitions, but carrying the subjective German

expressionist attitudes into his rubric. 'By using the faculty of empathy,' he wrote,

> our emotional experiences can be gathered together as an inner perception by which we can comprehend the essence of things beyond mere, bare sensory experience. The physical eye sees only the shell and the semblance; the inner eye, however, sees to the core and grasps the opposing forces and the coherence of things.

Between the objective pictorial grammar derived from cubist sources and the subjective metaphysics derived from Kandinsky and Klee (and from other artists Hofmann admired, such as Mondrian and Miró) lay enough territory for Americans to explore, and curious possibilities for combination. The terms which Hofmann established in his studio talks were soon to be the common language of art students —and critics. Such convenient ideas as 'positive space' and 'negative space' ('the configuration or "constellation" of the voids between and around portions of visible matter') were easily adaptable in criticism. The idea of the picture plane as inviolable was especially appealing to critics wishing to defend abstract painting: 'The essence of the picture plane is flatness. Flatness is synonymous with two-dimensionality.' There would be many references thereafter to 'poking a hole in the canvas,' which, of course, was tantamount to failure as a modern artist, and to Hofmann's prevailing idea of plasticity, translated in the list of terms as 'the transference of three-dimensional experience to two dimensions. A work of art is plastic when its pictorial message is integrated with the picture plane and when nature is embodied in terms of the qualities of the *expression medium.*'

Hofmann's volubility was an asset to the community. To the end of his long life, he continued to try to express in words what he knew about the language of painting. His most potent message was his faith in the act of painting—something that came with difficulty to most American painters. And it was a faith which endured. Only four years before his death I had the occasion to ask him on the telephone about a particular painting. With his habitual cordiality and his love of exchange, he said we should meet to discuss it. When he arrived, he handed me a piece of paper saying he had scribbled those thoughts the night before. This is what I read:

> A work of *art* can never be the *imitation of life* but only, and on the contrary, the *generation* of life.
> A dancer must not only master his body but he must be a *generation of life* in bringing the space to life wherein he dances, and this as the answer to his entire personality.

A painter who attempts to imitate physical life (a naturalist) can never be a creator of pictorial life, because only the inherent qualities of the means can create pictorial life. That makes the esthetic difference between *creation* and imitation.

Creation asks for the capacity of empathy.

I do not study nature but I'm completely taken in by its secrets and mysteries, and this includes the secrets and mysteries of the creative means through which I attempt to realize one through the other.

Picasso makes this quite clear when he says: 'First I eat the fish, then I paint him.' This is the transformation from culinary empathy into pictorial empathy.

These thoughts, completely characteristic of Hofmann, were the kind of nourishing statements that added to the gathering force of American vanguard ideas. One ingredient only was missing from Hofmann's synopticon of modernism, and that was the one movement that occurred after his removal from Europe, surrealism. When the doctrines of the surrealists were addded to the farrago of theories I have discussed so far, the range of thoughts that activated the proponents of what Barr was to call the 'New American Painting' is more or less complete.

The advent of Surrealism

André Breton had demanded nothing less than a total crisis of consciousness in his original surrealist manifesto in 1923. Eventually a large number of individuals in the artistic milieux appeared to have realized his imperatives. It was a long, slow coming, even in Europe which was amply prepared for his salvos against rationalism and materialism and which had long been nurturing well-developed sentiments against the bourgeoisie. In the United States the ground was not well fertilized for the elegant and highly literary formulations of the surrealist twenties in Paris. The crisis in consciousness came stealthily in small forays that enlisted just a very few of America's artists over the seventeen years between Breton's first manifesto and the outbreak of World War II. But those very few were to impress their attitudes upon a whole generation of artists beginning in the mid-nineteen-forties.

Many factors delayed the news of the great European adventure in reaching the consciousness of artists in America. For one thing, there were very few Americans who could read other languages, and there was paucity of translation into English. Except for the scarcely read little magazines such as *transition*, the antics of surrealism were not broadcast to most Americans. Many artists, it is true, would see copies of French journals with reproductions of the work of de Chirico, Magritte, and Dali, but they would miss the fiery rhetoric that constituted a point of view which could have impressed itself indelibly on their consciousness. Until the important 'Fantastic Art, Dada and Surrealism' exhibition in 1936 at the Museum of Modern Art, when Barr made of the catalogue a small anthology of surrealist theory, there were only two texts available in English, and those were very obscure: David Gascoyne's *A Short Survey of Surrealism*

published in London in 1935 and James Johnson Sweeney's *Plastic Redirections in 20th-Century Painting*, published in 1934 and touching very lightly on the surrealist movement.

If one considers the immense amount of lore accumulated by surrealism in Europe from its first eruption in 1923, it is all the more striking that the United States, so remote from any other continent, would have picked up the threads at all. But it did so, and with most significant results.

It was, however, a slow business, complicated by several American traditions: the old nationalistic impulse that resented the importation of theory from Europe; the snobbery of the élite, which swallowed all Gallic innovations whole, and fostered bitter resentment among the local artists; the pragmatic bias which found the manic lyricism in surrealist texts excessive, and repulsive; the puritanism that fought off the hedonistic impulses so visible in surrealist poetry and painting. Above all, there was the Anglo-Saxon tradition of rationalism which set Americans against everything that denied the functions of common sense and logic.

Artists had long been exposed to Freudianisms and the existence of the unconscious was accepted early, especially in New York. But they were, in the twenties and early thirties, consistently ambivalent about the uses of the unconscious, which belonged to a romantic tradition they could not wholly accept. The fervor with which Breton and his circle could advocate Freudian principles was partly derived from their experience during World War I, an experience that was very remote to New Yorkers. Even those few who had made the pilgrimage to Paris were rarely able to fathom the sources that fed into surrealist thought, not the least of which was the scandal of the Great War. Nor could they partake of the broad culture that was the glory of surrealist spokesmen. Surrealism may have been a cathartic movement, but it held fast to the great European intellectual traditions even as it condemned them. While the poets around Breton denounced the Cartesian clichés and insular traditions of French culture, they nevertheless construed a pantheon of international intellectuals, past and living, which would have been totally foreign to Americans. Aside from Nietzsche, whom Americans of the small bohemian élite had read assiduously, there were such figures as Nerval, Jean Paul, and Heine, to mention only a few, who would have been strangers in many ways to American culture.

The strangeness of surrealist sources was eventually neutralized by the local circumstances that opened the way to moral and artistic

rebellion. But the tenets established during the nineteen-twenties came through at a staggered pace, conditioned by a number of specific American problems. Until the thirties there was absolutely no fusion of artistic and social theory in the United States. Artists were occasionally political cartoonists, but they were rarely political theorists; in fact, they were not theorists at all, not even artistically. From the early days of the republic, artists had been wary of taking sides politically and had most often sought refuge in high principles resembling the art-for-art's-sake attitude in Europe. The resemblance was superficial, for when the individuals are considered closely, it can be seen that Europeans such as Courbet or Manet had a general cultural and political formation which equipped them to separate out the issues and to formulate a fairly coherent artistic position. Americans had no comparable culture, and were slow to enunciate even a rudimentary esthetic.

In France particularly, the existence of sophisticated theory of all kinds made it possible for each new movement to be assessed from many points of view. The specific issues of art and politics which the surrealists courageously faced, to their great credit, could never have been raised successfully in America before the Depression. The European was adept at reconciling art and politics because of his theoretical training. It was easy enough for him to lift the appropriate quotation from Engels to suit his polemic. The American, on the other hand, might have been able to quote Engels, but would have been incapable of quoting Baudelaire; he might have known his Marx but would have been vastly ignorant of art history. Or conversely, he might have known his Titian and Michelangelo, but would have turned away in despair before the Hegelian dialectic of the Marxist. It was his weakness but also his strength, for innocence was, as I have said, eventually turned to good account by the American artist.

The great outbreak of discussion in the thirties provided the chink through which surrealists' pollen might drift. The actual conditions—government sponsorship of the arts and a different orientation of awareness—did not favor immediate flowering. American artists were freshly exposed to a situation that was more than just a crisis of consciousness. The everyday scramble for survival, and later, the structure of a new social awareness in which they almost all participated, made the fantasies of the surrealists seem bizarre and remote. While in the mid-thirties the European surrealists were confronting the rapid fall of Europe as Fascism spread, they were still struggling

G

as a small band of eccentric individuals *against* society. The Americans, on the other hand, had been assimilated by society to some degree and were fighting *within* it for change. No matter how isolated and depressed a painter might feel as he saw the mediocre American-scene mural produced on the project, he still took a certain comfort in the mere fact of there being a project. Profound social change seemed just around the corner and a certain American optimism survived through those New Deal years.

In the surge of activity the federal art projects sponsored there was not too much moral energy for the questions surrealism posed. One of the insistent themes was directly counter to surrealism, in fact, and that was the necessity of realism and documentarianism. Documentaries in film, literature, and even in poetry (a peculiar American bent) appeared in those years, and deep faith was posited in the virtue of seeing whole and seeing clear. Painters of quality were less inclined to accept the importance of the document, but they found it difficult to marshal arguments when all around them their artistic counterparts were advocating realism. The dilemmas posed for artists and writers alike in that tremendous stock-taking movement grew only later to unbearable dimensions. The important thing is that they disturbed consciousnesses constantly, and helped to bring about impatience with all artistic precedents. Once the impatience was defined, it was not difficult for the character of surrealist thought to infiltrate American artistic consciousness.

The profound dilemmas posed at that time are clearly visible in the careers of many artists, especially the writers. A very good example of a gifted artist who was both shaped and tormented by his time is the poet and critic James Agee, who was born in 1909. A product of the South (Tennessee), educated in genteel Anglo-Saxon traditions that still prevailed at Exeter and Harvard, Agee had the good luck to get on the staff of *Fortune* magazine soon after his graduation in 1932. In 1936, when the appetite for documentaries was at its keenest and when scores of photographers (among them the painter Ben Shahn) were out recording the boundless misery, Agee was assigned, with photographer Walker Evans, to document the life of tenant farmers in Alabama. Both he and Evans had every intention of recording faithfully what they saw in the strictest documentary techniques, but both were artists of high caliber, and the impact of the experience was overwhelming. Their material was rejected by *Fortune*, so Agee resigned in order to complete his work in book form. It was published in 1941 under the title *Let Us Now Praise Famous Men* and sold only

14. Walker Evans, whose Depression photographs were greatly admired by New York School artists, some of whom were personal friends. Photo by James Mathews, courtesy The Museum of Modern Art

some 600 copies in all. Significantly, it was re-issued in 1960, widely praised, and in 1966 went through several paperback editions.

Agee's crisis in consciousness was acute. Walker Evans considered that the 27-year-old poet 'was in flight from New York magazine editorial offices, from Greenwich Village social-intellectual evenings, and especially from the whole world of high-minded, well-bred, money-hued culture, whether authoritarian or libertarian.'[1] Agee's rebellion was deeper than that, however. It was an artistic crisis conditioned by the particular moment in which it occurred, a crisis so intense that it made Agee question the tradition of his own art, and seek with visible anguish a new means to express his deepest repugnance in the face of unspeakable bleakness. Indeed, he says as much in the digressive passage of his book:

Above all else: in God's name don't think of it as Art. Every fury on earth has been absorbed in time, as art, or as religion, or as authority in one

form or another. The deadliest blow the enemy of the human soul can strike is to do fury honor. Swift, Blake, Beethoven, Christ, Joyce, Kafka, name me a one who has not thus been castrated. Official acceptance is the one unmistakeable symptom that salvation is beaten again, and is the one surest sign of fatal misunderstanding, and is the kiss of Judas.

His pressing need to reject a culture that cannot allay his pain in the face of the human condition he documented in Alabama leads to wild daydreams: 'If I could do it, I'd do no writing at all here. It would be photographs; the rest would be fragments of cloth, bits of cotton, lumps of earth. . . .' His mood shifts between a conviction that something can be told of what he has lived, and a conviction that the poet-intellectual has no place in this continental disaster:

As a matter of fact, nothing I might write could make any difference whatever. It would only be a 'book' at the best. If it were a safely dangerous one it would be 'scientific' or 'political' or 'revolutionary.' If it were really dangerous it would be 'literature' or 'religion' or 'mysticism' or 'art' and under one such name or another might in time achieve the emasculation of acceptance.

That which the vanguard painter regarded with distaste as over-polished, over-refined, and remote from his inner necessities in the European modern tradition, led him to reject much of that tradition and to extol, as did David Smith, the 'coarse' traditions more true to the American experience. It led him, finally, to reject all conventions of pictorial nicety and to seek an almost impossible state-of-the-soul approach. Agee, several years before the visual artists, had already found it: 'This is a *book* only by necessity. More seriously, it is an effort in human actuality, in which the reader is no less centrally involved than the authors and those of whom they tell.' The immense effort of James Agee to be quicker, truer to human actuality, and more acute than his art had ever before allowed, led him to a strange lyrical excessiveness that was not so far in timbre from certain surrealist writings (his incredibly long catalog of smells and textures, the slat-by-slat descriptions of tenant farmers' abodes, and delirious descriptions of the collages of magazine illustrations stuck on the poor walls). Agee's technique of evocation, his feverish catalogs of objects and swift deadpan passages of meticulous description, prefigure the phenomenological writings of the nineteen-fifties and sixties which by their very conscious opposition to surrealist ante-cedents are the product of surrealism:

The snakes are blacksnakes, garter snakes, milk snakes, pop snakes, bull snakes, grass snakes, water moccasins, copperheads and rattlers. Milk

snakes hang around barns and suck the cows' tits; hoop snakes take their tails in their mouths and run off like hoops; bull snakes well up and roar like a bull when they are cornered; grass snakes are green, small, pretty; rattlers are used as amulets by whites as well as negroes; copperheads are the worst snakes of all . . . on the leather land and sleeping of swamps, and sliding of streamed water, in light and deep shade, are poured up hickories, red oaks, cottonwoods, pines, junipers, cedars, chestnuts, locusts, black walnuts, swamp willow, crabapple, wild plum, holly, laurel.

Agee continues like this for several more pages.

Agee, like so many visual artists during the Depression, was driven to extremes that presaged a new consciousness. A larger share than is usually conceded belongs to the emergence of surrealist thought among American artists. The seminal ideas of surrealism were born in Paris in the mid-twenties but were not carried to America until ten or fifteen years later—and then through the efforts of a few painters and writers. Much of the later American adaptation of surrealist modes of thought derived from belated translations of texts that had appeared in Breton's magazines or, later, in *Minotaure*. The man who first organized the guiding lines of surrealist polemic was Julien Levy, a young New York art dealer and writer whose intimate knowledge of contemporary French culture was almost unique and enabled him to be faithful to the original texts and directions. When he came to write the first significant book in English on surrealism, Levy reiterated the essentials that had appeared a decade before in *La Revolution Surréaliste*, a journal published by Breton and his circle between 1924 and 1929.

In that journal, and in its successor, *Le Surréalisme au Service de la Revolution*, which appeared in 1930, sybilline voices repeatedly attacked positivism, offering instead the liberties of the bizarre and the marvelous. Issue after issue presented the materials for a new tradition—primitive art, metaphysics from the orient, and the revived voices of Lichtenberg, Novalis, Roussel, Lautréamont, Sade, as well as the psychoanalyst Dr Lacan and the Russian fathers of revolution. Myth engineering was a specialty, and there were frequent articles by anthropologists and poetic additions by the local cenacle, including Péret, Aragon, Eluard, Leiris, and even Valéry. Tremendous enthusiasm and high spirits marked the early years, even in such serious matters as the 'Letter to the Rectors of European Universities,' published April 15, 1925, in which Antonin Artaud announced: 'Enough play with language, with artifices of syntax, juggling formulas, now is the time to find the great laws of the heart . . . a guide to the spirit lost in its own labyrinth.' In the same issue the editors

published a translation of Theodore Lessing's essay on Europe and Asia in which he wrote that Asian thought is in the heart of nature while that of the West is *before* it 'looking for the key.' Their unceasing attacks on Western culture and on received ideas (especially in French culture) appeared in many forms—in Artaud's frequent contributions such as 'what I admire, what I crave, is the dumb intelligence that seeks, but doesn't seek to seek'; in Aragon's demonology; in Eluard's defense of Sade who 'wished to give again to the civilized man the force of his primitive instincts, to free the amorous imagination, and for absolute justice and equality.'[2]

In addition to learned articles on such exotic subjects as suicide, Charlie Chaplin, Paolo Uccello (by Artaud), and thirteenth-century nonsense poems, there were reproductions of the works of exotic cultures, such as the Indians of New Mexico whom Breton eventually sought *in situ*. And in the same issue (December 15, 1929) that carried Breton's second manifesto, there was the scenario for the film *Le Chien Andalou*. (When Levy came to write his book several years later, he also included a film scenario, *Monsieur Phot*, by the one American surrealist acknowledged by the Europeans, Joseph Cornell.)

During the increasing political disarray of the thirties the surrealists began to turn more and more to political issues, particularly the issue of internationalism. From 1930 on, there were frequent attacks on patriotism and chauvinism, and on such French institutions as the Catholic church in its reactionary political maneuvering. Eluard attacked colonialism and flag-waving, and specifically, in 1932, French torture methods in Indochina. There were increasing references to Lenin, Marx, Engels, and Hegel, especially Engels, whose views and language were more adaptable to surrealist purposes. Breton, who began his fight against communist agitation for a 'proletarian literature' cited Engels, as did Tristan Tzara, who also quoted Lautréamont (equally out of context) in his famous 'Poetry must be made by all.'

Minotaure, which first appeared in 1933, had a broader base of contributors and a rather more diversified content than the earlier journals. The editor, Tériade, continued the work of building a surrealist tradition by publishing scenes from *Ubu Roi*, fragments from Rimbaud (and his horoscope), scattered texts of Mallarmé, and comments by Breton on writers of 'black humor': Lichtenberg, Grabbe, Roussel, Kafka. There were more texts of a quasi-scientific nature, and increased space for anthropological material. The young

15. One of the first American surrealists to be recognized by the European fathers was Joseph Cornell. 'Variété de Minérologue' of 1939 was one of his early boxed tableaux. Coll: James Merril, Photo by Geofrey Clements

poet and anthropologist Michel Leiris took a large part in the planning of 'ethnology and archaeology articles in the light of the history of religions, mythology and psychoanalysis,' as they were announced. He himself wrote remarkable accounts of the Dakar–Djibouti Mission (1913–33) in which he participated, and he discussed at length the funerary dances of the Dogon. There were natural history articles, among them an extraordinary essay by Roger Caillois on the praying mantis as automaton, as female predator, and as mythology. *Minotaure* also included a great many well-printed reproductions of works by Picasso, Dali, Derain, Brassai, Matisse, Giacometti, Bellmer, Masson, Klee, and Cornell, the only American. It also ran an article by Kurt Seligmann on Haida Indians in its last issue in May 1939, an issue that concluded, much as Breton had begun in 1924, by

denouncing European rationalism: 'Before the incontestable failure of rationalism, a failure we had foreseen and announced, the vital solution is not withdrawal, but in the advance *towards new territories*.'

The most important continuous theme in these publications was the persistent search for a viable tradition. While the surrealists claimed to be rejecting the past, they nevertheless kept scouring their past for the rudiments of their new thoughts, for the support any theory requires. The publicized importance of the unconscious, of the bizarre, of the marvelous, was always in a context of precedents, but precedents as remote in time and space as possible. The distancing the surrealists performed was of singular significance for numerous Americans alerted by the smoke signals coming from abroad throughout those years until the war. It made it possible to sidestep the immediate local tradition and to escape from the bonds of 'taste.' Breton's emphasis on the 'convulsive' was a further benefice for the admittedly inhibited Americans.

There had been small but continuous exhibitions of works by surrealist artists in New York, mainly in Julien Levy's gallery, but also at Pierre Matisse and at the Valentine Galleries. Levy's group show of 1932 was followed by Man Ray and Max Ernst, then in 1933 by Dali, in 1935 by Giacometti, and in 1936 by both Tanguy and Magritte. At Pierre Matisse there was Miró in 1933, Masson in 1934, and de Chirico in 1936. Many artists made it their business to see all exhibitions of modern art—few as there were—and presumably they had discussed the surrealist works long before the 1936 exhibition at the Museum of Modern Art. Levy was a warm and enthusiastic mentor, and he often entered into conversations with visitors to his gallery. By his own account he was easily accessible to artists, and he has told of his encounter with Gorky when he first opened the gallery:

In the winter of 1932 he came urging me to look at the work of a friend of his named John Graham, and it was Graham who generously suggested that I also look at a portfolio of Gorky's own drawings. 'My portfolio is already in your back office,' Gorky reluctantly confessed, and my secretary told me that 'that man' is always leaving his portfolio in the back office. He comes back days later and pretends he had forgotten it.[3]

When Levy's book, *Surrealism*, was published in 1936, Gorky read it in the back room of the gallery and later borrowed it to take home. *Surrealism* was the first American version of what Levy called the 'surrealist point of view,' and it gave the small band of artists attracted to the modern European art a framework and language with which to pursue their dialogue with Europe.

94

Surrealism was faithful to the spirit of the movement and remains the most valuable early book in English through its success in capturing the ambience of surrealist thought. Like many European surrealist publications it proffers numerous long excerpts from surrealist writings and has lively typography and layout. There are local intonations, however, in Levy's appraisal of surrealism and certain accents that could easily be adapted to the American's needs. Unlike the Europeans who assiduously avoided the idea of metaphor, disliking its transitive aspects, and who relied on Freud's notion that 'for the most part dreams consist of visual images,' Levy includes metaphor as one of the primary aims of the surrealist spirit. Surrealism, he wrote on the first page, attempts to 'revivify mythology, FETISHISM, parable, PROVERB, and METAPHOR.' Another marked stress is on process. Like his own mentors in Paris, Levy resorts to a quotation from Engels to illustrate his point: 'The world is not to be viewed as a complex of fully fashioned objects, but as a complex of processes, in which apparently stable objects, no less than the images of them inside our heads (our concepts) are undergoing incessant changes, arising here and disappearing there, which, with all apparent accident and in spite of all momentary retrogression, ultimately constitutes a progressive development.' Considering how several of the most advanced American painters were to cleave to the theory of processes, and how they were to lean toward metaphor in their work, Levy's emphases may well have been influential in the development of attitudes in the new American painting.

As in the earlier French publications, Levy immediately takes his position against positivism. The first sentence of the book is: '*Surrealism* is not a rational, dogmatic and consequently static theory of art.' He later brings together his Freudian convictions with his attraction to the Orient, and in this, again, he accents something which was approached only casually in European publications. When he announces that Indian philosophy has long taught that dream and reality are similar and unreal, he draws on a tradition that Breton and his friends had perused lightly and without emphasis. But for Levy the East is important. He quotes from the *Tibetan Path of Knowledge*, published in London in 1935:

The initial comprehending of the dream referreth to resolving to maintain unbroken continuity of consciousness throughout both the waking state and the dream state. In other words, under all conditions during the day hold to the concept that all things are of the substance of dreams and that thou must realize their true nature (i.e. Maya or unreality).

He then goes on to quote Dali, who had spoken at the Museum of Modern Art in 1934 on realism, as including all the sordid mechanism of logic and all mental prisons: 'Pleasure includes our world of subconscious desires, dreams, irrationality and imagination. Surrealism attempts to deliver the subconscious from the principle of reality, thus finding a source of splendid and delirious images.'

After his introductory remarks, Levy discusses individually most of the surrealist founders, and pays deep homage to Duchamp (he owned several works by Duchamp; Gorky had seen *The Bride* in his apartment in 1937). His final remarks deal with Calder—'sometimes a surrealist and sometimes abstractionist'—and with Joseph Cornell, 'one of the very few Americans at the present time who fully and creatively understands the surrealist viewpoint.' Then the book becomes an anthology of his favorite surrealists, beginning with Lautréamont and including fragments from Breton, Eluard, Ernst, Péret, Dali, and even Picasso. Among the illustrations there are Giacometti's *Palace at 4 a.m.* and Meret Oppenheim's *Fur-lined Teacup*. Finally, there is an appendix with a challenging essay by Gaston Bachelard—the first publication in English of a philosopher who was, like surrealism itself, to have a delayed impact on America. Not for twenty-five years was another work of Bachelard to be translated into English, despite his tremendous stature in European philosophical circles. Levy's selection of Bachelard was all the more remarkable since the Europeans themselves, in 1936, were not especially enthusiastic about his eccentric views. As a philosopher of science, Bachelard had followed his instincts with close attention, but he had also moved beyond certain of the surrealists' most cherished assumptions, a fact that was to emerge most clearly after the war.

The essay Levy quotes is called 'Surrationalism,' and it is an attack on traditional logic couched in the aggressive language favored at that time. Bachelard advocates 'experimental reason,' which would 'take over those formulas, well purged and economically ordered by the logicians, and recharge them psychologically, put them back into motion and into life.' In diction that was to become very familiar in the United States in the mid-forties, he proclaimed that 'The risk of reason must, moreover, be total. It is its specific character to be total.

16. Cover reproducing a painting by Giorgio de Chirico for the Museum of Modern Art's influential surrealist exhibition catalog. The show opened December in 1936, and the catalog was reprinted several times, this edition being that of 1946. Photo: courtesy The Museum of Modern Art

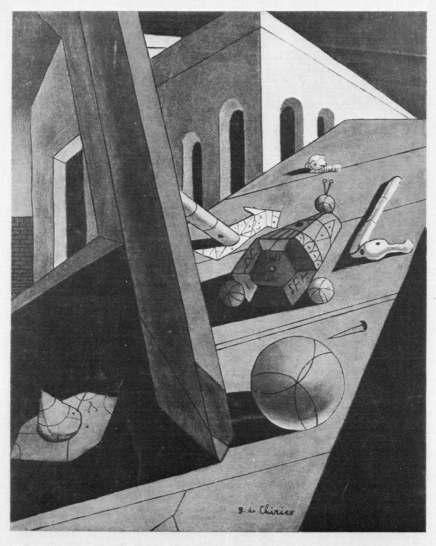

FANTASTIC ART
DADA SURREALISM

I make a physical experiment to transform my mind.... *In other words, in the domain of thought imprudence is a method. . . .*' Above all, Bachelard insisted that certitudes were no longer to be desired, and inveighed against the will toward closed systems. In later years, he was to evolve a beautiful open system of his own, proving that it could be done.

Few artists read that essay. Yet the ideas of the surrealists and of Bachelard were to be echoed in the New York artists' discussion in the Waldorf Cafeteria. We can be sure that Graham knew the texts, as well as several of his friends such as the Egyptian-born painter Landes Lewitin (who not only knew this essay, but had read all of Bachelard's subsequent books), probably Kiesler and Matulka, and certainly Cornell. As the submerged voices of Paris came whispering into the New York community in the early thirties and later became quite audible, so voices in New York began to echo them. Long before the influx of the surrealists from Europe, there had been lengthy discussions among the artists on the project on psychoanalysis and automatism. Rothko recalled that he had experimented with automatistic drawing at some time in 1938, and he was already at that time very much interested in the Oedipus myth—surely a direct inspiration from surrealism. Tworkov, who joined the easel project in 1935 when 'everybody you could think of was lined up for their checks (among them Davis, Gorky, Gatch, and de Kooning),' found incessant and confused talk of European avant-garde painting and claims now that the most advanced point of view was the surrealist.[4] He adds that psychoanalysis figured prominently in discussions, and that a number of artists had turned to theories of the unconscious in their work 'to let it all out.' Other artists have recorded their preoccupation with surrealist tenets, or their wonder when they saw the works. Even those such as de Kooning, who were never to embrace even the most abstract of surrealist notions, nevertheless showed their awareness of its impact in their work. Bradley Walker Tomlin, temperamentally far removed from surrealism, was all the same electrified by the exhibition at the Museum of Modern Art. He was at first deeply repelled but eventually returned again and again, admitting to his friend Gwen Davies that other art began to look dull by comparison.[5] Pollock, as is well known, was already deeply immersed in Jungian analysis in 1937 and had shown marked interest in the surrealist work of Miró and Picasso. Before the advent of the surrealists themselves, surrealism was already working to bring about the crisis of consciousness.

ℂVoices from ℂEurope

Except for Gorky, who loved every word of surrealist doctrine to the extent that he paraphrased Eluard in his love letters, most American painters were ambivalent about surrealism. The old suspicion of intellectuals and of elegance helped them to resist complete obeisance to the surrealist point of view. They were very like the Brazilian students Claude Lévi-Strauss described in *Tristes Tropiques*, who 'regarded the University as a tempting, but also a poisonous fruit. These young people had seen nothing of the *world*. . . . Yet we bore in our hands the apples of knowledge; and therefore our students wooed and rebuffed us, by turns.'

Americans in the newly established art milieu in New York did just that to the surrealists when they finally arrived in New York, but the Americans had ample reason to withhold their complete fealty. They had been swayed by so many shifts in experience and attitude during the Depression years that they had learned to reserve a part of themselves for the solitary years to come. For those painters who were to develop the new painting in the nineteen-forties, the last years of the Depression and the early days of World War II had been filled with confusion. The surrealist attitude represented a single facet of a complex vision they had received, suddenly and without much preparation, only a few years before. If they had been students during the twenties, their direct knowledge of modern art was unbelievably limited. If they had been young during the early years of the Depression, they needed time to assimilate the sudden revelations of the famous exhibitions at the Museum of Modern Art.

Students of that period such as Gottlieb, Newman, and David Smith went to the Metropolitan Museum, which had no modern art except a few prints; indeed, until 1929, when Barr opened the

99

Museum of Modern Art, there was no place to see even the masters of modern art. While. Barr was preparing the press for the grand opening, he reminded them (and via the press, the public patrons) that the Metropolitan had nothing to show from the heroic impressionist years; that the masters of the nineteenth century, particularly Cézanne, Van Gogh, Seurat, and Gauguin (with whose work he opened the museum) could not even be seen in New York. This was not to say that they didn't exist in the city. There were wealthy collectors with good examples of at least the nineteenth-century vanguard painters, and it was they who decided to bring this art to the attention of New Yorkers. Barr, a twenty-seven-year-old art historian, was appointed by four collectors, Lillie P. Bliss, Mrs Cornelius J. Sullivan, Mrs John D. Rockefeller, Jr, and A. Conger Goodyear, to direct their projected museum. Interestingly enough, the museum was essentially the dream of an artist, Arthur B. Davies, who had befriended Lillie Bliss during the days of the Armory Show and had wisely directed her to acquire paintings by Cézanne and others from the show. He had always encouraged her to found a museum, and it was largely through her initiative that these forward-looking and wealthy collectors of New York City took the plunge.

Barr was an energetic and agile director, managing to catch up on history by presenting ten exhibitions during the first year. (At the end of that year the Metropolitan finally inherited the Havemeyer Collection, which was certainly the most magnificent collection of impressionist paintings in America.) He kept a constant wave of controversy pulsing in the press and did his best to correct the abysmal ignorance of his colleagues. As he has said, during the years 1925 to 1930 there had been only five articles on modern art in the two leading art-historical journals. Owing to his intensive campaigns from 1930 the press was widely attentive (even if largely hostile) to modern art. Through his keen awareness of the absence of knowledge, even on the part of artists and art critics, New York City was quickly educated in the whole modern movement. But from the beginning there was a gulf between the institution and the contemporary artist, one that was exaggerated by the class-consciousness of the period. As Meyer Schapiro pointed out in 1936, the people interested in modern art 'consist mainly of young people with inherited incomes, who finally make art their chief interest either as artists or decorators or as collectors, dealers, museum officials, writers on art and travellers.'[1] Barr and his trustees lived in the world of bourgeois values that were under attack. Although Barr himself held distinctly liberal political

opinions, his closest colleagues were often less than respectable politically. There was a great scandal, for instance, when Philip Johnson, who had deeply influenced American architectural history with his great exhibition in 1932 which documented the heroic modern tradition in Europe, was said to have resigned in 1935 in order to join Huey B. Long and his gray-shirted henchmen in Louisiana. Pressure mounted to open the museum to contemporary American art, and it was attacked from all sides. Some were angered by its vanguard bias, others by its indifference to the momentous events of the Depression. Accordingly, the museum mounted several exhibitions of American art, one of which—'New Horizons in American Art'—was selected by Holger Cahill, then national director of the Federal Art Project. This show included Gorky's model for an aviation mural for Newark Airport and works by Brooks, Evergood, Knaths, Bolotowsky (one of the rare abstract paintings), Byron Browne, Stuart Davis, Willem de Kooning, George McNeil, and Marsden Hartley. Barr's sympathy for the works of the Project seemed to many abstract artists overplayed. Eventually Ad Reinhardt, then a peppery young member of the American Abstract Artists, led a picket line of protesters, accusing Barr and the museum of neglecting the great modern tradition of abstract art both in the United States and abroad. (This was done in spite of the important Bauhaus exhibition in 1938—but then, the Bauhaus was not very popular with New York artists largely because of its utilitarian pretensions.) Reinhardt's teacher, Carl Holty, had described the Museum as 'an eighteenth-century court in which ministers and post commanders have authority unless the hand from above is clamped down and then they become flunkies.'[2] Reinhardt took up the cause in 1940, and together with other members of the American Abstract Artists demanded new policies. 'Shouldn't "modern" conceivably include the "avant-garde"?' they sarcastically inquired, suggesting that the museum show Hartung, Magnelli, Hélion (who had been in New York), Eggeling, Sima, Max Bill, and other European abstract artists.

Unquestionably the political temper of the time affected the attitudes of American painters and sculptors, who found it increasingly difficult to rationalize the conflict of art and political conviction. The easy polemical discourse that permitted Europeans, especially the surrealists, to deal with the problem in words was not readily adaptable to the New York situation. Artists' unions and artists' congresses intervened. And above all, the Spanish Civil War intervened.

It would have been hard to find a writer or a painter who was not profoundly disturbed by the reports from Spain, or who did not have at least one friend who had volunteered for the International Brigade. Spain loomed large in everyone's thoughts, all the larger because it seemed so far away. Those who were firmly committed to modern art as an abstract idiom had second thoughts when the news of the disaster of Western culture reached New York. Those who had sought to infuse their art with a political meaning felt all the more justified. The natural reverence for Picasso was reinforced when rumors spread of his assuming the directorship of the Prado; when, in 1937, the American Artists' Congress met again, Picasso sent the American artists a special message. In it he assured them that as director of the Prado museum he would take all the necessary measures to protect the artistic treasures of Spain:

It is my wish at this time to remind you that I have always believed and still believe, that artists who live and work with spiritual values cannot and should not remain indifferent to a conflict in which the highest values of humanity and civilization are at stake.[3]

All those who were suspended between the poles of socially signifi-cant painting and the great modern tradition of abstraction found solace in Picasso's message. They were handed a ready-made rationale for their need to express more than plastic values. There was a surge of interest, not only in Picasso, but also in such artists as John Heartfield, who had imaginatively and with bitter power set about to destroy via the image the rise of Fascism. An exhibition of some 75 of Heartfield's masterly montages at the A.C.A. Gallery in 1938 attracted strong interest. But the greatest attendance was reserved for the exhibition of *Guernica*, which took place at the Valentine Gallery early in 1939. The exhibition of the painting was sponsored by the American Artists' Congress to raise funds for Spanish refugees. Without question *Guernica* drew, both from the press and from the general public, the widest comment any modern art had ever had in America. More seriously, it stirred the artists profoundly. Picasso showed the way for many to resolve the conflicts that had made the nineteen-thirties unbearable for so many artists. By offering symbolic and mythological reference, which allowed for the neces-sary universalization, yet maintaining the specific topical significance of his theme, Picasso indicated how a painter might bring together the archetypal symbol advocated by the surrealists and the expression of the social consciousness of the artist. The vast implications of his essay into moral indignation were not lost on American artists, who

17. The deep impression made by the Spanish Civil War remained ineradicable for Robert Motherwell as this version of 'España', dated c. 1964, indicates. Photo by James Mathews, courtesy the Artist

had become obsessed with the Spanish Civil War. At least one of them—Robert Motherwell—was to continue to confront the problems implicit in Picasso's titanic gesture.

The years 1936–40 were saturated with references to the Spanish Civil War and the coming world war. Many of the New York artists attended the numerous fund-raising parties and lectures for the Spanish Loyalists. A great and influential figure, André Malraux, appeared at a number of these functions, speaking with fervor of his experiences in Spain and warning his listeners that the fascists must be stopped before the entire world went up in flames. Few could have remained unmoved when Malraux described an enfilade of wounded followed by villagers that extended from the heights of the mountain to its base, 'the grandest image of fraternity I have ever encountered'; or when he told of how, on the first day of 1937, toys sent to the Spanish children from all over the world had been heaped up in the center of the great bullring in Madrid, and when the children went to collect them, a squadron of Junkers bombed the city. When the children went back later, none of them would touch the toy airplanes.[4]

H

Within the year, Malraux's novel of the Civil War, *Man's Hope,* was published by Random House. Although he had been known and read by a few of the literati, Malraux was, until the publication of this novel on Spain, relatively unfamiliar as an artist. Those who heard him in the Mecca Temple in 1937 were largely ignorant of his œuvre, and accepted his authority on the advice of a small coterie of voluble admirers. But now Malraux's views were heatedly discussed. His complex fabric of human situations, always edging toward the enunciation of some political doctrine, and always stopped short by his inherent suspicion of simplistic ideology appealed to, yet disturbed his readers. The problem of the individual in relation to collective action, which was his central motif, could not have been closer or more uncomfortable for the tormented artists and writers in New York.

For artists, Malraux was one of the rare men of letters who was as much interested in the history and meaning of visual art as he was in poetry and novels. When he established his representative characters, those who spoke for art were not only poets and writers, but painters and art historians, dealers and museum officials. In the course of *Man's Hope* Malraux located with great precision the dilemmas that had wracked artists in the mid-thirties, and his highly intelligent discourse was undoubtedly helpful to his artist readers. In the early pages of the book Malraux introduces the sculptor Lopez who had nimble wits, though only when discoursing about art. Lopez shares some of Siqueiros' and Rivera's characteristics and obviously represents the Mexican viewpoint when he exclaims to a sceptical American journalist:

What have I been crying for these last fifteen years? A renaissance of art. See? Eveything here is ready for it. That wall over there, for instance. All those fools go trotting their shadows over it, and never give it a look. We have such a mob of painters, they sprout between the paving stones. . . . Yes, sir, we'll give our painters bare white walls. 'Get to work! Draw! Paint! The people who are going to pass this way want you to *tell* them something—see? You can't fake an art that means something to the masses when you've nothing to say to them . . .' Art isn't a matter of subjects. There's no great revolutionary art, and why? Because they're always wrangling about its tendencies rather than its function.

Lopez goes on to allow for the artist's 'fixing it up your own way' and for a certain amount of freedom from specific themes, sounding much like Siqueiros' moderate message to the 1935 Artists' Congress. In his last speech, he sounds even more like the Siqueiros who had worked with the young Americans in Union Square:

It's unthinkable that, given people who have something to say and people who are willing to listen, we won't create a style. Just give them a free hand, give them all the air-brushes and spray-guns, all the modern contraptions they can want, and, after that, a hunk of modeling clay—and then you will see!

But the optimism of Lopez is offset in numerous other passages of the book where the discussions weave back and forth between the problems of the intellectuals and artists and the realities of war. One scene significantly takes place in the Santa Cruz Museum where, in the ultra-modern showcases of glass, chromium, steel, and aluminium, 'all the exhibits were in perfect order, except certain small objects that bullets had reduced to dust.' Another takes place in the book-lined study of a professor of art history where there were some baroque primitive statuettes by Spanish-Mexican artists. The professor refuses to be separated from his books, despite the impending invasion by the Moors. Passionately he explains:

I ran a picture gallery for many, many years. I was the first to show people here the Mexican baroque art, Lopez' sculpture, Georges de Latour, our primitives. A woman would come to my gallery, look at a Greco, a Picasso or an Aragonese primitive. 'How much?' Usually she was an aristocrat who came in her Hispano with all her diamonds . . . with all her miserliness. 'Excuse me Madame; why do you want to buy that picture?' Almost always she replied, 'I don't know.' 'Then, Madame, go home and think it over. When you know why, you can come back.'

(Was it possible Malraux had heard that identical oft-told story about Stieglitz?)

The professor's would-be rescuer mentions that he sometimes saw great pools of blood before the pictures in the churches of the South and that the pictures had lost their 'efficacy.' The old picture dealer answered: 'We've got to have new pictures, that's all,' to which the younger man replies that that is surely rating works of art too high. The art historian's answer, undoubtedly Malraux's answer, lay in his infinite faith in art. 'Not "works of art" but art. It isn't always the same works that give access to what is purest in ourselves, but it's always this work of art or that.' And yet, the old man's humanism is answered in dozens of passages in which the problem of collective action—the desperate, last-ditch action which closes out reflection—is confronted with sympathy and justification on Malraux's part. For all the clarity of thought and remarkable acuity of characterization in the book, Malraux the artist is himself at war with Malraux the revolutionary and with Malraux the doctrinaire theoretician. And this, in

so great a writer, undoubtedly gave a sort of sad comfort to his admirers in the United States.

In the intelligent nuances of Malraux's work the doubts which were to assail artists only a few years later were already apparent. Malraux returns again and again to the problem of blind allegiance to doctrine, usually leaving an impression of his own distaste for dogmatic politics. He had been born in 1901, a man of a generation that since World War I had turned resolutely against the idea that politicians could save the world. They were, as Stephen Spender has written, the cynical old men who had sent the young men to the trenches of the Western Front. The young writers looked not to political revolutions but to *poetic* revolution, which was why they revered T. S. Eliot for 'The Waste Land,' 'that poem which insulates the decadent Western civilization from all idea that it might be saved by politics—expressed a poetic consciousness creating, against a background of social despair, a poetry unhampered by any social or political involvement.'[5] To some extent, Spender notes, all the artists of his generation preserved their suspicion of political involvement, even as they wrote, under the stress of Spain and Germany, *Gebrauchsliteratur*. Their doubts, which the slightly younger generation of idealists—especially those who fought in Spain under red banners—could not morally afford to share, nevertheless contributed to the popularity of their work, which was widely published in the late thirties; many American artists and writers harbored the same haunting doubts. Again, this ambivalence did not occur only when World War II wiped the slate clean. It grew at a steady rate as information about Germany and Spain kept pouring in, and as the final blow to Communist idealism—the Hitler–Stalin pact—devastated the ranks of the politically inclined artists.

The faint aura of existentialism was already visible in the appetite for Kafka that Edmund Wilson found growing in the literary world since the first publication in English of *The Trial* in 1937. He noted in an article in 1947 that *The Castle* had come out as early as 1930 but had not attracted much attention. With considerable irritation, Wilson observed that Kafka's reputation and influence had been growing to such a degree that the little magazines had made of him a writer of towering stature. Wilson's quarrel with the Kafka vogue was as much a spirited extension of his earlier position as an aggressive protagonist of engaged literature as it was a literary appraisal which compared Kafka with Gogol, Proust, and Joyce and found him considerably inferior. He understood that

it is not merely a question of appreciating Kafka as a poet who gives expression for the intellectuals to their emotions of helplessness and self-contempt but of building him up as a theologian and saint who can somehow also justify for them—or help them to accept without justification—the ways of a banal, bureaucratic and incomprehensible God to sensitive and anxious men.[6]

With characteristic crispness Wilson asks, 'But must we really, as his admirers pretend, accept the plights of Kafka's abject heroes as parables of the human condition?' No doubt Wilson still preferred Malraux's earlier heroes, with their impulse to constructive action, to 'the denationalized, discouraged, disaffected, disabled Kafka' who, he admitted, was 'quite true to his time and place, but it is surely a time and place in which few of us will want to linger. . . .' Many others, however, felt more at home with Kafka's spiritual homelessness than they did in Malraux's world of veritable contention. And they began feeling that way before the decisive moment of the fall of France.

Wilson himself—the personification of hardy, intrepid intelligence—considerably modified his position as the thirties moved toward their disastrous conclusion. While still adhering to his belief in 'The Historical Interpretation of Literature,'[7] as one of his essays on criticism was titled in 1941, he no longer felt so much at ease within the Marxist framework. He pays homage to the fundamentally non-historical attitudes of T. S. Eliot (which were rapidly being transformed in America into the new objective creed of the New Critics), and he recognizes the value of qualitative omniscience. But he points out that the other tradition, founded in the eighteenth century by Vico, who asserted for the first time that 'the social world was certainly the work of man,' provides a more complex and enriching critical method. He again takes up Marx and Engels, only at this point in history he argues that they were not really so materialistic as they sounded. He recast them as 'modest, confused and groping,' and he tries to show them as more respectful to the arts than his readers might think. He does this by analyzing the Russian tradition that preceded them, asserting that the restrictive dogmas of Communism were a natural extension of an old Russian tradition: 'The insistence that the man of letters should play a political role, the disparagement of works of art in comparison with political action, were thus originally no part of Marxism.'

What he did to modify the Marxist approach to letters he also did for the Freudian approach, which he came to see as part of the complex equipment the modern critic must wield with considerable tact:

'The problems of comparative value remain after we have investigated the Freudian psychological factor just as they do after we have given due attention to the Marxist economic factor and the racial and geographical factors.'

Wilson's faith in Taine's critical principles was not shared by some of the rising young literary figures who were determined to restore the rigors of analytical criticism that had lost so much tone during the political effusions in the mid-nineteen-thirties. They came to be known as the 'New Critics,' for whom the historical materialist framework was yet another sham structure designed to falsify the inherent values of literature. They proposed to isolate the literary object, be it poem or novel, and examine its formal structure and interrelations with intense and minute accuracy. Their stance was similar to that of the painters who refused to relinquish the interior history of their art, and who sought, via the assumptions of the modern tradition, to formulate the issue in structured, objective terms. Like the critics they were restless, and none of the easy slogans of 1938 and 1939 seemed to satisfy them any longer. Yet the jolts that successively weakened the West left them no peace. If, in the literary world, the retreat from the heady days of doctrine of the mid-thirties took the form of increasing criticism, in the art world it took the form of increasing suspicion of criticism. The old rift between the intellectual and the brush-wielding artisan was revived. Writers could lament, as Alfred Kazin did, the rising tide of the critical bias. He saw it epitomized in the *Partisan Review*, whose inner circle he felt unconsciously disdained creative imagination as simple-minded unless it came from the Continent:

This boundless belief in criticism was actually their passport to the post-war world, for as society became more complex and intellectuals more consciously an elite, the old literary radicals were among the few, in an age of academic criticism, who understood the relation of literature to institutions.[8]

Painters on the whole did not publicly lament the new turn to academicism. On the contrary, the swift changes in temper and ambience in their milieu seemed to insulate them from the literary retreat to academicism. If surrealism was not the sole factor in this healthy restlessness, it was certainly an important one. The surrealist celebration of the creative imagination was the best retort to the literati. Even in the darkest days of 1939, when Spain collapsed, Germany invaded Poland, and finally Russia attacked Finland, some artists could still sustain their faith in art, and surrealism helped.

Where a literary artist fell prey to the deepest doubt, as for instance Auden, whose poem 'September 1, 1939' so eloquently expressed his despair as a writer (though he no longer thinks so), the visual artists were preparing for a great adventure into the realm of imagination. Auden's poem sets the New York scene in a gloomy perspective:

> I sit in one of the dives
> On Fifty-second Street
> Uncertain and afraid
> As the clever hopes expire
> Of a low dishonest decade . . .[9]

Auden's final plea for 'an affirming flame' has a disconsolate ring. A painter, similarly depressed by 'negation and despair,' seemed better able to generate the affirming flame in his work as the world moved into the war. His restlessness and despair, springing not only from what he knew to be a spiritual rout in the outside world, but also from his own conflicts within his art, seemed to provide the impetus toward a new creative endeavor.

Many of the familiar institutions of that 'dishonest decade' were collapsing. The W.P.A. was, for all practical purposes, in its death throes by 1939, although a few artists remained on the rolls until the definitive demise in 1941. The artists' organizations were weakening. Only the American Abstract Artists seemed able to thrive, partly because of their internationalist operations (such as their helping European artists leave Europe in time) which gave them a *raison d'être*. New recognition of the arts was making itself felt in such stupendous undertakings as the 1939 World's Fair, in which a great many American artists who had worked on the project found commissions and were exhibited with enthusiasm—among them Gorky and de Kooning and Guston. Plans announced in 1938 called for twenty-three buildings with 105 murals and 102 sculptures, which in itself indicated the considerable change in attitude toward American art and artists.

Meanwhile, the artists themselves were accumulating more and more direct experience with their European counterparts. The huge Picasso exhibition in 1939 at the Museum of Modern Art was an unparalleled success, drawing thousands of visitors daily, among them practically every artist in New York. At the same time, another institution opened its doors, bringing an important and somewhat neglected tradition into prominence and all but completing the art education of the American painter. The Museum of Non-Objective Art was the child of the liaison between an infinitely wealthy col-

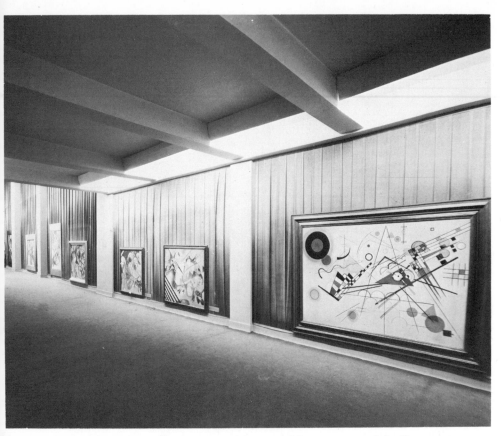

18. Unusual installation was one of the many bizarre aspects of the Baroness Rebay's first Museum of Non-Objective Art, c. 1946.

lector, Mr Solomon Guggenheim, and an infinitely eccentric devotee of certain expressionist brands of abstract art, the Baroness Hilla Rebay. The Baroness launched her first polemic offensive in 1936 in the socialite haven of Charleston, South Carolina. There she exhibited what she called the 'historical builders' leading toward non-objective art (Léger and Gleizes among them), along with the genuine progenitors of her notion of abstract art, of whom the most prominent was Wassily Kandinsky. To the *Charleston Courier* the Baroness announced that non-objective painting 'is particularly beneficial to business men as it carries them away from the tiresome rush of earth, and strengthens their nerves once they are familiar with this real art.' Her favorite was Rudolf Bauer, a weak imitator of Kandinsky, who

19. Calla lilies, carpets, and piped heavenly music at the Museum of Non-Objective Art, c. 1949.

was quoted as saying that 'National Socialism is only a political affair and could not possibly influence art'—a statement not calculated to win favor with more sophisticated artistic audiences. All the same, within a year, the Baroness had carried her campaign into the New York press, insisting that 'non-objective' art has no 'meaning' and that it had an 'inevitable' progressive mission in the twentieth century. Some of the Guggenheim collection was exhibited in 1937 at the Philadelphia Art Alliance and drew upon her the wrath of the popular press and artists alike. In the October 1937 issue of *Art Front* a group of artists, among them Jan Matulka, Byron Browne, and George McNeil, took issue with the Baroness, rejecting her notion that art has no meaning and represents nothing.

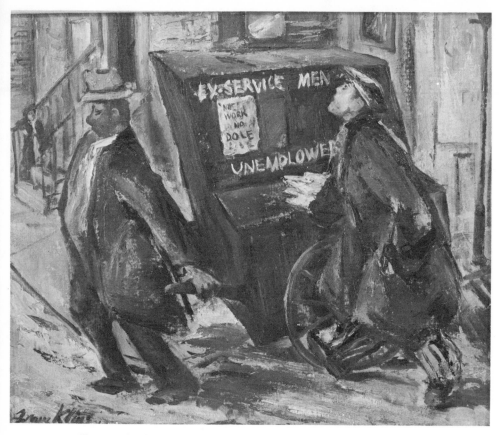

20. Franz Kline's painting of 1941 known as 'Ex-Servicemen and the Unemployed' was among the last social comment he made in his work. Coll: Dr and Mrs Edlich.

It is our very definite belief that abstract art forms are not separated from life, [they wrote] but on the contrary, are great realities. . . . Abstract art does not end in a private chapel. . . . The modern esthetic has accompanied modern science in a quest for knowledge and recognition of materials, in a search for a logical combination of art and life . . .

Apparently the Baroness agreed that modern art does not end in a private chapel, for in 1939 she persuaded Guggenheim to show his collection publicly. On June 1, 1939, a town house on Fifty-fourth Street was converted into a museum, opening with an exhibition of 'The Art of Tomorrow,' which included about half of Guggenheim's collection of 726 paintings. With thick gray carpets, silver décor, and

the music of Bach, Beethoven, and Chopin piped in to facilitate the Baroness' idea that viewers should have 'cosmic contacts with art,' the strange new museum established itself importantly in New York. Despite the prevalence of works by Bauer, the museum, during its ten years on Fifty-fourth Street, managed to publicize thoroughly the Russian genius of Kandinsky, as well as the painters Klee, Léger, Hélion, and even a few Americans such as John Ferren, Perle Fine, and I. Rice-Pereira.

Kandinsky's presence, via his works and the writings the Baroness faithfully transcribed in English during those years, was incalculably effective. New York artists absorbed his abstract lyrical paintings with alacrity. It is certain that Jackson Pollock, who worked briefly as custodian at the museum, Gorky, who was a frequent visitor, and several of their colleagues were deeply affected by their encounter with Kandinsky. The art education of painters was very nearly complete by 1940 when the final act of the drama of the nineteen-thirties brought them release from the dilemma—defined in *View*—between the masses and the unconscious. The fall of Paris, as Harold Rosenberg poignantly wrote in 1940, shut down the laboratory of the twentieth century. For the American painter, not only was the laboratory whose products they had so avidly studied closed, but also many of its leading workers appeared in New York. It was the end of one kind of isolation and the beginning of another.

Myth and Metamorphosis

In the spring of 1938 appeared the penultimate issue of *Minotaure*. The cover was designed by Max Ernst, there were reproductions of drawings by André Masson and paintings by Yves Tanguy, Wolfgang Paalen, and Matta; and its contents included the first of Matta's many published commentaries. The young Chilean architectural student preceded his article, 'Mathématique sensible—Architecture du temps,' with a collage bearing an explanation of his surrealist vision of space. It was a sketch for an apartment which would have a space appropriate to the vertical human being, with different planes, a staircase without a banister 'to conquer the void,' a 'psychological ionic column,' pneumatic armchairs and lots of paper and inflated rubber objects. In the article, adapted from the Spanish by the tireless surrealist apologist, George Hugnet, Matta adopted the feverish recitative pace he had learned from the surrealist founders to express his vision of anti-Renaissance space. 'We need walls like wet sheets which change form and marry our psychological fears,' he wrote, adding a list of 'objects' to deliver us from 'angles.' Also, he added, 'other objects half-open with sexual attributes of unheard of con-formations of which the discovery provokes active desires to the point of ecstasy;' and also, 'for each of these umbilical cords which put us into communication with other suns, objects of total liberty which would be like plastic, psychoanalytic mirrors.'

Within a year Matta, fully armed with surrealist doctrine which he modified to suit his vision of a 'psychic morphology', had arrived in New York (in the fall of 1939) and was immediately embraced by several of the most adventurous painters in the new milieu. In May 1939, a double issue of *Minotaure* had appeared with a desperately hopeful editorial titled 'Eternity of Minotaure,' in which the editors

proclaimed their intention of continuing to advance toward new territories. Their progress, however, was effectively checked in Europe by Hitler, and was to be made only when a large number of the *Minotaure* team reached the Western Hemisphere. That last issue, with a cover design by André Masson, pursued many of the familiar surrealist themes, including still further analysis of Lautréamont, even including his handwriting. But it also heralded the leading motifs which the surrealists were to introduce in person to the artistic discourse of New York.

Breton, who had missed the previous issue because of his trip to Mexico, made up for it by contributing two articles to the first section of the double issue and one very long article to the second section. In his first essay, 'Prestige of André Masson,' he launched an idea that would find very sympathetic echoes a couple of years later in New York. He suggested that instead of the exhausted still-lifes that turn always around the same objects and effects, the artist should substitute what he called 'the work-of-art-event,' which would draw its justification not from formal perfection but from its power of revelation: 'The taste for risk is undeniably the principal mechanism capable of carrying man forward to an unknown way.' Masson, he wrote, has this sense of risk, and also a spirit responsive to the appeal of life, 'that life which he wishes to surprise at its source, and which draws him eclectically to *metamorphoses*.' The language of this brief essay was to become very familiar to those listening to the cafeteria discussions in New York in the early war years. The idea of 'risk' became an obsession, while the idea of painting as an 'event' was eventually broadcast by Harold Rosenberg in his notion of 'action painting.' Finally, the importance of mobility and process enunciated in the cherished surrealist theory of metamorphosis was to be registered in the work of New York painters.

Immediately following his homage to Masson, Breton commented on 'the most recent tendencies in surrealist painting,' noting a pronounced renewal of interest in automatism. He went on to discuss the recent experiments in painting by Matta, whose early morphology he reproduced. Matta, wrote Breton, is notable for his will 'to deepen the faculty of divination by means of color.' Matta's friend, Gordon Onslow Ford, he added, tends to describe a world where the last clear angles of cubism are disjoined, and noted that both he and Matta display a need to suggest a quadri-dimensional world of several horizons. In his view the younger surrealist painters, with the exception of Wolfgang Paalen who had long proved his

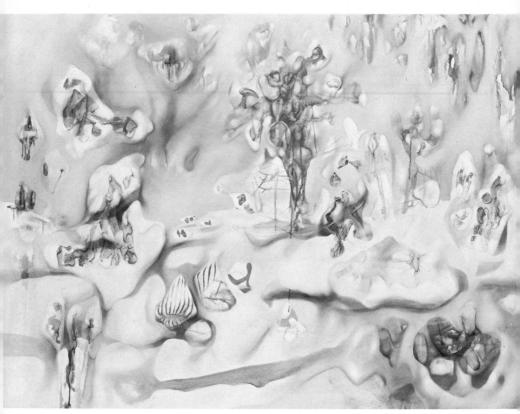

21. The wheeling space and biomorphic shapes in Matta's 'Prescience' of 1939 impressed the New York School artists he came to know during the war. Photo: courtesy The Wadsworth Atheneum, Hartford

mastery of surrealist principles, seemed to be influenced most by Tanguy, while Dali's influence was rapidly declining. All the painters mentioned in this article, and Breton himself, were to arrive in New York within the next three years.

Another poet, Benjamin Péret, who would soon take refuge in South America, wrote an article on the ruin of ruins, a poetic reflection in which he brings in references to the New Mexican Indians who fashion dolls having heads with the silhouette of a castle which they have never known and will never know. Kurt Seligmann, who had already removed to America, reported an interview with a Tsimshian Indian in the Pacific Northwest. The interview deals with origin myths, and the comparative theology of myths from the classic world and the new world. He recounts some of the Haida

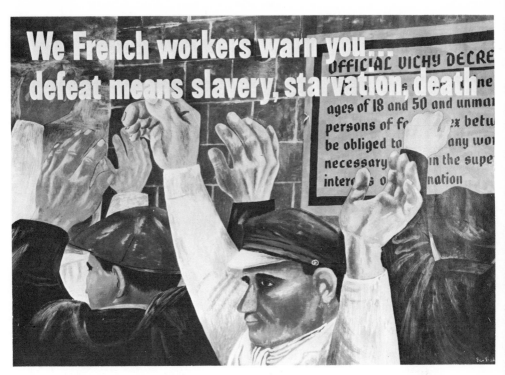

22. In the war period the artists, like Ben Shahn, who had always worked with narrative content found new outlets, such as this 1942 lithograph. Photo by Sunami, courtesy The Museum of Modern Art

myths (through the Indian elder) and manages to suggest, rather than to describe directly, the mythical meaning of the totems, masks, and ceremonial dance costumes with which he illustrated the article. Both Péret and Seligmann continued to comment vividly on the indigenous primitive cultures of the New World when they arrived in America; there was scarcely any interruption between their studies for *Minotaure* in Paris and those for *View*, which first appeared in New York in September 1940.

Myth, metamorphosis, risk, event-painting—these liberating possibilities were little by little impressing themselves upon the troubled psyches of many New York painters. In the year or two following the fall of France, while Americans were adapting their psychology to war conditions, many artists touched bottom spiritually. The natural habitat developed during the W.P.A. years was swiftly transformed into an even more alien environment than artists had known before.

New York quickly became a center for all kinds of war promotion, ranging from information agencies to poster-producing units, which absorbed the energies of many artists and writers. In any case, the sense of community that had at least had an embryonic existence because of the Project, was severely menaced by the exigencies of the war. For a time, the problems of artists seemed all too trivial even to artists. 'In 1940,' wrote Barnett Newman, 'some of us woke up to find ourselves without hope—to find that painting did not really exist. . . . The awakening had the exaltation of a revolution. . . . It was that naked revolutionary movement that made painters out of painters.'[1] Gottlieb, in his contribution to the same symposium, agreed: 'During the 1940s, a few painters were painting with a feeling of absolute desperation. The situation was so bad that I know I felt free to try anything no matter how absurd it seemed. . . . Everyone was on his own.' Gottlieb stressed the individualism of the painters in New York, and their sense of 'aloneness.' The war produced yet another vacuum, and discouraged all those who, through their incipient sense of the need for a milieu, found once again that it did not, and perhaps could not, exist in American culture.

At precisely this point of moral desperation the arrival of some renowned Europeans—energetic and endemically optimistic—made a difference. Not only did they infuse the New Yorkers with a sense of purpose, but they also helped reconcile various esthetic conflicts; for it was not only Ernst, Tanguy, Masson, Seligmann, and other convinced surrealists who trod the streets of New York, there were also Mondrian, Léger, Glarner, Lipchitz, and Zadkine, among others. When Peggy Guggenheim opened her gallery, she was careful to wear one earring by Tanguy and one by Calder, 'in order to show my impartiality between surrealist and abstract art.'[2] Such impartiality was growing steadily. The synthesis of ideas drawn from all modern traditions was certainly one of the major achievements of the period. It is not true that the surrealists were opposed to such syntheses. Breton may have decreed various orthodoxies, but he was able to understand the significance of the modern tradition as a whole, as he proved when he helped to edit Peggy Guggenheim's first catalogue, *Art of this Century* (published in 1942). The catholicism evidenced in that catalogue had, of course, a long anterior history. In her comings and goings on the European continent Peggy Guggenheim had managed to enlist the aid of an extraordinary number of brilliant participants in the making of modern art. One early counselor was Marcel Duchamp, who had long since proved his

objectivity in forming the *Société Anonyme* collection. Later, she listened to the enthusiastic conversations of Herbert Read, already in the early thirties an authority on the various branches of the modern movement. Then there was Howard Putzel from California, who helped her acquire many artists of divergent tendencies in the last months before the invasion. There was also her friend, the widow of Theo van Doesburg, and numerous other distinguished members of the European vanguard. She had also been in contact with the group around Jolas' magazine, *transition*, with which the American art critic James Johnson Sweeney was intimately connected. With such advice, it is not surprising that the scope of her collection was broad and that, despite her liaison with Max Ernst, she continued to be interested in various other expressions of modern art.

It was Breton, in fact, who had diligently researched each artist in the collection, selecting appropriate statements, and who insisted that the manifestoes of the futurists and of Gabo and Pevsner in 1920 be included at the end, together with Max Ernst's 1932 'Inspiration to Order' and Ben Nicholson's 'Notes on Abstract Art' of 1941. In the front of the catalogue they printed André Breton's 'Genesis and Perspective of Surrealism,' Hans Arp's 'Abstract Art, Concrete Art,' and Piet Mondrian's 'Abstract Art,' which was written especially for the occasion. The collection itself included every major twentieth-century tendency and seemed weighted in no particular direction. It represented, in fact, a meshing of an entire international set of assumptions that flew, like so many iron filings, to the single magnet of New York. The old 'milieu' that featured Graham, Kiesler, Gorky, de Kooning, Rothko, Gottlieb, and Newman, was expanded to include not only Motherwell, who in 1940 was studying art history with Meyer Schapiro, Matta, Baziotes, Hare, Pollock, and others among the artists; but also, significantly, patrons and critics and museum officials. Peggy Guggenheim's early consultants, such as Herbert Read, James Johnson Sweeney, and Duchamp, were augmented by Alfred Barr and James Thrall Soby. A newly active breed of patrons appeared, such as Mr and Mrs Bernard Reis, who opened their home to the surrealists and were largely responsible, financially, for founding *V.V.V.*, the other organ of the war years' surrealist activity.

The inter-relating of the isolated circles in New York was largely achieved by the passage of such unabashed talkers as Graham and Kiesler from one circle to another, helped by an increasing concentration on the part of local authorities in museums and publications on events in New York. This was partly because of the stream

I

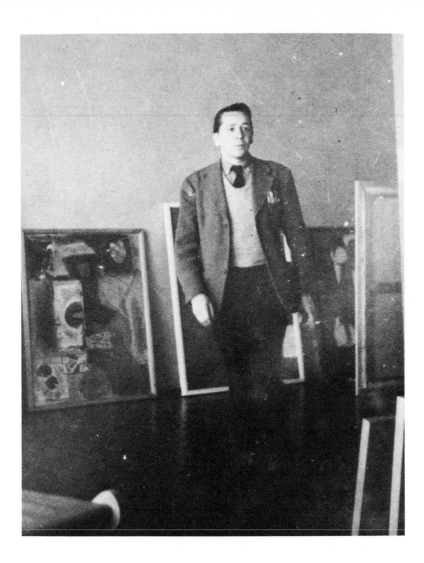

23. William Baziotes at Peggy Guggenheim's Art of This Century Gallery where he had his first one-man show in 1944. Photo: courtesy Mrs William Baziotes

of eminent emigrés to New York from Europe, partly because the moment was natural for a grand rapprochement, and partly, of course, because everyone who had so gaily traveled the international circuit before 1939 was now obliged to stay at home. Peggy Guggenheim's gallery was one of the places that was good to stay in—the nearest thing to a boulevard café, the easiest way for a chance encounter with a 'monument,' be he Mondrian, Ernst, or Breton himself.

If the history of agitated esthetics of the nineteen-thirties is borne in mind, and if it is remembered that Kiesler had flitted from the pages of *Art Front* to the inner sanctum of surrealism, it is not surprising that his design for Peggy Guggenheim's gallery should have been such an eminently talkable event. Barr had long been interested in Kiesler, whose reputation in Europe as a vanguard stage designer as well as theoretical architect was already known to him in the twenties. Guggenheim's only condition was that the pictures should be unframed, and one suspects that this reflects the influence of Sweeney, whose passion for unframed paintings occasioned many comments years later when he was director of the Guggenheim Museum. So the congregation of Kiesler and Peggy Guggenheim's other interested parties was an event that would indeed be a tremendous stimulus in forming a milieu in the broadest sense.

In a narrower sense, the milieu Kiesler provided by inventing a unique gallery was to attract enough attention to encourage the coalescence of various artistic interests. It drew the press as no gallery exhibitions ever had. Reviewers were astounded by a surrealist gallery of curved walls, with paintings mounted on baseball bats that could be tilted at any angle. The cubist gallery consisted of a canvas curtain attached to floor and ceiling by strings and curving around the room; paintings were hung on strings from the ceiling at right angles from the wall and there was Kiesler's famous chair which could be used for seven different purposes. Finally, through a hole in the wall, the reproduction of Duchamp's œuvre could be viewed by cranking what Guggenheim called 'a very spidery locking wheel.'

After this opening coup, featuring her own collection, Peggy Guggenheim showed Joseph Cornell and Duchamp together; then, following Herbert Read's advice, she organized a spring salon, judged by Barr, Sweeney, Soby, Mondrian, Duchamp, Putzel, and herself. According to her, the 'stars' that emerged from it were Jackson Pollock, Robert Motherwell, and Baziotes, to all of whom she would

soon give their first one-man exhibitions. She also mentioned Hofmann, Still, Rothko, Hare, Gottlieb, Sterne, and Reinhardt as 'discoveries.'

Other things were moving. John Graham had organized an international exhibition for the McMillin Gallery in January 1942, in which, among others, he juxtaposed Braque, Bonnard, Matisse, and Modigliani with Pollock, Lee Krasner, Stuart Davis, and, for the first time, de Kooning. Breton and Duchamp organized an exhibition called 'The First Papers of Surrealism,' which opened at the Whitelaw-Reid Mansion in October 1942, and for which Duchamp created a lure to the press in the form of six miles of white string crisscrossing paintings and room-openings. Again Europeans of great renown such as Picasso, Miró, and Arp shared the space with young local American artists, among them David Hare, Baziotes, Motherwell, and Cornell, and with other foreign artists who were to become an integral part of the New York community such as Matta and Hedda Sterne.

The modifications of surrealist theory that occurred during these years were as much the work of the surrealists themselves as of the resistances and adaptations of the American artists. There were many conditioning factors. One was certainly the long history of American sympathy for Freudian theory and psychoanalysis in general. An artist such as Robert Motherwell, for example, did not need to wait for Freudian parlor games to understand the importance of psychoanalysis; in college he had written an interpretation of Eugene O'Neill in relation to psychoanalytic theory. Others had shown keen interest in Freud during the thirties, and those who were not inclined to read theory were nevertheless aware of psychological theories. The most important book for many artists, at least partially because of its psychological orientation, was Joyce's *Ulysses*, which had long been sacred in the United States in spite of its being legally unavailable until 1934. The orientation of American artists and intellectuals toward psychology was culturally supported when the rise of Hitler brought many analysts—in fact, they were the first emigrés to appear —to the United States. Laura Fermi estimates that about two-thirds of all European psychoanalysts were eventually driven to the United States.[3] She points out that the ground was fertile: both Freud and Jung had lectured in America before World War I, and during the late twenties and early thirties several of Freud's inner circle, including Otto Rank and Sandor Ferenczi, settled in New York. Analysts were welcomed, although those with leftist political

leanings were screened out by the government and refused entry. The list of distinguished analysts who did settle here includes Franz Alexander, Wilhelm Reich, Siegfried Bernfeld, Hanns Sachs, Erich Fromm, Karen Horney, Bruno Bettelheim, and Ernst Kris.

The Freudian doctrine was augmented by numerous other viewpoints, including that of Jung, who found a more ready climate than Freud for his esthetic views in the United States, where there was a puritanical reluctance to grant the libido total creative monopoly. While accepting the importance of automatism as initially Freudian in inspiration, the artists who began to experiment with Matta (among them Baziotes, Motherwell, Gorky, and Pollock) were already instinctively trained toward other horizons—horizons that were existent in Jung's amorphic cosmos rather than in Freud's causal pathology. Jung had the advantage of dealing with works of art as though they were not necessarily symptoms of neurosis and of calling upon the traditions of the East to enrich his vision. For those who, like Gorky, admired Kandinsky, the Jungian psychology of creation was congenial. There are no records of who might have read Jung, although it is certain that Motherwell, who had done graduate work in philosophy at Harvard, had done so. Yet, a resounding emphasis of what Jung called 'primordial art' appeared with increasing frequency in artists' journals and in statements appearing after 1940. More particularly, it was Jung's interpretation of what he called the visionary mode (as opposed to the psychological mode) that seemed to speak through the new developments in art. In the visionary mode, Jung maintained, the experience that furnishes the material for artistic expression is not familiar, as are love or crime situations in the psychological mode.

It is a strange something that derives its existence from the hinterland of man's mind—that suggests the abyss of time separating us from pre-human ages, or evokes a super-human world of contrasting light and darkness. It is a primordial experience which surpasses man's understanding, and to which he is therefore in danger of succumbing . . . the primordial experience rends from top to bottom the curtain upon which is painted the picture of an ordered world, and allows a glimpse into the unfathomed abyss of what has not yet become.[4]

He says that such works positively impose themselves on the author, but yet 'in spite of himself he is forced to recognize that in all this his self is speaking, that his innermost nature is revealing itself, uttering things that he would never have entrusted to his tongue.'

Jung never suggests, as does Freud, that the images which emerge from the unfathomed abyss are interpretable symbols. On the

contrary, he always insists that art is essentially beyond the interpretative power of the analyst. Nor does he favor the automatistic canon of truth. The unconscious can never be the sole source of a work of art:

Recoiling from the unsatisfactory present the yearning of the artist reaches out to that primordial image in the unconscious which is best fitted to *compensate* the insufficiency and one-sidedness of the spirit of the age. The artist seizes this image and in the work of raising it from the deepest unconsciousness he brings it into relation with conscious values, thereby transforming its shape, until it can be accepted by his contemporaries according to their powers.[5]

Jung's insistence on the relation of conscious values to the materials of the unconscious represented one of the hidden modifications that surrealism underwent when it was transferred to the New World. The minor heresies that were springing up found many responses from American artists, who were never wholly comfortable with the uninhibited exploitation of the unconscious. Even Breton himself was susceptible to the new trends. Although the magazines that were influenced by him, especially *View*, continued to discuss the orthodox surrealist propositions, there were allusions to other sources. The repeated conjuration of Nietzsche, for instance, whose dual Apollonian–Dionysian position looked more and more interesting as the world moved into the nineteen-forties, was a measure of the spiritual restlessness. Breton's favored protégés were also deviating from the established lines of discourse. Irving Sandler has pointed out that when Gordon Onslow Ford delivered lectures (attended by Gorky, Baziotes, Hare, and Jimmy Ernst among others) at the New School for Social Research in the winter of 1941, he cited Matta for having developed the possibilities opened up by Tanguy in his 'psychological morphologies.'[6] Matta's morphologies were certainly far removed from the reproduction of the dream envisioned by Breton. He had developed more directly from the abstract visionary tradition of Kandinsky, using the same radial vision of space without vanishing points that Kandinsky had been the first to propose. His effort to relate the non-Euclidian space 'by which we could refer to the number of constants and variables which are in an event' put painting on a different plane than the fusion of dream and reality proposed by Breton. There was a rational substructure in Matta's approach that defied the surrealist reverence for the irrational, and that provided his American colleagues with the 'meaning' their tradition inevitably demanded.

One of the most curious modifications produced by contact with the New World occurred in the attitude of Wolfgang Paalen, who like

Matta had been one of the last to be praised by Breton in *Minotaure*. Paalen, whose background was broad, and who had not only studied with Hofmann in Germany but had also been a respected member of the Abstraction-Création group, left Paris in May 1939. His first move was to travel to Alaska and Canada, where he sought out the remains of the Indian art so highly regarded by the French surrealists during the thirties. Paalen's conscientious studies of the totemic origins of Pacific Northwest art were highly respected, even by anthropologists. In the fall of 1939 he settled in Mexico, where he began organizing an international surrealist exhibition. In 1940 he had his first one-man show in New York, at the Julien Levy Gallery where he again met Matta and some of the American painters. There, he first began to question his allegiance to surrealism. And in this, significantly, he was assisted by his discovery of the philosophy of John Dewey. Paalen's exposure to modern American philosophy, which traditionally emphasized reason and took a pragmatic view quite alien to the *pronunciamento* tone of the surrealists, brought him to a position that had some points in common with Jung but little with Breton's Freud. 'The dream,' he wrote in December 1941,

egoistically preoccupied with satisfying individual desire, usually remains without collective importance even when using universal symbols—while artistic creation, using symbols personally, attains collective importance when it succeeds in formulating what inspiration reveals in the depths of the ego—there where 'I is another.'[7]

This is, though he doesn't mention Jung, a clear transposition of Jung's ideas. Paalen's suggestion that art and science must be more closely examined was of interest to other young artists because it removed the excessive accent on irrationalism. He claimed that it was false to try to poeticize science, which was surrealist error, and equally false to try to make a scientific art, which was the error of the abstractionists. He proposed instead a rather vague cosmological approach that would bypass myths and somehow represent creatively the way the world now looked as a result of new scientific observations: 'Between the abysses of the incommensurably great and the incommensurably small which science has opened, we are lost if we do not succeed in finding the true dimension of men.'

In 1941, Motherwell, who had been studying engraving with another surrealist student of the lore and magic of science, Kurt Seligmann, left with Matta for Mexico. The two of them spent a great deal of time with Paalen, and Motherwell became interested in Paalen's theories. Motherwell's own catholicism in relation to painting

enabled him to transmute the automatistic exercises that he had undertaken with Matta into a much looser attitude that corresponded to free association. He would have certainly been drawn to Paalen's exposition of the new position; their harmony is attested by the fact that when Paalen founded his magazine *Dyn* (based on the Greek word *Dynaton* meaning 'the possible') in 1942, Motherwell's work was frequently reproduced, and he later contributed one of its most important articles. When Motherwell returned to New York he continued discussions with Baziotes, and sometimes with Pollock, on the emergent post-surrealist ideas.

Other discussions were beginning to bear visible fruit. Rothko, Gottlieb, Newman, and others had been ruminating on similar lines. Gottlieb, who later said the situation was so bad he would have tried anything, no matter how absurd, took his courage in his hands and painted his first 'pictograph' in 1941. It was on the Oedipus theme, which was a general favorite of the surrealists—and one with which he and Rothko had been preoccupied for a couple of years. From classical Greece, Gottlieb plunged immediately into Pacific Indian lore, painting a familiar condensation of the symbol he and the others had been quick to notice in the journals documenting the Pacific Northwest. Pollock was working out his own version of primordial symbolism with similar allusions to primitive sources, in a painting such as *Male and Female*, 1942. Rothko was edging toward his first aquatic, oneiric images; while Baziotes was exploring the non-Euclidian spaces proposed by Onslow Ford, Matta, and Paalen.

They, and many other artists as well, found themselves more open to a worldly view just as the world seemed to be hurtling to disaster, and just as the Europe they both loved and hated was cut off from them. In 1940 another artists' group was organized, the American Federation of Modern Painters and Sculptors, which announced: 'We condemn artistic nationalism which negates the world tradition of art at the base of modern art movements.' For its third annual exhibition in June 1943, the Federation reasserted its internationalist stance, quoting Kant to the effect that the purpose of existence is the development of consciousness and exhorting the public to acknowledge that art is the most deeply conscious of all human expressions and 'therefore the truest measure of a nation's development.' Now that America was recognized 'as the center where art and artists of all the world meet, it is time for us to accept cultural values on a truly global plane.' Members of the Federation at the time included Milton Avery, George Constant, Herbert Ferber, John Graham,

Balcomb Greene, Adolph Gottlieb, Louis Harris, Marcus (Mark) Rothko, Joseph Stella, Bradley Walker Tomlin, and Ossip Zadkine.

With the advent of this exhibition, three of those members were to make modest history. As a result of a lengthy and somewhat derogatory discussion of the exhibition in *The New York Times*, Adolph Gottlieb and Mark Rothko, with the help of Barnett Newman, wrote a letter to its art editor, Edward Alden Jewell; it was the opening salvo of a long-term fusillade. The New York artists had found their voice and proceeded to become almost as voluble as their European contemporaries. The letter, dated June 7, 1943, begins with a sarcastic reference to Jewell's public confession of his 'befuddlement,' and then announces that the artists do not intend to defend their pictures, which they consider clear statements: 'Your failure to dismiss or disparage them is *prima facie* evidence that they carry some communicative power.'

We refuse to defend them not because we cannot [they go on]. . . . It is an easy matter to explain to the befuddled that 'The Rape of Persephone' is a poetic expression of the essence of the myth; the presentation of the concept of seed and its earth with all its brutal implications; the impact of elemental truth. . . .

It is just as easy to explain 'The Syrian Bull' as a new interpretation of an archaic image, involving unprecedented distortions. Since art is timeless, the significant retention of a symbol, no matter how archaic, has as full validity today as the archaic symbol had then. Or is the one 3000 years old truer?

But these easy program notes can help only the simpleminded. No possible set of notes can explain our paintings. Their explanation must come out of a consummated experience between picture and onlooker. The appreciation of art is a true marriage of minds. And in art, as in marriage, lack of consummation is grounds for annulment.

The point at issue, it seems to us, is not an 'explanation' of the paintings but whether the intrinsic ideas carried within the frames of these pictures have significance.

In this early section of the letter a new tone of confidence, a jaunty asperity, indicates the growing sense of importance the artists in New York felt. In the subsequent paragraph, frequently cited as one of the important early documents in the development of abstract expressionism, the writers outline a few of their esthetic beliefs —indicating again an assurance that had certainly not existed when Gottlieb described the despair of 1940. The program, as they outlined it, has several telling passages which indicate the degree to which many members of the New York milieu had assimilated the leading ideas of the surrealists. It mentions the importance of risk, defending the

irrational and alluding to the primitive and archaic. But the divergence from surrealist theory is also notable, and presents the essential development away from European prototypes:

1. To us art is an adventure into an unknown world, which can be explored only by those willing to take risks.
2. This world of the imagination is fancy-free and violently opposed to common sense.
3. It is our function as artists to make the spectator see the world our way —not his way.
4. We favor the simple expression of the complex thought. We are for the large shape because it has the impact of the unequivocal. We wish to reassert the picture plane. We are for flat forms because they destroy illusion and reveal truth.
5. It is a widely accepted notion among painters that it does not matter what one paints as long as it is well painted. This is the essence of academicism. There is no such thing as good painting about nothing. We assert that the subject is crucial and only that subject matter is valid which is tragic and timeless. That is why we profess spiritual kinship with primitives and archaic art.

Consequently if our work embodies those beliefs, it must insult anyone who is spiritually attuned to interior decoration; pictures for the home; pictures over the mantle; pictures of the American scene; social pictures; purity in art; prize-winning potboilers; the National Academy; the Whitney Academy; the Corn Belt Academy; buckeyes, trite tripe; etc.

The fusion of modern impulses this letter represents was an accurate gauge of developments in New York. While these artists reject formal surrealist ideas, including that of non-Euclidian spaces (in their assertion of the picture plane they remain true to the Hofmann school of thought and to the cubist tradition), they accept the philosophical implications of non-linear thought and all that is 'timeless.' While they scorn purist art, they favor the simple expression of the large thought. And, though they deride representational modes, they nevertheless insist that to be good a painting must have a subject, a view very much in keeping with their own tradition, which had never embraced the sensuous self-justification of a work of art and always sought a more profound meaning to justify the existence of the artist in society.

Gottlieb recalls that the letter was drafted with Barnett Newman, whom he thinks wrote the first few paragraphs. The exuberantly defiant tone of the early paragraphs certainly support Gottlieb's recollection, for Newman was at that period emerging as theorist for the new tendencies in the paintings of Gottlieb and Rothko. The references to archaic art and to the classical myths reflect Newman's

interests. A few months later Gottlieb and Rothko reiterated their principles in a public broadcast over the municipal radio station on October 13, 1943. They reasserted their strong interest in archaism and again broached the Jungian notion of the collective symbol. Rothko's contribution also suggests that he might have been inspired by Nietzsche's *Birth of Tragedy*, especially when he refers to the archaic Greeks who 'used as their models the inner visions they had of their gods.' The artist's real model, he added, is 'an ideal which embraces all of the human drama.'

If our titles recall the known myths of antiquity, we have used them again because they are eternal symbols. . . . They are the symbols of man's primitive fears and motivations, no matter in which land, at what time, changing only in detail but never in substance.

Even more Nietzschean is his belief in the 'primeval and atavistic roots of the idea rather than their graceful classical version,' and the pessimism in the following:

Those who think that the world of today is more gentle and graceful than the primeval and predatory passions from which these myths spring, are either not aware of reality or do not wish to see it in art.

Gottlieb reinforced Rothko by suggesting that the emphasis on the mechanics of picture-making had been carried far enough. He makes clear the reservations he and his associates had about the surrealists who, he said, have asserted their belief in subject matter but only to illustrate dreams, which for the New York painters was not enough: 'While modern art got its first impetus thru discovering the forms of primitive art, we feel that its true significance lies not merely in formal arrangements, but in the spiritual meaning underlying all archaic works.'

Gottlieb concluded by expressing the abiding malaise of the New York painter who had, through historic circumstance and local tradition, struggled with the problem of the collective aspiration versus his individual salvation. Once again the masses are acknowledged, but this time they are seen as victims of the violence of their time whose feelings can be expressed only through a symbolic art with a subject matter. The conscience of the artist, as it developed during the thirties, was not able to accept what he called niceties of color and form in the face of the terrors rampant in the modern world. He tells of primitive expression that reveals the constant awareness of powerful forces, the immediate presence of terror and fear, and he insists that 'an art that glosses over or evades these feelings is superficial or meaningless.'

26. Theodoros Stamos was one of the youngest members of the
New York School when he exhibited 'Echo' in 1948. Courtesy
Metropolitan Museum of Art, Arthur H. Hearn Fund, 1950

OPPOSITE Betty Parsons opened her gallery in 1946 with
an exhibition of Northwest Coast Indian art selected
by her and Barnett Newman, who wrote the foreword.

ABOVE (24) Double-faced wolf mask, Kwakiutl, from
Vancouver Island.

BELOW (25) Alaskan Tlingit robe of Shaman.

The distinct ethical bias revealed in the various statements of Rothko and Gottlieb in 1943 was characteristic of many abstract expressionists during the early forties. Later, when Barnett Newman busied himself with publicizing the attitudes of his friends, we find his rhetoric filled with philosophic and moral allusions. His diction provides an index not only to the preoccupations of the older Europeans (for many of Newman's favorite themes had been well explored in the French art journals of the late twenties and thirties) but also of the way Americans skewed and emphasized certain notions in an idiosyncratic way. Like Breton, Newman was a moralist whose primary interest was to find the appropriate means to bring about a total crisis of consciousness. His path was always circuitous, leading now toward philosophical anarchism, now toward practical political action, now toward exalted philosophic speculation, now toward flat, hard-nosed logic. His volatility was of great service to the artists' community, for they too shifted and feinted to avoid association with a fixed esthetic theory.

Newman began his public proselytizing in 1944 with a catalogue introduction to Gottlieb's exhibition at the Wakefield Gallery, and he followed that up with an important text for an exhibition he himself had assembled in 1946 for the new Betty Parsons Gallery. The show, entitled 'Northwest Coast Indian Painting,' was designed to bring out the ritualistic aspect of primitive painting and, above all, its tendency to abstraction. It suited Newman's needs to adapt Worringer's theory of primitive abstraction to the exhibition, which was in itself a polemic to illustrate Newman's opening sentence;

It is becoming more and more apparent that to understand modern art, one must have an appreciation of the primitive arts, for just as modern art stands as an island of revolt in the stream of Western European estheticism the many primitive art traditions stand apart as authentic esthetic accomplishments that flourished without the benefit of European history.

Newman goes on to say, somewhat disingenuously, that the art of the Northwest Coast Indian, if known at all, is invariably understood in terms of the totem pole. The fact was that many aspects of Pacific Northwest Indian art had been broadly discussed for some years, and that the Museum of the American Indian was well frequented, particularly by the surrealists who came from Europe. Surely the artists in New York had been exposed, by one means or another, to the implications of the indigenous Indian arts? Newman did, however, critically emphasize the traditions in which Indians 'depicted their mythological gods and totemic monsters in abstract symbols, using

organic shapes, without regard to the contours of appearance.' And he used the show as a vehicle for his propagation of modern art, or at least those among the modern artists of whom he approved:

Does not this work rather illuminate the work of those of our modern American abstract artists who, working with the more plastic language we call abstract, are infusing it with intellectual and emotional content and who, without any imitation of primitive symbols are creating a living myth for us in our own time?

Several months later Newman wrote another introductory essay for a show at Betty Parsons. 'The Ideographic Picture,' January 20 to February 8, 1947, featured paintings by Hans Hofmann, Pietro Lazzari, Boris Margo, B. B. Newman, Ad Reinhardt, Mark Rothko, Theodoros Stamos, and Clyfford Still. His introduction began by immediately conjuring up a Kwakiutl artist painting on hide, an artist unconcerned with the 'meaningless materialism of design.' This artist, like Newman's friends, was wielding abstract shapes because he was directed by a 'will toward metaphysical under-standing.' Invoking the Worringer theory, Newman suggested that to the Kwakiutl artist a shape was a living thing, 'a vehicle for an abstract thought-complex, a carrier of the awesome feelings he felt before the terror of the unknowable.' This, he said, constituted the ideographic idea, and he offered a dictionary definition of the ideograph as 'a character, symbol, or figure which suggests the idea of an object without expressing its name.' His rhapsodic, metaphysical impulse was reflected in his choice of language, such as when he spoke of 'the idea-complex that makes contact with mystery—of life, of men, of nature, of the hard, black chaos that is death, or the grayer softer chaos that is tragedy.' The exalted tone is extended, a month later, in his introduction to Theodoros Stamos' show. Stamos' ideo-graphs, he felt,

capture the moment of totemic affinity with the rock and the mushroom, the crayfish and the seaweed. . . . Stamos is able to catch not only the glow of the object in all its splendor, but its inner life with all its dramatic implications of terror and mystery. . . .

Up to this point, then, in 1947, the heavy aura cast by surrealism still touched the thoughts of several of New York's major younger painters who, by shifting the emphases, were in the process of developing quite other intentions.

American culture or mass culture?

In many ways the existence of surrealist theory provided a shelter for the painters. In 1940 the causes of consternation had considerably altered for the literary intellectual who, newly alienated from politics, found other snares awaiting him. Painters, especially those whose consciousness had been invaded by the surrealist periodicals, had retreated from political turmoil. While the literary course seemed to be set in critical and often doctrinaire directions in the early forties, the visual artists were pronouncedly undoctrinaire and eager to retain an attitude of experimental rebellion—again, theirs was a rhetoric of no rhetoric.

One of the peculiar aspects of traditional American culture had been the total isolation of the different arts. American artists noted early in the century that, unlike artists on the Continent, they had no literary companions. The lack of poetic voices that did so much to stimulate and advertise the School of Paris was keenly felt in New York. It was a situation that was to be rectified by the infusion of poetry from the surrealist sensibility. In September 1940, the first copy of *View* carried a group of maxims by Wallace Stevens, the one American poet with whom the artists could identify, which was largely because he was the only poet who could identify with them. Unlike most of his contemporaries, Stevens had accepted the French traditions that made the poet the natural ally of the painter. Throughout his poetry and criticism, he alluded to the art of the painter as equal to his own and—more important—as springing from the same imaginative sources. Painters, who often saw themselves somewhat as their society saw them—as useless and craft-ridden supernumeraries to real culture—were given a measure of self-esteem in the deference paid them by this poet.

Stevens' maxim number XIX in *Materia Poetica* states his conviction: 'To a large extent, the problems of poets are the problems of painters, and poets must often turn to the literature of painting for a discussion of their own problems.' Among other maxims in that first issue of *View* was number XXII, in which he states, 'Not all objects are equal. The vice of imagism was that it did not recognize this.' Stevens proved his good faith by turning, in 1942, to the literature of painting for a discussion of his own problems, focusing very sensitively on the words of Cézanne. His lectures in the nineteen-forties were liberally threaded with allusions to the literature of painting and to painting itself, for the thrust of his argument was that imagination must not give way before the onslaughts of those blindly wedded to reason. In painting he could isolate those inexpressible aspects of imagination (what Cézanne called 'primary force') that illustrated his poetics. While what he called 'the pressure of reality' was the determining factor in the artistic character of an individual, he nonetheless maintained that unreality (of which Klee, Kandinsky, and even Mondrian had so often spoken) was an essential ingredient in the work of art. By maintaining the Latin tradition in which connotative language was supreme, and in which the romantics such as Baudelaire and Rimbaud figured highly, Stevens was set apart from many of his poetic colleagues and could begin the rapprochement with the painters that was so necessary to the evolution of American art. His essay of 1943, 'The Figure of the Youth as Virile Poet,' concludes with the virile poet in contemplation, 'thinking of those facts of experience of which all of us have thought and which all of us have felt with such intensity'; he soliloquizes:

Inexplicable sister of the Minotaur, enigma and mask, although I am part of what is real, hear me and recognize me as part of the unreal. I am the truth but the truth of that imagination or life in which with unfamiliar motion and manner you guide me in those exchanges of speech in which your words are mine, mine yours.[1]

Stevens' unflagging faith in the romantic imagination, tempered by his acknowledgment of 'the drift of incidents' in everyday life, matched the mood of the artists, who never quite settled into the extravagant irrationalism of French surrealist orthodoxy, but never quite relinquished their faith in imagination as salvation. Their turning to romantic poets in the Anglo-Saxon tradition was one indication of the broadening of the surrealist base when it removed to the United States. When, for example, Matta had an exhibition in April of 1940, Nicolas Calas, who was soon to become a vivacious

commentator in *View*, wrote a newspaper-like catalog which he opened with a quotation from Shelley's *Prometheus Bound*:

Ten thousand involving and involved
Purple and azure, white, green, golden
Sphere within sphere; and every space between
Peopled with unimaginable shapes.

Even T. S. Eliot, whose 'Waste Land' had loomed large over English and American letters, but whose profession of Anglo-Catholicism and Royalism had furnished many critical excuses to turn away from his 'Ash Wednesday,' came in for reconsideration. The allegorical content was re-examined, and as the decade grew somber with war, the dark figures of speech were welcomed for their mood rather than their context. This new reading of Eliot no longer took him to task for his traditionalism, but found the unexampled fecundity of his imagination totally justified. While the New Criticism promised to rid critical writing on poetry of biography, metaphysic, mysticism, impressionism, and magic, the poetry increasingly reflected a rejection of critical rationalism.

The intuitive, darkling side of the imagination was admired by many, including W. H. Auden, who had settled in New York late in 1939 because, as he told an interviewer, he was attracted by the 'openness and lack of tradition of America.'[2] In New York, he said, you are forced to live as everyone else will be forced to live. 'There is no past. No tradition. No roots.' Auden dispossessed himself of literary company, of his tradition which had included a brief Marxist period in the thirties, and he turned his thoughts increasingly to distant legend and to the great intuitive master, William Blake. In fact, the resurrection of Blake was to be very important during the forties, as Auden well understood. His Blakean vision of diabolism in a modern context was appropriately titled 'The Age of Anxiety'; the reference to Kierkegaard is obvious. Auden was one of the first of the Anglo-Saxon poets to sound the existentialist note and to sustain it in the long, pessimistic poems that appeared in America in the early years of the war.

The stirrings of the elemental poets, whose faith in the deepest sources of consciousness moved them away from English classicism toward the myth and magic of Yeats, became increasingly evident at this time. Blake, Donne, and Coleridge, the French symbolists, Poe, and above all Yeats, were acknowledged by such poets as Theodore Roethke, Stanley Kunitz, and many others. Kunitz claimed that 'poetry is not concerned with communication; it has its roots in

magic, incantation, and spell-casting,' and he cited Blake, Milton, Hopkins, Baudelaire, Rimbaud, and Yeats as his witnesses. It is significant that both he and Roethke acknowledged the Jungian viewpoint. Kunitz later became intimate with a number of New York School painters who had traveled the same spiritual route.

Even more emphatic was the attitude of Allen Tate who, like Eliot and Auden, turned for solace to the theological framework, and in the early forties began to proclaim the supremacy of the imagination, as well as the importance of communion rather than communication. To commune with the great and tragic past, with the immemorial human drama, with matter and time personified, seemed to many in those early years of the war, the only respectable function of the poet and of the painter. At the same time the painters seemed to have a more open field. The world of letters was, on the whole, turning away from experimental modes, despite the few who strove for magic and mystery. When Granville Hicks summarized the nineteen-thirties, during which he had been editor of *The New Masses*, he speculated that in the following decade there would be a considerable interest in estheticism and mysticism.[3] Writing in 1940, he predicted that 'some sort of aristocratic, authoritarian doctrine' would overtake the intellectuals. He cited an article by Louise Bogan in which she called for 'pure writing . . . [in] the purely formal and delight-giving manifestations of language.' Her call was heeded in many instances, and Hicks had been accurate in his prediction. But then men of letters in New York, with few exceptions, had not been influenced by continental Europe, only by the motherland of England. The art world had had a different experience.

Artists and writers shared, however, the engulfing sense of isolation induced by the war. Some writers, and some artists too, saw a clear epoch ahead heralding the coming of age of America. John Peale Bishop, a highly respected poet who had been the managing editor of *Vanity Fair* and who was deeply versed in European culture, delivered a lecture at Kenyon College in 1941 in which he suggested that the new center of culture would have to be the United States. He offered the exhilarating hope that the emigrés would enrich America, and be enriched by her, and that America would at last deepen its commitment to culture generally. Bishop did not take a chauvinist view. Rather, he said that 'the presence amongst us of these European scholars, artists, composers is a fact,' one that might be as significant for Americans as the coming to Italy of the Byzantine scholars after the sack of their capital by the Turks:

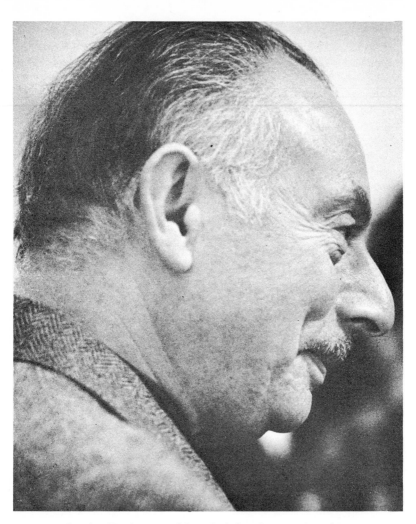

27. Stanley Kunitz, one of America's best known poets, became friendly with many artists—among them Rothko, Kline, Tworkov—during the years of rapprochement in the nineteen-fifties.

The comparison is worth pondering. As far as I know, the Byzantine exiles did little on their own account after coming to Italy. But for the Italians their presence, the knowledge they brought with them, were enormously fecundating. Cut off from Europe, Americans have been turned as never before to their own resources. . . . There is a richness in America of which none can see the end.[4]

(Bishop's prophesy was amply justified in the following years. When Richard Howard wrote his massive analysis of the art of poetry after 1950, he called it *Alone with America*. Implicit in his title is the renunciation, *force majeur*, of the great Anglo-Saxon tradition, and the desire, so characteristic of his generation, 'to lose the gift of order' which they had inherited from that tradition.)

But Bishop also exhorted his listeners to remember that no matter how much they might henceforward be fascinated by the particularity of their own heritage, they would have to remember that they, as part of the West, shared a wider heritage. In the years to come that heritage—a source of both inspiration and resentment—was to become for many artists a bone that stuck in the throat. When carried to extremes, the will to get out from under resulted in a retreat from both traditions. The burgeoning interest in the East, and the Jungian withdrawal to the immemorial were both clearly symptoms of exasperation with the constant turmoil within the larger heritage.

The older European cultural tradition, Bishop's larger heritage, had been imported by scores of emigrés, and had already, by 1940, become a source both of nourishment and of conflict. Bishop's predictions were to prove largely correct. The very presence of so many august figures in the history of the arts was a fecund influence. But it was also provocative, spurring the unconscious competitive drive in many Americans, and reinforcing their self-protective chauvinism. (Pollock, for instance, always stoutly maintained his reverence for the masters of the French school, but frequently told his intimates that he would 'show them.' The same ambivalence has been reported of de Kooning and others.)

Besides the psychoanalysts, who began moving in when first Hitler showed his fist, a great many professional artists and scholars had fanned out over America during the thirties and early forties. Their presence in the colleges and universities provided an incalculable impetus toward the generation of a sound culture. Sometimes there was an accidental concordance of interests which merged into strong currents affecting the reception of the arts. It is of significance, for instance, that whereas in Europe the phenomenologists and

metaphysicians had enjoyed a resurgence (the first existentialist wave that caught up Sartre and Simone de Beauvoir in the thirties), in the United States quite another branch of philosophy was given force by the presence of European teachers. Logical positivism took deep roots soon after the arrival in 1936 of Rudolf Carnap, who lectured at the University of Chicago until 1954. In view of the earlier influence of James and Dewey, it is not surprising that Carnap and the other positivists had such a strong impact. Laura Fermi quotes Joergen Joergenson's description of the logical positivist movement as 'an expression of a need for the clarification of the foundations and meaning of knowledge,' in order to make philosophy 'scientifically tenable through critical analysis of details rather than to make it universal by vague generalizations and dogmatic construction of systems.'[5] Such aims were at odds with the growing interest in myth and metaphysics, at least among artists and poets, and once again cut off the artist from a source of spiritual support. Not until after 1960 were the methods of the positivists to find widespread support among artists. The pragmatic bias of American philosophy never really permitted the growth of speculative metaphysics, as Simone de Beauvoir was to remark when she toured American universities in the late forties. Metaphysics, she noted, hardly existed at all, and when she spoke with students they doggedly resisted speculation.[6] Like the absence of the poets' voices among the artists, the absence of speculative philosophy was keenly felt; later in the decade it was to be positively, if awkwardly, taken into the discourse of the artists, who could no longer tolerate their lean traditions.

In the other arts, these years saw the fruits of long gestation, particularly in music. The avant-garde Europeans had begun early in the century to take advantage of the potentially enormous audience in America. One of the first to arrive was Edgar Varèse in 1915, and he was followed by a host of European and Russian masters, most of whom settled down in American universities and introduced generations of students to previously unfamiliar standards. Certain disciplines, such as musicology, were absolutely unknown; in 1930, when Curt Sachs took the chair of musicology at New York University, it was the first post of its kind anywhere in the country. He was followed soon after by the other great European musicologist, Alfred Einstein, who went to Smith College. Among composers, Arnold Schoenberg came to the University of California in 1933, to be followed by Ernst Krenek; Darius Milhaud went to Mills, and Hindemith to Yale. Their vigorous pedagogy quickly resulted in new

enterprize among their American hosts, and a music public had developed very rapidly by the time World War II broke out. This public had been partly prepared for by the activities of the Federal projects, which brought serious music into the hinterlands for the first time, and in which musicians, like painters, had considerable freedom to develop knowledge and taste.

Of course, the growth of a public for all the arts, especially for the performing arts, was stimulated naturally by the war economy. Art forms that had previously enjoyed only limited audiences drawn from the so-called educated classes found a public that was open and eager for just about any kind of artistic contribution. The effect of war-economy prosperity was most marked in the development of the dance. Classical ballet had already had a long history in the United States thanks to the intrepid Diaghilev, and since World War I Russian and European touring companies had played to audiences in many American cities. Ballet was accepted without question as a form of higher culture (as was opera—households that possessed neither books nor pictures often had Enrico Caruso records). But it was tacitly assumed that the classical ballet was something from 'over there,' never to become a native possession; girls who dreamed of becoming ballerinas assumed they would go abroad to study. It wasn't until Lincoln Kirstein succeeded in establishing the School of American Ballet in 1934 that there was any hope of native development on any scale. Kirstein deliberately announced his intention to 'provide adequate material for the growth of a new national art in America.'[7] To this end he provided the school with George Balanchine, who began training the students in the most rigorous Russian tradition. Attempts to produce an 'American' ballet were, at first, less than satisfactory. As Edwin Denby said in an interview with the author, everyone was in favor of the idea, but until the nineteen-forties, 'we all knew that the young Americans weren't the best and we couldn't forget it.'

However, thanks to the war-time public, which had money to attend the performances and which was relatively unprejudiced, the development of a native ballet progressed rapidly during the forties. Denby, who was the critic for *The New York Herald Tribune* from 1942 to 1945, estimates that the public for the ballet doubled during those years. That public consisted of the old cognoscenti, who wanted European-style ballet and resisted experiment, and the new untutored audiences that seemed ready to applaud anything. Denby himself, a critic of simplicity, tremendous sensibility, and high

standards, resisted the American dancers for some time, but eventually became their warmest admirer and certainly the only enlightened voice among the critics. By 1947 he could praise the 'charming figures, the long legs of American girls,' and say that 'in any kind of dancing a bunch of young Americans do together they are likely to show a steadier and keener sense of beat and a clearer carriage of the body than Europeans would. . . .'[8] He could even refer to an American ballet style:

Large, clear, accurate and unaffected our ballet style looks—and particularly among the slender young girls remarkable for speed, toes, and prowess; its phrasing is not very personal . . .

George Amberg, who wrote the first comprehensive book specifically about American ballet, agrees with Denby that the war was a decisive factor:

It is certain that the contemporary American ballet owes its prodigious growth, its solid reputation, and its immense popularity to the situation created by the war. Isolated from the rest of the world, entirely reduced to its own sources and resources, our ballet was suddenly submitted to the decisive test.[9]

Perhaps even more significant than the development of an American classical ballet was the firm status won during the war and after it by the exponents of the modern dance. Since Isadora Duncan there had been a small but very intense group of artists and devotees to the modern tradition, but they always worked under the most tenuous economic circumstances and with little support from the general public or the popular press. They were largely identified with the bohemian tradition of the twenties and were the victims of numerous sneering jokes throughout the next twenty years (my own father used to laugh at what he called Martha Graham and her six little crackers). All the same, the modern dance tradition took root, mainly due to the intense personality of Martha Graham. Girls who emerged from upper middle-class families and went to school with Graham, either at Bennington during the late thirties, or later in New York, became powerful converts. When they entered adult society, they helped to create a newly receptive atmosphere which in the late forties brought Martha Graham international fame. Her history closely parallels the careers of several poets, painters, and sculptors in the United States. She absorbed the main theories of the Europeans Laban and Wigman, but always sought to articulate what she considered to be American rhythms, tempi, and psyche. She early felt the need to work in the

idioms of the American continent, seeking in the literature of the puritan culture (she drew on both Hawthorne and Emily Dickinson), as well as in the authentic native traditions of the American Indian, some key to the American psyche. She was one of the first to see the expressive beauty of the Southwest Indian rituals, which she commemorated first in 1931 in 'Primitive Mysteries,' and later in one of her most famous pieces, 'El Penitente' (in which her most notable student, Merce Cunningham, danced the Christ figure), presented in 1940.

A child of her generation, Martha Graham never ceased to believe in the supremacy of the psychological verities. Nonetheless, she too was affected by 'the drift of incidents' in the thirties, and toward 1935 turned her attention to the sturdier American traditions, in much the same way as the regionalist painters had done. Engaging the sculptor Isamu Noguchi to provide a working decor, she presented in 1935 'Frontier—An American Perspective of the Plains,' in which she portrayed the strength and power of the pioneer woman. Similar motifs were expressed again the following year, when she danced 'Horizons' in a setting of mobiles by Alexander Calder. And in 1940, when the search for American roots was converted into an adamant defense of America in light of the war, she presented 'American Document,' complete with a simple, somewhat naïve patriotic text. This she took on a transcontinental tour and for the first time won converts outside New York.

But her staunchest supporters were in New York. From the early thirties her performances there were always crowded with artists from every field, and often painters and sculptors were her strongest defenders. Every account of the sensational New York openings mentions the large number of artists in the audience. In 1944, in fact, it was a group of artists who combined with some actors to subsidize her first one-week Broadway debut. (This tradition has persisted; until recently, Merce Cunningham was often subsidized by the community of artists.)

After exploring American themes Graham, like so many painters, turned back to myth and ritual. During the war years, the brooding introspective quality of her scores indicated her interest in a Jungian vision of the universe, and her work obviously had a rapport with the direction the artists were taking. Of 'Dark Meadow,' for instance, she said: 'It stems back to our remote ancestry, going into the barbaric, the primitive, the roots of life, coming out of racial memory. It is concerned with the psychological background of mankind.'[10]

28. Isamu Noguchi's set for 'Voyage' was designed for Martha Graham in 1953, who later used the same set for 'Circe.' Photo: courtesy Isamu Noguchi

And in a statement of 1947,[11] she cited Picasso who, she said, thought that a portrait should not be a physical or spiritual likeness, but rather a psychological likeness. It is not impossible that she too had been captivated by Picasso's evocation of the Minotaur and other Greek myths, for it was only after Picasso's renowned exploration of the ancient netherworld in the late thirties that she began to deal with such themes as the Minotaur, Medea, and Oedipus.

Her Minotaur paraphrase was, in fact, a singular artistic occasion in New York. Noguchi created for it one of his most original settings, using a white ribbon, which snaked across the upper spaces of the stage and trailed to the floor, to suggest Theseus' thread. The use of these flexible, linear props was extended to the Oedipus story, called 'Night Journey,' in which Noguchi used a thick white rope to

symbolize the complicated intertwinings of the tragic lives in the legend. Graham's increasingly visible presence in the New York culture of the war period was one indication of the swiftly broadening horizons for the avant-garde artists. When Denby reviewed the first of her psychoanalytic journeys, 'Deaths and Entrances,' produced at the Ziegfeld Theater in December 1943, he remarked that he had rarely seen such animated lobby discussion as he did on the two occasions it was performed. This was all the more surprising since 'the piece is a harsh one; it has neither a touching story, nor a harmonious development, nor wit and charm to help it along.'[12] What it did have, Denby felt, was 'the rapid succession of curiously expressive and unforeseen bursts of gesture. . . .' He correctly saw that Graham had recaptured romantic fervor in reinventing gestures which, as he said, were shocking in their extreme originality. It is of interest, recalling Denby's response in 1944, to remember that at that time he was already an intimate of Willem de Kooning and was familiar with Pollock. The emphasis on original gesture, harsh and without charm, divested of pretty stories, was at that moment considered to be highly desirable in painting. The dark violence of myth, or at least the evocation of the terrible drama of human history, whether abstract or directly allusive, was salient in the works of many artists, from Stevens' plea to the sister of the Minotaur to Rothko's preoccupation with the Oedipus myth, Pollock's absorption in the Jungian interpretation of the psyche, and Martha Graham's probing psychoanalytic scores.

Through the accidental circumstance of war, these invocations of the Nietzschean universe found many new avenues of release, as did many other hangovers from the preceding decade. War prosperity encouraged a consumer mentality, and entrepreneurs in the arts and business became legion. Some chroniclers have pointed out that certain consumer goods and services were in short ration during the war, forcing a good deal of energy in the direction of the arts. Certainly many business organizations, such as the Container Corporation of America, augmented their activities as sponsors and patrons. Even the great department store, Macy's, found space for a large exhibition of what they called 'living' American art, which was selected by Sam Kootz, who had recently published his *Modern American Painters*. In Macy's press release, dated December 31, 1941, the exhibition was said to reflect a number of pronounced trends in American painting, among them abstraction, expressionism, surrealism, primitivism, realism, and something called texturism.

This was all posed with the end in view of contributing to a 'better understanding of our native work.' And, significantly, 'in line with Macy's established policy,' the prices were as 'rock-bottom as possible.' This claim was justified, for the prices of the paintings ranged from $24.97 to $249.00. The show included among its 179 works two paintings by Rothko, entitled *Oedipus* and *Antigone*, for less than $200 each, several works by Avery ranging from $49.75 to $124, and equally moderately priced works by Bolotowsky, Holty, George L. K. Morris, and Jean Xceron.

The shift of patronage from the government to industry represented a significant change in social attitudes toward the arts. I have no doubt that the vast government project forced the issue; that the establishment of the arts as legitimate agents in American society during the W.P.A. days alerted industry to their potential use (and perhaps final neutralization). As early as 1937, the Container Corporation, with the wise counsel of Herbert Bayer, began its long career as patron, commissioning works from Léger, Henry Moore, and Ben Shahn among others. The I.B.M. Collection was begun in the same year by an advertising agency, N. W. Ayer & Son, which used painting and sculpture to enhance the image of the I.B.M. empire. In 1939, the Dole Pineapple Company commissioned a series of artists, among them Georgia O'Keeffe, Isamu Noguchi, and Pierre Roy, to go to Hawaii and record their impressions—no strings attached—and they were followed during the war by a number of industrial concerns with 'cultural' ends in view. In 1943 the *Encyclopaedia Britannica* began collecting in the contemporary field, and in 1944, with a great blast of publicity and some very effective maneuvers, the Pepsi-Cola company staged a great exhibition of contemporary art, printing 600,000 catalogues with a color reproduction by Stuart Davis, and later compiling a calendar of contemporary works, demolishing the old American tradition of calendar art.

These corporate efforts, which a good many artists resisted with good reason, probably did a great deal to focus attention on artists in America, but did not appreciably increase the actual market value of contemporary works until several years after the war. Those who ran art galleries in New York during the war always remarked on increased attendances but few sales. According to Marian Willard, one of the most distinguished dealers in New York, people during the war years seemed grateful that everything wasn't closed down and thronged the galleries as never before. They wanted some contact with art for the first time, a need Mrs Willard feels was positively

psychic and generated by the war.[13] All the same, these new converts to the visual arts were by national standards a small minority. Attitudes toward contemporary artists remained largely hostile, both in the press and among its mass of readers. For example, in the third issue of *View* in November 1940, Edouard Roditi reported from California that people tended to lump modern artists with what Representative Yorty referred to as the 'Trojan horse tactics of fifth columns of communazi political termites.' Local townsfolk, he added, viewed migrants from the dust bowl as if they were undesirable aliens like Jews and Communists, and these were always associated with artists.

The same issue of *View* carries a note about the announcement of Selective Service lists of those who had no right to deferment from war service. The list ran: 'clerks, messengers, office boys, shipping clerks, watchmen, doormen, footmen, bellboys, pages, sales clerks, filing clerks, hairdressers, dress and millinery makers, designers, interior decorators and artists.' At the bottom of the list, artists were pretty much regarded by the public at large and by the institutions carrying on the war, as expendable. (This is still fundamentally true. When during the 1970 depression the universities were forced to cut their expenditures, the first cuts they sought to make were in the arts departments.) The artists' cause was rarely pleaded on a mass scale. Newspapers throughout the country carried few accounts of modern art, and those few were usually hostile. Even in New York City, the leading journalist-critic of the *Times*, Edward Alden Jewell, was always very sceptical about indigenous artists, as the famous letter of Rothko and Gottlieb attests. Chauvinism, patriotism, and a basic belief that modern art was somehow fraudulent, continued to plague newspaper criticism. As late as 1947, when the Chicago Art Institute staged an important exhibition, 'Abstract and Surrealist Art,' and gave Baziotes the first prize for his *Cyclops*, the most important paper in Chicago, the *Daily News*, raged for days. C. J. Bulliet wrote: 'These "isms" grown stale and sterile in the lands of their origin, are further enfeebled crossing the Atlantic.'

Public pressures were brought to bear on the arts which, once again, were considered more 'useful' than cultural. Even Arshile Gorky was fired with the general zeal which characterized the war period and tried to evolve a course in camouflage, which as he said in his eloquent prospectus, was best understood by the modern artist since he, above all, had the visual intelligence. 'This course,' he wrote early in 1942,

is dedicated to that artist, contemporary in his understanding of forces in the modern world, who would use this knowledge in a function of increasing importance. Such an artist will gain a knowledge that will deepen and enrich his understanding of art as well as make him an important contributor to civilian and military defense.[14]

Many of Gorky's friends were as willing as he to formulate a useful role for themselves in the war effort, but they sought always to preserve their identities as artists. The artists were subject to many well-meaning efforts to integrate them into the society as artist-warriors and to restore them to those utilitarian graces in American society they had so vehemently rejected. For instance, in the June–July 1941 issue of *Magazine of Art*, Margit Varga, later to become a senior editor at *Life Magazine*, reported on an exhibition of British wartime art at the Museum of Modern Art, and asked why America shouldn't have the same:

The U.S. today has something it never had before—a corps of artists who have worked under the government and are trained to carry out commissions. In the past seven years, through the program for decoration of our public buildings they have brought America closer to the hearts of the people.

In general, even the art magazines took a sentimental view of the joys of wartime art and indulged in embarrassing excesses of flag-waving. Their excessive relief at the new useful function of the modern artist must have done a great deal to push the resolute avant-garde even further into what the conservative critic Forbes Watson called 'a waning aura of bohemianism.'

Despite their cheerleaders, few artists seemed willing to convert themselves into visual propagandists or journalists. Reviewing the massive 'Artists for Victory' exhibition held at the Metropolitan Museum in the *Magazine of Art* for December 1942, Manny Farber noted, 'It is interesting how few of these painters were influenced by the war.' This show, which drew 8,000 entries, exhibited 532 paintings, 305 sculptures, and 581 prints and was one of the first massive exhibitions of contemporary art, was a source of great excitement. Unfortunately, as Farber pointed out, it was largely notable for 'its canned subject matter.' Another important writer, commenting on the artificial aspects of American culture during the war, referred to the 'canned' institutional programs. Elizabeth McCausland, in 'Art in Wartime' (*The New Republic*, May 15, 1944) notes that despite the war, there was no cutting of institutional funds. There was 'unabated support for art but little support (public or private) for

living art.' More important, Miss McCausland noticed with remarkable astuteness the problem of what she loosely called the 'cartelization of culture.' She wrote that perhaps a more colloquial term would be canned culture: 'At any rate, an increasingly evident and powerful manifestation in the art world . . . is the practice of circulating exhibitions.' Originating in a handful of major museums, they reflected, she wrote 'the taste and esthetic criteria and world outlook of a small handful of museum potentates.' She pointed out that the independent museum was in the same position as the independent press, threatened by the same forces of cultural monopoly.

The easiest prey for cultural monopolists was the one art form in the domain of mass culture—the movies. From around 1940, when a reviewer noted that *The Grapes of Wrath* had its preview in New York where 'three rows of the parquet were occupied by officers and directors of the Chase Manhattan Bank (which controls 20th Century Fox),' cultural commentators were exceedingly worried. The idea of a mass culture itself had only just become fashionable, with scholarly sociologists and literary men attempting to define just what mass culture was. They all agreed that it was a product of rapid urban development and that it would undoubtedly flourish more and more as America expanded its glowing wartime economy. The necessity of propaganda was uneasily admitted by nearly everyone, from the willing Hollywood mogul to the refined editor of a little magazine, and the film was the obvious medium for wartime propaganda. Even so sensitive a reviewer as James Agee, who wrote the film column in *The Nation* during the war years, found himself in favor of popular war films if they could meet minimum standards of taste. Agee pleaded with Hollywood to make the war films intelligent and moderate without much success. By 1943 he was accusing the average American film-maker of ignoring 'the great potential sensitiveness of the general audience,' to whom, he said, they acted like 'house-broken Nazis.'[15] Those who were attracted to the medium precisely because it reached the masses, and because they had lingering hopes of improving the taste and intelligence-quotient of those masses, were inevitably disappointed, sometimes bitterly. The writers who had hoped to do their part in the war effort through serious films came up against the strictures of their employers, whose war efforts were specifically designed to make profits.

There are many accounts of the disastrous relationships between artists and the rulers of the film industry. Lillian Hellman recounts an episode with Samuel Goldwyn, who had made a very advantageous

agreement with the Russian government but wished to relieve William Wyler and Hellman of their fees in the interest of patriotism. Eventually, Wyler went into the Air Force without making the film, but Hellman wrote the script for *North Star* which, as she ruefully remarks, 'could have been a good picture instead of a big-time, sentimental, badly directed, badly acted mess it turned out to be.'[16] Most of the Hollywood products, as Agee realized with considerable despair, were fated to be big-time and sentimental. The relationship of film artists to the industry was always to their disadvantage. Lillian Ross quotes one of the most sensitive directors of the Hollywood establishment, John Huston, describing Hollywood as 'a closed in, tight, frantically inbred and frantically competitive jungle'[17] —a jungle that managed to strangle a good many of Huston's more original ideas and distort even his views on such important themes as war. Artists in every field kept a close watch on films as the popular medium par excellence. The lessons implicit in the aborted talents that were drawn to Hollywood were not lost on them. The sustaining power inherent in the *art pour l'art* viewpoint was increasingly recognized as the sole salvation of the serious artist. The numerous discussions about the film in relation to the fine arts that appeared during the forties in the United States (similar to those in Europe ten years earlier) indicate the genuine anxiety that beset the arts in the face of the rapid proliferation of the mass media. As early as 1936, the brilliant German critic Walter Benjamin posed the problems of art in the technological era with its mass public. In a penetrating analysis, Benjamin concentrated on the film as a potential art-form, introducing new apperceptions and mitigating the worldview of its viewers, but also seeing films as a tool that could all too easily yield to the political ends of its controllers. Most of the serious esthetic dilemmas that have been known to serious film writers ever since were broached in that important chapter 'The Work of Art in the Age of Mechanical Reproduction.'[18] (The vulnerability of the artist in the film industry was demonstrated only two years after the war when the government singled out the Hollywood writers for persecution and actually sent ten of them to prison.)

The perils of mass acceptance, or rather mass exploitation by cultural cartels, were keenly sensed by many of the vanguard painters in New York, who struggled in various ways to avoid being trapped. But they were aware, at the same time, that only 'success' in the mythical American sense could insure their existence in the culture. Many of them had relinquished their idealistic dreams of influencing

society through their critiques in painting when the war broke out. But there was a lingering residue of ambition to break the silence of America in relation to the arts, particularly in painting and sculpture. Nearly all the members of the New York School suffered throughout their lives deep conflicts concerning success and their role in the society. Their behavior—now hostile, now almost obsequious— toward the forces that controlled renown in America, became a part of the myth of the New York School. Insofar as they were children of the United States they shared to some degree the universal reverence for success. Even Jacques Maritain, whose welcome in America was so warm that he became its leading French defender, listed the passion for success as one of the notable American illusions:

It is generally believed that success is a thing good in itself, and which it is, from an ethical point of view, mandatory to strive for. In this American concept of success, there is no greediness or egoism. It is, it seems to me, rather an over-simplified idea that 'to succeed' is to bear fruit, and there-fore to give proof of the fact that psychologically and morally you are not a failure.[19]

Although Maritain gently suggests that this American illusion will in time change, he gives, in the same book, a sound analysis of the adverse conditions which spur on Americans, especially artistic Americans, in their drive toward this illusory goal. He notes that although Americans are kind, open-minded, thirsty for knowledge, and serious, they do not take artists seriously:

In France, artists are kings; everybody is interested in their doings and in the opinion of a great novelist or a great painter in national affairs. Here, on the contrary, their opinions carry less weight than that of promi-nent businessmen; furthermore, and this is more serious, they seem to arouse some suspicion and communion between the beholder and the artists is lacking in the very place where it should exist, namely, in that area which, though indeed larger than the small group of expert connoisseurs, is narrower than the general public, and which may be called the enlight-ened public.

He adds that the general public has vulgar taste in America as in every other country, but that the enlightened public, who should know better, 'are no more interested in the inner creative effort of a painter or a writer than, I would say, in that of a cook who prepares food for them in restaurants.'

For the American youth dreaming of a career in the arts, success was as necessary a goal as it was for the youth planning a career in business. And success carried with it the idea that only those capable of competing could ever know it. The tragic comedian Lenny Bruce,

who grew up during the Depression and served in the Navy during the war years, wrote bitterly about his own earlier cravings, on which he reflected while standing on the deck of a warship in battle:

Our society is based on competition. If it isn't impressed upon you at home with the scramble for love between brothers and sisters, they really lay it down to you in school. . . . You bring home 100 per cent and your mother hugs you and your father pats you on the back. The teachers beam at you. But not your schoolmates; they know they're in competition with you, and if you get a high percentage they must get a lower one. . . . In essence, you are gratified by your schoolmates' failures. We take this with us into adulthood. Just look at the business world.[20]

Some of the potency of these American values, and some of the shame, became attached to the rise of the New York School during the war years. Willem de Kooning is widely quoted for having said 'Jackson broke the ice'; he is usually interpreted as meaning that it was Pollock who opened painting to unprecedented freedoms. But it is more likely that de Kooning meant that it was Pollock who, through his success in breaking into the citadels of enlightened opinion (which had never before been very much interested in contemporary art), dug the channel through which all the gifted vanguard artists would sail to success.

cAbstract Expressionism

How Jackson Pollock broke the ice—quite aside from his genuine esthetic contribution, which was quickly recognized by the *cogno-scenti*—is neatly summarized by Peggy Guggenheim, his first commercial agent. Writing about his first one-man show at Art of this Century, held in November 1943, she cites all the significant factors in his success:

The introduction to the catalogue was written by James Johnson Sweeney, who helped a lot to further Pollock's career. In fact, I always referred to Pollock as our spiritual offspring. Clement Greenberg, the critic, also came to the fore and championed Pollock as the greatest painter of our time. Alfred Barr bought the *She Wolf*, one of the best paintings in the show, for the Museum of Modern Art. Dr Morley asked for the show in her San Francisco Museum, and bought the *Guardians of the Secret*.[1]

Unquestionably, the intervention of all these powerful figures—Sweeney, well-connected with the international art world, Barr, the key arbiter of the enlightened middle echelons of culture, Greenberg, the first polemical art critic with literary standing, and Dr Morley, the most successful museum director on the West Coast interested in the avant-garde—headed Pollock toward the kind of success that he was to find so hard to bear. The support of these well-placed cultural pundits, with the inevitable dependence of the artist on their initiatives, was at once a blow to the pride of the bohemian artist and a source of both secret joy and secret despair. The stories of Pollock's violent behavior and his ability to be highly uncivil to the very people who most 'helped' him to success can certainly be interpreted partly by his extreme discomfort at having been the first avant-garde artist to 'break the ice.' With Pollock in hand, the forces interested in sponsoring an American painting culture capable of breaking the hegemony of Europe had a powerful weapon. Only think how an artist would feel knowing that someone—even someone

29. In the late nineteen-forties, the Pollocks spent most of their time in their East Hampton house, where Pollock kept a pet crow. Photo by Herbert Matter(?), courtesy Lee Krasner Pollock.

as charmingly naïve as Peggy Guggenheim—could speak of him as 'our spiritual offspring.'

As Elaine de Kooning later said, Pollock was 'the first American artist to be devoured as a package by critics and collectors (whom he cowed).'[2] By 1949 *Life* magazine was beginning to see the popular news value of artistic wildlife. A famous article in the issue of August 8, 1949, was given the title 'Is Jackson Pollock the Greatest Living Painter in the United States?' by which the editors virtually invited the readers to respond indignantly in the negative. The article presented Pollock as a kind of mad genius, whose techniques and manners are incomprehensible:

Even so, Pollock, at the age of 37, has burst forth as the shining new phenomenon of American art. . . . Pollock was virtually unknown in 1944. Now his paintings hang in five United States museums and forty private collections. . . . Last winter he sold twelve out of eighteen pictures.

154

This little success story, with its proper American emphasis on how many pictures had been sold, and its patent disrespect for the artist as such, typified the new processing the media gave the avant-garde and caused many a New York painter to grind his teeth in chagrin.

Making the first perceptive comment on Pollock's temperament, James Johnson Sweeney had written in the catalogue to the exhibition in 1943 that Pollock's talent was volcanic, lavish, explosive, and untidy. He praised Pollock's freedom to throw himself into the sea and, significantly, bolstered his independence, making it seem an avant-garde virtue. 'But young painters, particularly Americans, tend to be too careful of opinion. Too often the dish is allowed to chill in the serving. What we need is more young men who paint from inner impulsion without an ear to what the critic or spectator may feel—painters who risk spoiling a canvas to say something in their own way.' In this sentiment, Sweeney was to be followed by all those who willed a New York School.

Greenberg in a review in *The Nation* of November 27 also praised Pollock's audacity, energy, and force; while Pollock's young colleague, Robert Motherwell, writing in *Partisan Review* in the winter of 1944, called him 'one of the younger generation's chances.' The ranks were forming and a constellation of people was consciously embarking on a public adventure. For some time, all this energy was centered on Peggy Guggenheim's gallery, which lost no time in presenting the work of young artists who painted from the inner impulsion that Sweeney had demanded. In fact, several of the artists were presented by Sweeney himself. One-man shows of Baziotes, Motherwell, Rothko, and Still followed in the next couple of years. Sweeney wrote the catalogue introduction for Motherwell's exhibition, again stressing the importance of process: 'With him a picture grows, not in the head but on the easel.' The Museum of Modern Art duly acquired its first Motherwell, and the San Francisco Museum, under Dr Morley's adventurous leadership, then held a one-man show. So it went. Now, a milieu rapidly became enlarged to include not only artists with a sense of growing importance, but also patrons, critics, museum officials, and an increasing circle of *aficionados*.

Not all the artists experienced such effective dispatch in the propagation of their work. The senior member of the avant-garde—at least in terms of exhibiting—was Arshile Gorky, and his experience was one of constant anxiety in relation to the success he felt he merited. Although the Museum of Modern Art had acquired one of his paint-

30. Arshile Gorky was always a romantic figure. This photograph was probably taken on his Virginia farm, possibly in the summer of 1946. The photographer is unknown.

ings as early as 1941, largely because his close friends decided to contribute it (as they contributed paintings to the San Francisco Museum), Ethel Schwabacher has pointed out that in the seven remaining years until his death, no more paintings by Gorky were bought by museums or presented to them, nor did he receive any grants or prizes.[3] And when he had his first important one-man show at Julien Levy's gallery in March 1945, for which Breton wrote a

celebrated foreword, it found a cold reception. Clement Greenberg went so far as to say that 'Gorky has at last taken the easy way out,'[4] a comment that was perhaps doubly cruel because of Breton's sponsorship. Jeanne Reynal, Gorky's close friend who was then in San Francisco, wrote angrily to Gorky about the review and urged him to try to get to France where his work would be appreciated. There was more than a little asperity in the New York milieu toward the artist who had most obviously thrown in his lot with those visible reminders of the once-powerful European leading strings.

All the same, increasing press coverage, however hostile, and more and more serious reviews in the specialized journals, forced the artists —who had once lamented their isolation—to recognize their new, and not always welcome, relationship with society. The acceptance of abstract art as the appropriate avant-garde mode was accomplished before the war was over. By 1946 the hostile critic Milton Brown could write in the April issue of the *Magazine of Art* of the 'vogue' for abstraction and remark testily that 'the experience of the war and world crisis have not shaken the artist out of his esthetic shell.' Brown specifically lamented the success of Avery, Graves, and Tobey, the last of whom had had a one-man show at the Willard Gallery in 1944 in New York—the first since 1917.

The number of seriously engaged critics grew rapidly during the war years. From the surrealist camp came Parker Tyler, with his sophisticated reviews of both films and painting, and Nicolas Calas, a young Greek poet and critic whose volatile temperament was first revealed in the pages of *View*. From the ranks of the old left-wing literati came both Clement Greenberg and Harold Rosenberg, whose voices continue to dominate American art criticism today, although both have changed considerably in tone. These and a few others managed to keep a steady stream of intelligent discourse and commentary alive in the pages of both political and literary reviews. Barr, Sweeney, James Thrall Soby, and others identified with institutions also contributed to the growing literature on contemporary American art. For the first time, the visual arts began to assume for editors the importance they had always given to music, literature, and even the dance. *The Nation*, which as late as 1940 was resolutely silent on painting and sculpture (in its 75th Anniversary issue in February 1940 there were commentaries on music, records, books, theater, and film, but no art), engaged Clement Greenberg, who began regular reviewing of art shows early in 1941. (Before that time Greenberg, like most other intellectuals, had been largely interested in a socialist

analysis of the arts—an attitude he later relinquished almost entirely, leaving the field to Rosenberg.) *The New Republic*, which had featured sociological film criticism by Manny Farber, which had covered poetry and literature exceptionally well and was even advanced enough to have a regular column on science and technology during the war years, was finally persuaded about 1945 to recognize painting and sculpture. Manny Farber then switched to art criticism, bringing insight and verve to his reviews, especially of the works exhibited at Art of This Century.

The art magazines were on the whole unaware of the new situation. Between 1941 and 1945, the *Magazine of Art* did not mention a single abstract expressionist; but when Robert Goldwater was appointed editor in 1948 he promptly ran features on de Kooning, Motherwell, and Still. *Art Digest* was consistently unfavorable; and even *Art News*, which was shortly to become, in the hands of Thomas B. Hess, the leading advocate of abstract expressionist painting, was singularly unimpressed by it during the war years.

It was largely in *Partisan Review*, where George L. K. Morris, Motherwell, Sweeney, and finally Greenberg wrote, and in *The Nation*, where Greenberg passionately promoted the new reputations, that the critical writing became significant. The most consistent writer was Greenberg who, after 1939, abandoned Marxist analysis in favor of descriptive writing about specific artists and works of art. He assumed the role of leading art critic during the war years, forsaking the mantle of the man of letters. He showed himself to be a good pupil of Hofmann, and in one of his first *Nation* pieces analyzed the characteristic bias of the American mind as its positivism, its reluctance to speculate, its eagerness for quick results, and its optimism. All the same, his own bias soon appeared when he launched attacks on what he called 'neo-romanticism.' His bêtes noires were the surrealists, whom he accused of reversing the anti-pictorial trend of cubist and abstract art (on November 14, 1942). The 'laws' of which Hofmann had always spoken were very attractive to Greenberg, who adapted the rhetoric of Hofmann's studio in his early criticism, always referring to cubist space and to the crimes of those who poked holes in the canvas, those whose work was anecdotal, and those who abandoned the tenets of modernism as passed down from Cézanne to the cubists. In 1943 he attacked Mondrian's *Broadway Boogie-Woogie* as wavering and awkward (and in the next issue had to apologize for having reported that there was orange, purple, and impure color in the painting). He also criticized Matta

158

for making 'the comic strips of abstract art,' and he complained of the Museum of Modern Art's taste for the School of Paris. For the next year or so, Greenberg continued to harry the museum for its support of the romantic revival, which he considered retrograde. In January 1944 he remarked that American art, like American literature, seemed to be in retreat and lamented that everyone couldn't see that the only possibility of originality was in abstract art. There is clear evidence of Hofmann's teachings in all his criticism written between 1943 and 1944. His insistence that a painting must not be a window in a wall, and that two-dimensionality and the picture plane must be respected, comes through again and again. Greenberg's tendency toward obiter dicta appears early and nearly always sounds prescriptive. His antipathy for the surrealists was unbounded, and he would point out their deficiencies whenever he could. In view of his devotion to Pollock, from whom he undoubtedly learned a great deal, it is strange that he never modified his views about the surrealists. But this was not in his temperament, as subsequent years would prove. Rather, he had a stern exclusive preoccupation, which made him inaccessible to anything that appeared to depart from the central abstract tradition: 'The extreme eclecticism now prevailing in art is unhealthy and it should be counteracted, even at the risk of dogmatism and intolerance' (June 10, 1944).

The growing interest in Kandinsky around 1945 incensed Greenberg, who again employs Eighth-Street studio rhetoric to denounce Kandinsky's paintings—in which the picture planes are 'pocked with holes' and the 'negative space' is not properly accounted for. Perhaps Pollock's obvious regard for Kandinsky and Gorky's outright homage galled Greenberg. In his review of Gorky's show in 1945 he didn't mention Kandinsky, but instead reproached Gorky for replacing Miró and Picasso with 'that prince of the comic strippers, Matta,' and for the easy 'biomorphism' to which it led; and on April 7, 1945, in reviewing Pollock's second one-man show, he complained that Pollock sometimes left 'gaping holes' in his canvas. (Given Greenberg's distaste for the free expressionist works of Kandinsky and Gorky, his devotion to Pollock might almost seem an aberration; perhaps it was the personal contact with Pollock which made Greenberg, for a time, his most eloquent advocate.)

Greenberg's resistance to the increasingly lyrical tendency in the abstract painters can be felt in his review of an exhibition at Howard Putzel's new gallery. In the issue of June 9, 1945, he commented on the 'New Metamorphism,' seeing in the tendency toward poetry and

imagination a rebellion against cubism which he found regrettable. What he called the 'return of elements of representation, smudged contour lines and the third dimension' are, in his opinion, regressive. He objected because 'instead of exploring the means of his art in order to produce his subject matter, he will hunt about for new "ideas" under which to cover up the failure to develop his means.'

Pollock was obviously exploring *his* means in 1945, but he probably had more in common with his poetic confrères than Greenberg wished to concede. In fact, he had to insist that Pollock's 'habits of discipline' and 'unity' stemmed from his obeisance to the fundamentals of cubism. A certain scholastic insistence on category underlines all Greenberg's early criticism. By repeating the magic word cubism (either as what artists must respect as fundamental to the modern tradition, or as what they must go beyond, as exemplars of the modern tradition) Greenberg keeps his footing in the world of form. Everything that seemed to deviate from this position (and it is astonishing that in his eyes Pollock did not) came in for criticism. For instance, when Gottlieb, Rothko, Still, and Newman first appeared on the horizon, Greenberg was distinctly hostile. Of Gottlieb's exhibition he wrote in the issue of December 6, 1947:

I myself would question the importance this school attributes to the symbological or metaphysical content of its art; there is something half-baked and revivalist in a familiar American way about it. But as long as this symbolism serves to stimulate ambitious and serious painting, differences of 'ideology' may be left aside.

What made the first phase of Greenberg's criticism important in the genesis of the new American painting was his willingness to speak firmly, and often with keen passion, of the issues that preoccupied the artists who interested him. His ear for studio talk—always important to a good art critic—was alert, and his ambition for his chosen artists was tremendous. This ambition made it possible for him to claim, unabashedly, superior status for Pollock and later for one or two others. It enabled him to declare that Pollock was 'great' (a statement that would have made many another art critic blush), and that there was something brewing in America that was superior to developments elsewhere. His role as *agent provocateur* in relation to the general public was indispensable. When Greenberg said 'great,' the press replied 'heaven forbid'; but Greenberg's consistency and his confidence could not be ignored.

Another extremely important function he performed, along with the few others writing in the intellectual weeklies and monthlies, was

to bring painting and sculpture into focus as a significant sector in the arts. By their writing in *The Nation* or *Partisan Review* or *The New Republic*, these few critics reached what Maritain called the enlightened public, the same public that Alfred Barr had been patiently besieging for two decades. When the man of letters, the poetry lover, or the college-educated professional opened the pages of these publications, he was reminded again and again not only that America had painters and sculptors, but also that they were exceptional. In this way the growing sense of importance felt by the artists and critics themselves was communicated to a widening public. And since so intelligent and perceptive a man as Greenberg was willing to see greatness in this new phase of American culture, it was not difficult for others to accept the possibility that it was true. Even if the seemingly wild and anarchic creations of Pollock were not understood, the knowledge that he and a few others—the mad geniuses of America—existed was very appealing to the perpetually hungry cultural enthusiasts.

The artists themselves, unaccustomed to so much serious approval, began to feel they really had something going that required close examination. Conversations in the Waldorf Cafeteria took on new color, and issues were discussed in new terms. Gradually reference to European precedents was sublimated. By the end of the war, the New York artists and their friends on the West Coast were fairly certain that their special situation was new and the idea that there was indeed a modern *American* painting grew in their consciousness, no matter how obliquely. This liberated many spirits from old conflicts, enabling them to address themselves to the broader issues. One of the artists most given to discourse, Robert Motherwell, tried to summarize these issues in a talk given at Mount Holyoke College in 1944 and published by his friend Paalen in *Dyn*. Given Motherwell's position within the new situation—his intimacy with Baziotes, Pollock, and for a time Rothko and Matta, and his exhibiting at Art of This Century—it is safe to assume that the questions he discussed were commonly regarded by the New York painters as pressing and worth discussion.

Calling his essay 'The Modern Painter's World,' Motherwell, only a few years removed from his studies with Meyer Schapiro, undertook an analysis of the relation of the painter to the middle-class world. Schapiro's views are reflected when Motherwell says that modern artists have always met with hostility from the middle class:

In the face of this hostility, there have been three possible attitudes of which the artist was not always conscious; to ignore the middle class and seek the eternal, like Delacroix, Seurat, Cézanne, the cubists and their

heirs; to support the middle class by restricting oneself to the decorative like Ingres, Corot, the impressionists in general, and the fauves; or to oppose the middle class like Courbet, Daumier, Pissarro, Van Gogh and the dadaists. . . .

This discussion in terms of a class society, of historical values, of the roles of Marxism and Freudianism, reflects Motherwell's inheritance from the thirties. But the optimistic and often naïve assumptions made by the Marxist critics during that period are avoided in Motherwell's propositions. He isolates one central problem for the young artists who had emerged from the experience of war and genocide: 'The artist's problem is *with what to identify himself.* The middle class is decaying, and as a conscious entity the working class does not exist. Hence the tendency of modern painters to paint for each other.' Motherwell sees little hope of mending the breach between the modern artist and his predominantly middle-class society, and he sees the real crisis in 'the modern artist's rejection, almost in toto, of the values of the bourgeois world.' He acknowledges that the surrealists have attacked those values too but rejects their abjuration of the mind (or formal values) which, as he says, can be actualized in the act of painting (here, he speaks in concert with Paalen, who had already announced his departure from surrealist convictions): 'Painting is therefore the mind realizing itself in color and space. The greatest adventures, especially in the brutal and *policed* period, take place in the mind.'

Throughout the essay there is a rueful, pessimistic undertone, a consciousness of the degradation of war-prone bourgeois society and, necessarily, the artists within it. Motherwell examines the possible ways of expressing the epoch and concludes that the eternal esthetic values—those that derive purely from form—provide the only means for the modern artist who stands in opposition to society; that basically he has little choice but to strengthen and deepen his abstraction. This, clearly, is a regretful conclusion on Motherwell's part. His earlier thoughts on Marxism, and his initial excitement about surrealism, have had to give way. On this point particularly there must have been widespread agreement among the artists of the New York School. As they gained confidence, so they found the courage to throw out even their most cherished assumptions. The drift toward metaphysics and toward pure estheticism were both to be means of escape from the confusion of the nineteen-thirties. Motherwell's regret that the American artist could not paint a *Guernica*, that he could no longer hope to find the symbols that would relate him to

his fellows, was, as he later demonstrated in his own series of symbolic paintings on the Spanish Civil War, permanent. The conflicts were never to be resolved, but as the artist moved into the second half of the forties, the issue of his relationship to society was more or less forgotten.

Most artists seemed inclined to accept Motherwell's first proposition to ignore the middle class to seek the eternal; a few, however, set themselves up as 'personalities' in aggressive opposition. Only three years later, when Motherwell and Harold Rosenberg founded what was to be a single-issue magazine, *Possibilities*, the tone had become even more pessimistic. This was all the more significant in view of Rosenberg's immediate past. He had seen the keenest moments of accomplishment during the W.P.A. period, and must certainly have shared the soaring hopes of his generation just before World War II. After his brief stint as editor of *Art Front*, Rosenberg went to Washington on the writers' project, where he was national art editor of the American Guide Series. This remarkable group of books, produced by many distinguished writers, set out the history and cultural history of various American regions and remains a model for such undertakings. As editor from 1938–42, Rosenberg would have seen a vast amount of previously neglected cultural material. With this broad synoptic view, he laid the foundation for his penetrating cultural criticism in years to come. While the American Guides were being produced, everyone involved saw broad cultural opportunities but, writing in the journal *Possibilities* only a few years later, Motherwell felt they had become depressingly circumscribed.

Rosenberg and Motherwell declared that 'through a conversion of energy something valid may come out, whatever situation one is forced to begin with . . . if one is to continue to paint or to write as the political trap seems to close upon him he must perhaps have the extremest faith in sheer possibility. . . .'[5] This pessimistic statement that something *might* come out of what realistically appeared a hopeless situation undoubtedly reflected one aspect of the abstract expressionists' ambivalence. As a statement of their last remaining value—that of their individuality somehow mirrored forth in their work—it represents both their despair and their wild hope. It definitely indicates that their earlier faith in the value of political action, symbolic social-content painting, group activity and programatic movements had been eroded. All that remained was what Rosenberg later called their 'action' on the canvas, and the 'extremist faith in sheer possibility.'

Artists and Dealers

Looking back in 1955, Greenberg found that 1947 and 1948 constituted a turning point. He wrote that in 1947 there had been a great stride forward in general quality, and that in 1948 'painters like Philip Guston and Bradley Walker Tomlin "joined up" to be followed two years later by Franz Kline. Rothko abandoned his "surrealist" manner; de Kooning had his first show; and Gorky died.' His slighting reference to those who 'joined up' indicates that the long-hoped-for constellation that could be called a New York school was becoming visible, and also viable. There was unquestionably a surge of enthusiasm among painters all over the country as they began to hear of a real movement, and they were drawn eastward. People down at the Waldorf Cafetoria were talking away, their ranks swelling daily. Uptown there were new galleries opening; museums were beginning to take notice. The myths that had supported the vanguard few were slowly being controverted, although the decisive moment didn't arrive until several years later.

Greenberg took note of those myths in an article in *Horizon* in October 1947, writing that

The morale of that section of New York's Bohemia which is inhabited by striving young artists has declined in the last 20 years, but the level of its intelligence has risen, and it is still downtown, below 34th Street, that the fate of American art is being decided—by young people, few of them over forty, who live in cold-water flats and exist from hand to mouth. Now they all paint in the abstract vein, show rarely on 57th Street, and have no reputations that extend beyond a small circle of fanatics, art-fixated misfits who are isolated in the United States as if they were living in Paleolithic Europe.

And three months later in *Partisan Review* he again referred to fifth-floor cold-water studios, poverty and the 'neurosis of alienation.'

31. Toward the mid-nineteen-forties Bradley Walker Tomlin moved away from his romantic cubist style into experiments with calligraphic imagery. The pressure of experiment spreading throughout the art community had brought Tomlin to a remarkable peak in his work, which was honored in 1952 at The Museum of Modern Art in its 'Fifteen Americans' exhibition. Photo: courtesy The Museum of Modern Art

He maintained that the myth of bohemia in nineteenth-century Paris was only an anticipation; it was in New York that it had become completely fulfilled, and it was clear that he believed in the myth as a constructive force. Having already reached an art-for-art's-sake position by 1945, Greenberg found it congenial, while lamenting the 'alienation'—a term that appeared not only in his own column in *Partisan Review* but also in the writing of almost everyone else's work published there in 1948—to take solace in the fierce individualism such alienation engendered. He was attracted, as intellectuals often are, to the Promethean violence of conviction many of the

165

downtown artists displayed when times were hard. From this band who had touched spiritual bottom he expected to forge a movement, even though he pretended to see their plight as injurious, and asked plaintively in 1947, 'what can fifty do against a hundred and forty million?'

Greenberg's discernment showed when he grasped that the real fruits of the spiritual malaise of his *peintres maudits* were those large and daring paintings that led him to speak of 'The Crisis of the Easel Picture.'[1] It is quite possible that he got this idea from Pollock, who early in 1947 wrote in his application for a Guggenheim grant that he intended to paint 'large, movable pictures that will function between the easel and mural,' and added: 'I believe easel painting to be a dying form, and the tendency of modern feeling is toward the wall picture or mural.' Thereafter, Greenberg raised the issue again and again, always suggesting that the easel painting would be replaced by the new 'polyphonic' modes suggested in Pollock's paintings. Curiously, his article in *Partisan Review* included a number of reproductions of the work of de Kooning, whose first exhibition had been a signal event that year, and who stubbornly persisted in easel painting.

De Kooning's myth was well established. He had been considered, as Hess understood, a 'painters' painter' since the thirties. He was, as Denby has said many times, absolutely incorruptible, a man who lived a life of total honesty, and who chose the uncomfortable rather than conform to anyone else's idea of what a painter's life should be. He had always lived as a 'loft rat' and at the same time had always been a cosmopolitan. His cosmopolitanism was exemplified in his association with so rarely sensitive an intellectual as Denby; with Graham, Gorky, and Burckhardt; with Cage; and with a great many poets, writers, and connoisseurs who were not intimately connected with his downtown routines. It was apparent in his tremendously knowledgeable conversation about painting and in his deep interest in the history of art and culture. He loved the complexity of the cosmopolis, and he found in its physical appearance an excitement and beauty that he consciously tried to reflect in his paintings.

Throughout the forties, those who gravitated to New York, or who painted by day and talked with each other by night, heard stories of de Kooning's courageous resistance to blandishments both from dealers and from occasional patrons. It was well known that he and Gorky chose poverty rather than to compromise in their work. De Kooning's reputation for working slowly, scraping out, starting all

32. In this unpublished illustration for Frank O'Hara's *In Memory of My Feelings*, de Kooning reminds us of the rapport finally established between poets and painters in the early nineteen-fifties (drawing made in 1967)

M

over again, and never really finishing a painting, was legendary already in 1943, when Denby recalls how conscientiously de Kooning sought to avoid the gratuitously beautiful, and how, despite the chance to exhibit in a good uptown gallery if he could only produce finished pictures, de Kooning waited and worked. It was Charles Egan who at last managed to get together de Kooning's first one-man show. Egan, who is fondly remembered to this day by many of the artists he once exhibited, had long been acquainted with downtown bohemia. He was intelligent, genuinely interested in painting, and had enough humor to be acceptable to the inner circle at the Waldorf, as well as in individual studios. His own idiosyncracies and his bohemian temperament endeared him to many painters who, even when exasperated with his dilatory appearances at the gallery, never despised him as they did so many dealers who sprang up in the late forties and early fifties.

Egan had had a good background. He had begun as a young salesman in 1935 in Wanamakers' art gallery. There he immediately began introducing contemporary artists, among them John Sloan and Stuart Davis. Later he worked at the Ferrargil Galleries which also dealt in contemporary American art, and still later, he worked with the veteran J. B. Neumann. When he opened his own gallery in 1945, he began with older American painters (Stella and Walkowitz) but paid close attention to what was happening among the younger vanguard painters. His independence of spirit, always marked and sometimes detrimental to the marketing aspects of his business, must have impressed de Kooning. With this first exhibition, both he and Egan had their long labors crowned with surprising success. All those who had ever heard of the de Kooning legend flocked to the modest gallery, often to find the doors locked, since Egan always kept irregular hours and loathed the businessman's code. All the same, the press turned out in full force, the museums sent representatives, and the event was a spectacular success in the art world.

There were a few other dealers whom the artists respected, and whose energies were devoted to the realization of an important school of modern American painting. Sam Kootz, a tall, genial southerner who had already indicated his interest when he published *New Frontiers in American Painting* in 1943, and who had been responsible for the huge exhibition at Macy's, took over Baziotes and Motherwell from Peggy Guggenheim and, when he opened his gallery in 1945, represented also Byron Browne, Carl Holty, and Adolph Gottlieb. Wisely, he persuaded literary men to provide

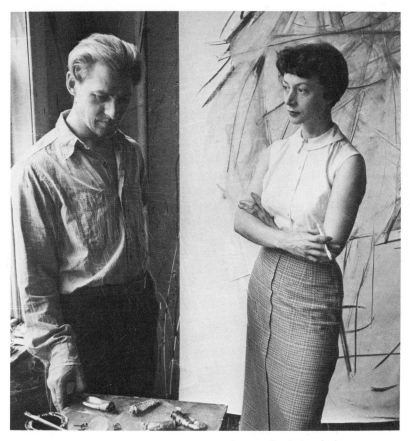

33. William and Elaine de Kooning in 1950 in their 4th Avenue
studio at 12th Street. Photo by Rudolph Burckhardt

catalog introductions, so that the artists' work was often presented
with well-written critical essays. He was also shrewd enough to stock
his back room with Picassos to keep the gallery going until the market
for his young rebels would materialize. In his memoir in the *Archives
of American Art*[2] he recalls that Alfred Barr liked Motherwell,
Gottlieb, and Baziotes—a fact that would be very significant to any
dealer at that time trying to get started with an American stock. He
also mentions how few the sales were during the period, and how low
the prices; for example, one picture by de Kooning from the 'Black
and White Show' in 1949 (the only one he sold) went for $700.

Another influential dealer whom the artists liked was Betty Parsons.
She had the advantage of having come from the upper classes, of

being familiar with their mores and their peculiar areas of snobbery, and of knowing many of the patrons of the Museum of Modern Art through her family connections. Her other advantage was that she had rebelled at an early age and had gone to Paris to study art. She began exhibiting in New York in the mid-thirties. Her acquaintance with such influential figures as Frank Crowninshield of *Vanity Fair* (a close friend of most of the Museum of Modern Art's original trustees) undoubtedly made her entrée in the field of art-dealing easier. Her first notable gestures were when she was a partner at the Wakefield Bookstore, where she was a cordial and sympathetic viewer of almost any art brought to her attention. When Mortimer Brandt took over the shop, he made Betty Parsons director of the contemporary section, and it was there she presented Theodore Stamos, Adolph Gottlieb (with a catalogue introduction by Barnett Newman), and works by Rothko, Hedda Sterne, and Ad Reinhardt. In September 1946 she opened the Betty Parsons Gallery.

Peggy Guggenheim relates that when she closed up shop she tried to find a dealer willing to take on Jackson Pollock. The only one courageous enough was Betty Parsons, who also fell heir to Rothko and Still. Her first show was arranged by Barnett Newman, whose judgment and humor Betty Parsons keenly appreciated. Thereafter, Newman was a considerable force in the decisions of the gallery and, for a time, Newman, Rothko, and Still formed a distinct trio in the gallery, with Pollock somewhat apart. Because of her intelligence and her outstanding sense of justice, Betty Parsons was able to cope with the considerable temperamental tension these men generated. Both Still and Rothko had already begun to shield themselves from the encroachment of an affluent society by provocative gestures of refusal and statements of their incorruptibility. For a dealer trying to build a market, such behavior could be very trying, but Betty Parsons, herself an artist, was not only patient, but also supportive. In their efforts to control the 'life' of their paintings, Still, Rothko, and Newman seemed to have consulted with each other. Still, in his letters to Betty Parsons, was constantly arguing against group exhibitions and art appreciation in general, and he and Rothko refused to show at the Whitney Museum, proffering arguments that were phrased practically identically. This early quarrel with the establishment grew more acute as the fame of these artists grew, and their dealers' problems increased accordingly.

All the same, the new dealers were working effectively with the museums and the small sympathetic press, and mutual interest

170

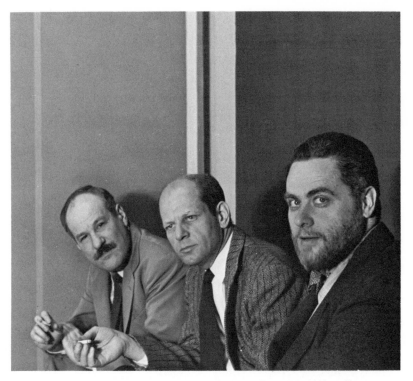

34. Barnett Newmans' first triumph was at Betty Parson's gallery on East 57th Street. He is seen here (extreme left) with Jackson Pollock and the architect-sculptor Tony Smith. Photo by Hans Namuth, courtesy Betty Parsons

served to create an ever-widening interest. For instance, when *Life Magazine*, with rather pompous pride, presented its first Round Table on Modern Art[3] ('in which fifteen distinguished critics and connoisseurs undertake to clarify the strange art of today') the paintings of 'young American extremists' reproduced and discussed by the experts included de Kooning's 1948 *Painting*, which had just been acquired from Egan by the Museum of Modern Art; Baziotes' *The Dwarf*, warmly defended by the Museum's own James Thrall Soby (against Greenberg's assertion that it was bad art); Gottlieb's *Vigil*, shown by Kootz the year before; Stamos' *Sounds in the Rock*; and Pollock's *Cathedral*, which had just been shown that season at Betty Parsons to the predictable praise of Greenberg and Sweeney. Both the selection of paintings and the choice of experts indicate that the newly established galleries for American vanguard art were making

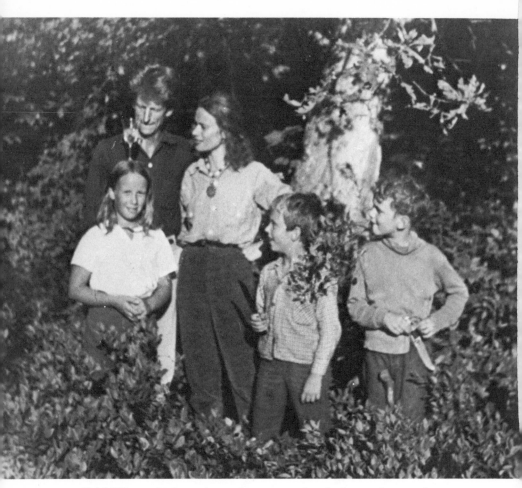

35. David Hare, who loves the outdoors as much as he loves urban tensions, seen in the mid-nineteen-fifties with his wife, the photographer Denise Hare, and family. Photo: courtesy Denise Hare

headway in broadcasting the importance of their venture. That so many distinguished experts—among them Meyer Schapiro, Aldous Huxley, and Georges Duthuit—could be gathered together by *Life* to consider an absurdly posed question on modern art, was in itself a measure of the need postwar America was feeling for the modern art experience. The question posed for these experts was: 'Is modern art, considered as a whole, a good or bad development? That is to say, is it something that responsible people can support, or may they neglect it as a minor and impermanent phase of culture?' Their willingness to deal with such a loaded question is some indication of their missionary intentions.

The enthusiasm of the experts predictably met with increasingly agitated hostility from most of the popular papers, and in May 1949, Holger Cahill expressed in the *Magazine of Art* his anxiety concerning the growing attacks on 'unintelligibility,' particularly on artists who came out of the thirties. He named Rothko, Pollock, Motherwell, Baziotes, Cavallon, Still, Gottlieb, Hare, Smith, Gorky, de Kooning, and Tomlin as significant artists who were not appreciated, and he lamented the impoverished state of art criticism. This list of names betrays Cahill's own evolution from the thirties, when he was still hoping that American art would relate to the people. Clearly, no one in his position could any longer entertain such hopes. The breach was widening rather than narrowing.

Existentialism

When Rosenberg and Motherwell wrote pessimistically in *Possibilities*, offering the barest hope that something *might* come of the artist's individual struggle, they had already begun to see the renewed conflict between artists and their society. On the one hand, there was the rising sense of importance in the artists' circle, and on the other, a rising awareness of the problem their importance posed for society. Acting in the name of the United States government, society acknowledged the new American painting by proudly sending abroad a selection of work, and then, in 1947, rescinding it. Secretary of State Marshall's cancellation of 'Advancing American Art' was the cause of considerable alarm. This incident, and others that might be characterized as political, helped to increase the uneasiness within the ranks of the art world. Artists, on the whole, were driven further and further away from the issues that had once inspired so much discussion. The pressures that had built up in the thirties now seemed remote. The artist, like every American citizen, faced a postwar society that had little in common with that which he had known in his formative years.

The first postwar election reflected the prosperity generated by the war. The Republicans did well; corporations were well represented; and the liberal legislation passed by New Dealers in the nineteen-thirties was effectively vitiated. From 1946 onward, businessmen lobbied to reduce government spending for the public good with such success that, in the fifties, there were sociologists who could speak of an age of corporations and conformity (while I. F. Stone referred to the 'haunted fifties'). Old reactionary tactics were revived, and a zealous, ambitious politician called Joseph McCarthy saw the value of renewing the red scare that had been used before to stave off social reform. It is significant that McCarthy got his start in the field of real

estate. Those who had hoped to institute a new era with good public housing and liberalized city-planning were the natural enemies of speculators. McCarthy consciously climbed to political prominence by attacking government housing projects. His first target, in fact, was the Rego Park Housing Project, containing 1,424 units for veterans. He visited the project in 1947 and then called a press conference to denounce it as 'a breeding ground for Communism' (at that time he represented the pre-fabricating industry). It was brought to his attention that public housing was not a good issue for him in view of the veterans and the housing shortage, and so he moved into greener pastures, such as the universities, Hollywood, and the cultured classes in general.

As such sensational events as the Alger Hiss case swept the red scare into prominence, and as McCarthy easily destroyed the solidarity of the professionals he attacked, the malaise of the intellectuals deepened. Silence fell. Marxism, which had once been so vital to artistic discourse, faded into the background of new discussions of existentialism. The old conflict between individualism and the collective ethic was interiorized. While President Roosevelt could see the virtue of giving the artist his experimental head, Truman could publicly deride the 'ham-and-eggs school' of painting, while approving its suppression. Times had changed indeed.

'Where to go now? What to live for?' These, wrote Theodore Solotaroff, 'became the leading questions as the "economic crisis" of the thirties faded into the "moral crisis" of the forties, and the "alienation of the masses" was changed by the war psychology and the war economy into the "alienation of the individual." '[1] In his introduction to the essays of Issac Rosenfeld, an intellectual who was a product of the Depression, Solotaroff stresses Rosenfeld's knowledge of the invigorating value social orientation has for an intellectual and describes Rosenfeld's distress when, in 1946, he noted a shift from Marx to Freud—from 'change the world' to 'adjust yourself to it.' Rosenfeld saw that it was an orientation appealing to the bourgeois in all of us, Solotaroff notes, by shifting the perspective from a radical and historical understanding of contemporary society to one of accommodation and apologia. The change was noticeable not only in the literature of the period, but also in the rhetoric of the visual arts. The dilemma faced by painters, sculptors and sympathetic onlookers was accurately reflected in an article written by René d'Harnoncourt, then director of the Museum of Modern Art, called 'Challenge and Promise: Modern Art and Modern Society':

It is obvious that the dilemma of our times cannot be solved by directive or by pressure. It can be solved only by an order which reconciles the freedom of the individual with the welfare of society and replaces yesterday's image of one unified civilization by a pattern in which many elements, while retaining their own individual qualities join to form a new entity.[2]

If alienation was to be the *leitmotif* of the decade following the war, the visual artist had a head start, having always been the last of the intelligentsia to receive his rewards. It was not difficult for the developing community of vanguard artists to establish the individual act as the only possible escape from the social and political hazards facing him. Attitudes expressed in the late forties grew closer to the position that had always been maintained by a few painters—most notably by de Kooning, who had remained aware of but deliberately aloof from everything extrinsic to the interior development of his work. Though he had always had wide interests, he rarely took action in any situation other than that in his studio. His very style of painting had evolved in a state of tension between form and its antithesis, and ambiguity, that most important component in existential philosophy, was as familiar and profound to him as intelligibility was to his antagonists.

De Kooning's organic vision was geared from his early years to the discernment of unexpected disjunctures of form, and the constant sense of flux beneath outward appearances. In this work of the early thirties there are signs of his temperamental attraction to all that was equivocal and unfixed—signs that ambiguity was to him a source of tremendous excitement. His quest for a fixed image, as all his friends testify, was always fraught with doubts about the value of a fixed image. Process was his natural mode, as it was for his nineteenth-century romantic forebears. As his assurance increased, de Kooning employed painting techniques which reflected his attitudes. In the early forties there were frequent allusions in his work to the drama of what had once been there on the canvas; little, half-erased signs of previous life, scraped off the surface but still existing in phantom-like areas behind the immediate picture plane. Between 1943 and 1946 he painted many versions of seated figures, usually women, in which he juxtaposed forms clearly defined by his strong curving lines, with forms that were blurred almost to extinction. An arm or a shoulder would seem discrete from the rest of the composition until the eye chanced upon those mysterious whispered allusions—the forms that were at one and the same time erased and retained in a state of ambiguous suspension.

176

When late in 1946 he began to experiment with black-and-white lacquer paintings, his forms were enunciated by wispy or sharp white linear passages threading through the black masses. Even here the eye could never be quite sure whether the light that passed in and out of the surface pigment was indeed the determining edge of a form, or whether the curving black shapes were themselves the formal determinants. It was absolutely inherent in de Kooning's temperament that the image be allusive and, finally, ambiguous. It is not surprising that he became a kind of hero in vanguard circles. Having maintained a consistently open position, and having spurned any final stylistic decisions, he represented a point of view that in those postwar years was apposite to spiritual needs. 'Spiritually,' he said at a Museum of Modern Art symposium in the spring of 1951, 'I am wherever my spirit allows me to be, and that is not necessarily in the future.'[3] His other remarks in the same talk also met the new intellectual needs of the artists (although for de Kooning they were not new at all, but entirely consistent with his stance throughout his painting life):

Art never seems to make me peaceful or pure. I always seem to be wrapped in the melodrama of vulgarity. I do not think of outside or inside—or of art in general—as a situation of comfort. I know there is a terrific idea there somewhere, but whenever I want to get into it, I get a feeling of apathy and want to lie down and go to sleep. Some painters, including myself, do not care what chair they are sitting on. It does not even have to be a comfortable one. They are too nervous to find out where they ought to sit. They do not want to 'sit in style.' Rather, they have found that painting, any style of painting—to be painting at all, in fact—is a way of living today, a style of living, so to speak. That is where the form of it lies. It is exactly in its uselessness that it is free. Those artists do not want to conform. They only want to be inspired. . . .

By casting the artist in a role of openness, of restlessness, of spiritual independence, de Kooning announced an attitude that was to sustain the artists in New York for some years to come. It freed them from the insoluble conflicts posed during the thirties, and aligned them with the prevailing current of thought in the intellectual community. Those years immediately following World War II were dominated with ideas that could be called 'existentialist' in a broad sense. There could be no 'situation of comfort' as de Kooning had said, and the artists could no longer 'sit in style.' Anxiety—another way of referring to such inspiring discomfort as de Kooning described—was to be a key phrase. In 1946, Auden wrote 'Age of Anxiety,' in which his own existentialist propositions were repeatedly stated, as for instance:

I have watched through a window a World that is fallen,
The mating and malice of men and beasts,
The corporate greed of quiet vegetation,
And the homesick little obstinate sobs
 Of things thrown into being.[4]

Even Auden's diction here is tinctured with the basic philosophic vocabulary of the existentialists, particularly Heidegger's notion of being 'thrown into being.' References to Heidegger and his interpreter Jean Paul Sartre were frequent in the literature of the period. By 1947, there was a noticeable existentialist bias in *Partisan Review*, for instance. During that year there were articles by William Barrett on both Kafka and Joyce, in which he explored the idea of 'authentic' art (another of Heidegger's terms), and there was a long article by James Burnham on Kafka. Later Barrett wrote 'A Dialogue on Anxiety' in which he opposes Heidegger to Freud. There was also, during 1947, a note on Sartre's *No Exit* and *The Flies*, which began 'Sartre has defined his theatre as one of situations rather than characters . . .'[5] Here, the idea of situations, which was growing in importance, presents a new theme for critics, and in many ways sums up the views of the painters. Louis Finkelstein, himself a painter and friend of de Kooning, wrote of him in the October 1950 issue of the *Magazine of Art* that 'instead of painting objects he paints situations.' Such 'situations' were understood by most painters of that period to be unstable, difficult to define, fraught with imperceptible hazards, and in constant danger of being unsituated. In 1948 Sartre himself published an essay 'What is Writing?' in *Partisan Review* in which he discussed that vital issue—the myth. 'Originally, poetry *creates the myth*,' he claimed, 'while the prose writer draws its portrait.' He defends the idea of 'engagement' for the prose writer but does not insist on it for the painter or composer.

The language of the existentialists began to grace art criticism in the late forties and early fifties. In a review of Pollock's work, for example, Parker Tyler spoke of his 'paint stream' and his paradoxical attitude to perspective, and called the painting 'being in non-being.'[6] Sartre himself wrote the introduction for David Hare's exhibition at the Kootz Gallery in 1948, using the impressive battery of ambiguous phraseology at his command:

He offers us at the same time passion and its object, labor and its instrument, religion and the sacred object. . . . Graceful and comical, mobile and congealed, realist and magical, indivisible and contradictory, showing simultaneously the mind which has become an object and the perpetual bypassing of the object by the mind . . .

178

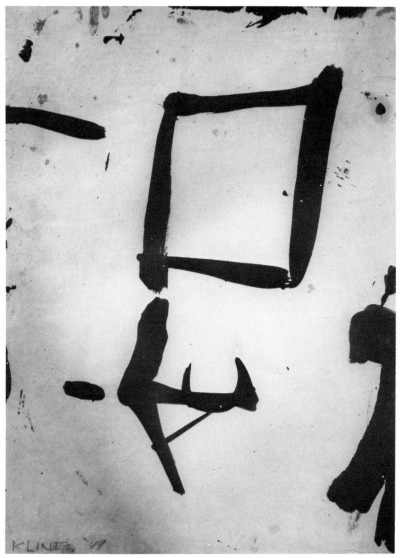

36. When Franz Kline abandoned his figurative style in the late
forties, he made many small ink drawings on paper, such as this
calligraphic and quite Oriental looking sketch of 1949. Photo
from Estate of Franz Kline, courtesy Marlborough Gallery,
New York

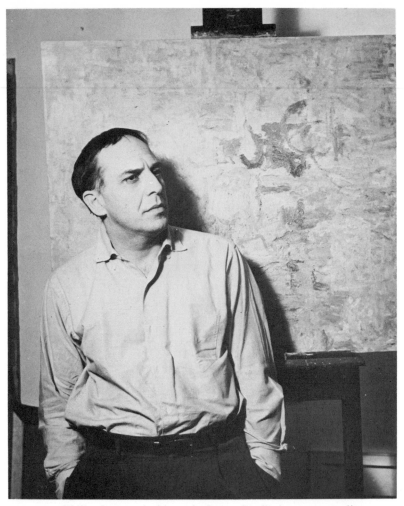

37. Philip Guston in his 10th Street Studio in 1951 standing before one of the delicate, pink-hued abstractions exhibited in his one-man show at the Peridot Gallery in 1952. Photo: courtesy Philip Guston

The emphasis on duality, ambiguity, and metamorphic quality found in this fragment of Sartre's esthetics was appreciated as a positive value during that period. When Franz Kline began to paint his black-and-white abstractions, which he showed for the first time in 1950, he worked from a position in which the 'situation' was imagined to be fluid, reversible, always open. The word 'situation' itself entered his discourse frequently. He spoke of his opening strokes as 'the beginning of the situation,' and he told David Sylvester that, in composing, he tried to rid his mind of anything else and 'attack it immediately from that complete situation.'[7] The ambiguities in the painter's 'situation' were increasingly the subject of discussion. Philip Guston, who had begun to paint nervous, calligraphic abstractions about 1950, and had his first important exhibition at the Peridot Gallery in 1952, later spoke of 'the delights and anguish of the paradoxes on this imagined plane,' and of forms that 'having known each other differently before, advance yet again, their gravity marked by their escape from inertia. . . .'[8]

The dynamic hidden in the existentialist position was helpful to the painters who willed to break free from their previous preoccupations, and it was confirmed by reading Sartre, especially when he insisted on the 'subjective' aspect of his philosophy. When he explained that existence preceded essence because 'man first of all exists, encounters himself, surges up in the world—and defines himself afterwards,' it suited the needs of artists who wanted to believe that in the subjective process of painting itself they would find their own definition:

Man is, indeed, a project which possesses a subjective life, instead of being a kind of moss, or a fungus or a cauliflower . . . Subjectivism means on the one hand, the freedom of the individual subject, and, on the other, that man cannot pass beyond human subjectivity. . . . What we mean to say is that a man is not other than a series of undertakings, that he is the sum, the organization, the set of relations that constitute these undertakings.[9]

Even more important perhaps was Sartre's often reiterated belief that in 'choosing' what he would be in essence, a man was choosing for all men. By making the subjective existence an ethical existence, by suggesting that from his own willing and choosing a man could still represent all mankind, Sartre offered an invaluable buoy in a rough sea of contention. The painter could thus pursue his individuality in the course of his acting on canvas and still maintain a thread of hope that what he was doing would have some value for

mankind. It was surely this hopeful salve for the individual conscience that attracted so many artists to the existentialist position.

The existentialist sensibility was expressed not only in the little literary magazines, but also in the newly-born reviews of the postwar period in which the role of the visual artist was conceded to be on a par with that of the poet and composer. The European booksellers Heinz Schultz and George Wittenborn, whose shop on East Fifty-seventh street was a mecca for those interested in the fine arts, understood the necessity of injecting the European breadth into the literature of the arts, and they sponsored a number of highly significant publications in their two series, 'The Documents of Modern Art' and 'Problems of Contemporary Art.' The first issue of *Possibilities*, edited by Harold Rosenberg and Robert Motherwell, was the fourth in the general series, which was announced as 'an open forum for twentieth-century artists, scholars, and writers, the word "art" being taken in the broadest sense.'

The breadth was immediately apparent in these publications, which were the first to move easily among all the arts, as the little reviews in Europe had always done. *Possibilities* was without question the most exciting synoptic view of the postwar preoccupations of artists, and when it appeared in the fall of 1947, it was eagerly acquired by the whole community of New York artists. In their introduction the two editors set a clearly existentialist tone. The opening pages were adorned with reproductions of new paintings by William Baziotes, who wrote of his open situation, of his belief that the painter can work in any stylistic mode that suits his emotions, and who stressed that the works were the means of his individuation: 'They are my mirrors. They tell me what I am like at the moment.' In the same issue Jackson Pollock made his famous statement describing how he painted on the floor in order to feel closer to and more a part of his painting, and how he strived to keep contact with his painting by being being *in* it, an intimate part of it; and announced his intention of getting farther and farther away from the usual painter's tools such as easel, palette, and brushes. Pollock's piece was followed by an essay entitled 'The Romantics were Prompted' by Rothko, who in 1947 was still working with individual shapes having totemistic associations. He described them in language that

38. Pollock's East Hampton studio was widely photographed, and especially well-observed by Rudolph Burckhardt. Photo by Rudolph Burckhardt, courtesy Lee Krasner Pollock

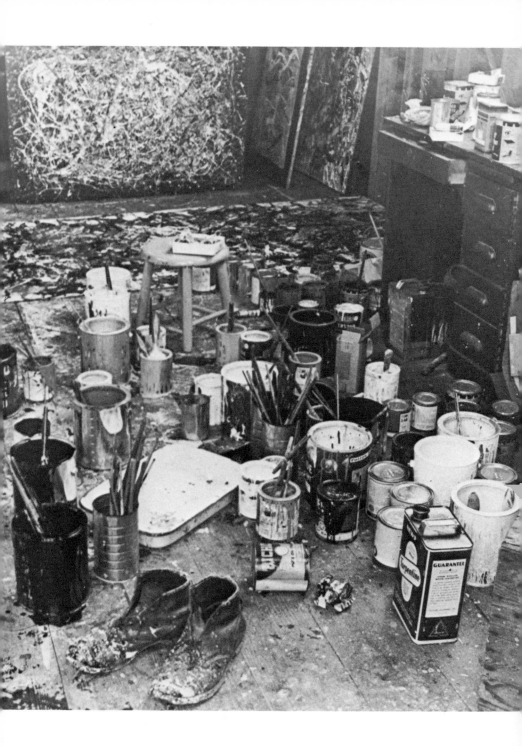

corresponds with that of the literary existentialists writing in *Partisan Review*:

On shapes:
> They are unique elements in a unique situation.
> They are organisms with volition and a passion for self-assertion.
> They move with internal freedom, and without need to conform with or to violate what is probable in the familiar world.
> They have no direct association with any particular visible experience, but in them one recognizes the principle and passion of organisms.

Finally Rosenberg himself, who had been gradually assuming the role of spokesman for those artists not under the aegis of Greenberg, injected certain of the existentialist assumptions in his introduction to six American artists—William Baziotes, Romare Bearden, Byron Browne, Adolph Gottlieb, Carl Holty, and Robert Motherwell, who had exhibited in Paris in the spring of 1947 at the Galerie Maeght. Rosenberg first detaches these postwar artists from the American tradition of realism, and then carefully situates them in the internationalist modern tradition. Moreover, he insisted for the first time, as he continues to insist, that 'they are not a school, they have no common aim,' but that they have 'appropriated modern painting not to a conscious philosophical or social ideal but to what is basically an individual, sensual, psychic, and intellectual effort to live actively in the present . . .' He then described their estrangement from American objects, which he says reaches the level of pathos, and concluded with Sartrean eloquence: 'For each is fatally aware that only what he constructs himself will ever be real to him.' (A strong current stemming from the nineteenth-century romantic tradition flows into Rosenberg's writings in the late forties. In the same issue he published a brilliant inquiry on *Hamlet* and Hamletism—a traditional romantic preoccupation which suited perfectly the existentialist temperament.)

In the same year that *Possibilities* appeared, the other very important publication of the late forties, *Tiger's Eye*, commenced publication as a quarterly. Its sponsors, Ruth and John Stephan, were equally familiar with the milieu of the poets and the painters, and immediately set out to promulgate the genuinely intellectual role of the visual artist. In this they were assisted for the first few issues by Barnett Newman, whose zeal during those years provided the painters with their first serious outlet for written discourse. The Stephans had taste and a sense of adventure, and they tended to publish the more extravagant and anarchistic writers who were then in revolt against

39. During the early nineteen-fifties, East Hampton came to be an outpost of the New York School. At one of the many beach parties Harold Rosenberg is seen at right, and standing facing the sea are (r. to l.) Franz Kline, Alfred Leslie, and Herman Cherry. Photo by Denise Hare

English literary traditions. In the second issue, for instance (in December 1947), there are contributions by Kenneth Rexroth and Paul Goodman, as well as translations of Raymond Queneau, and reflecting the surrealist interests, of a Kwakiutl Shaman song.

As its contribution from artists the issue included 'The Idea of Art,' in which ten painters made brief statements, all reflecting a distinct new sense of confidence. Newman himself wrote an arch, provocative statement in one sentence: 'An artist paints so that he will have something to look at: at times he must write so that he will also have something to read.' Newman's tone of sublime confidence, of arrogance even, was unfamiliar to the majority of unsuccessful visual artists, but those who contributed to *Tiger's Eye* shared his sense of the growing importance of what Rothko was to call their 'endeavor.'

They shared also a penchant for the eruptive intelligence of the individualist philosophers whom the French existentialists had

40. Adolph Gottlieb in his Provincetown studio during the summer of 1949 when intense discussions took place everywhere, with Hans Hofmann exhorting the younger artists not to lose sight of the importance of European painting. Photo by Maurice Berezov

reappraised. Nietzsche, as we have seen, had been an influential background figure in the immediate postwar years. In the third issue of *Tiger's Eye* a quotation from Nietzsche was casually inserted on a page bearing a drawing by Theodore Stamos. It is a statement pitched in the oracular tone Nietzsche adopted when he was writing poetically—the tone that most nearly matched the feelings of so many painters in New York at that time:

I shall keep my eyes fixed on the two artistic deities of the Greeks, Apollo and Dionysus, and recognize in them the living and conspicuous representatives of TWO worlds of art differing in their intrinsic essence and in the highest aims. I see Apollo as the transfiguring genius of the PRINCIPIUM INDIVIDUATIONIS through which alone the redemption in appearance is truly to be obtained; while by the mystical, triumphant cry of Dionysus the spell of individuation is broken, and the way lies open to the mothers of being, in the innermost heart of things

The confusions that attended the emergence from the thirties were surely not clarified in Nietzsche's views, but they *were* given heroic character. Those artists who were seeking a raison d'être not deriving from a specific social situation could believe that by transcending the individual emotion they might lead themselves and others to 'the innermost heart of things.' At the same time, the existentialist canon was to realize the self through the full and intense development of individuality. The intrusion of Nietzschean paradox proved to be both a source of continuing consternation and a source of Nietzschean heroics.

Newman, who probably chose the Nietzsche text, wrote in a similar vein in the same issue, returning to the Greeks, as he had learned to do from Nietzsche, to examine both the Apollonian (which he associated with European nostalgia and therefore rejected) and the Dionysian, with which he clearly identified:

. . . The artist in America is, by comparison, like a barbarian. He does not have the super-fine sensibility toward the object that dominates European feeling.

He does not even have the objects.

This is, then, our opportunity, free of the ancient paraphernalia, to come closer to the sources of the tragic emotion. Shall we not, as artists, search out the new objects for its image?

This preoccupation with the Dionysian, and with Greek tragedy, which informs the comments of Newman, Rothko, Gottlieb, Baziotes, and many others during those years, found its perfect spokesman in Nicolas Calas, a Greek thinker living in America, who performed the indispensable function of being an expert by birth and by intellect.

His analysis of the essence of tragedy which appeared in the same issue shows his erudition, his imaginative volatility, and his ability to gather in his speculative net the disparate but clear, leading ideas of the moment. His role in the development of the visual artist's stance in society should not be underestimated. By bringing his resourceful imagination to bear on esthetic and political problems derived from concourse with artists, he was able to give weight to their new claims as working members of the cultural milieu. To a remarkable degree, Calas' essay touched on the strong existentialist themes, while limiting its ostensible subject-matter to a study of Greek tragedy. His analysis could well be juxtaposed with Sartre's informal explanation of existentialist positions: 'It is because individualism is grounded in self-confidence that the individual who has extreme self-confidence and great will power can rise above others and become a hero,' Calas wrote. 'However, the hero's self-confidence should never blind him to the fact that, as an individual, he, like all mortals, remains exposed to the vicissitudes of fortune.' Calas' juxtaposition of religion, which he regarded in a completely Nietzschean light as an unhealthy leveler of both freedom and tragedy, and the Socratic heroic position must have fallen on very sympathetic ears in the art world. His concluding sentences anticipated those painters who would soon be talking about the value of 'risk' in the act of painting: 'Doubt is not the consequence of faith but of self-confidence. Only there where doubt exists does temptation have meaning. Through self-confidence and doubt the hero challenges temptation.'

The romantic preoccupation with myths—both Greek and American Indian—continued for at least another year to dominate the discourse in *Tiger's Eye*. In the issue of October 1948, for instance, Baziotes wrote in an exalted Nietzschean style:

> To be inspired, that is the thing;
> to be possessed; to be bewitched;
> to be obsessed. That is the thing.
> To be inspired.

Other voices struck the same lyrical note (one of the legacies of surrealism) in thinking about inspiration, and sought to explain the importance of challenging temptation and working with doubt. In a rather technical description of the character of the monotype, Adja Yunkers, who had recently arrived from Europe, spoke of the surprises, the organized incidents, and the charm and magic of the medium 'depending upon imponderabilia and "hazards" of the "distrustful

no-man's land of shadow" of free execution, where dream and reality happen on the same plane!'[10]

By 1949 the literal assaults on the problem of myth subsided, and the will toward transcendentalism in abstract painting, already inherent in Rothko's position in 1947, reveals a new confidence in the discoveries those intense two years brought forth. In the October 1949 issue of the journal, several of Rothko's 'clarified' paintings, in which all traces of the mythic allusions disappear, are reproduced along with his brief statement of triumph over the problems which had thwarted him:

The progression of a painter's work, as it travels in time from point to point, will be toward clarity: toward the elimination of all obstacles between the painter and the idea, and between the idea and the observer. As examples of such obstacles, I give (among others) memory, history, or geometry, which are swamps of generalization from which one might pull out parodies of ideas (which are ghosts) but never an idea in itself. To achieve this clarity, is, inevitably, to be understood.

This statement reflects the pressing need Rothko and others felt for a clear and direct emotional position. The work, as he saw, needed clarification, just as the esthetics of the postwar period had to be modified to deal with the new imagery that appeared so rapidly between 1940 and 1950. Many artists were quite willing to follow their more intellectual companions into previously unfamiliar realms of art philosophy. There is an ironic flowering of philosophical, even meta-physical, speculation in the literature the artists consumed at the same time that they were pressing beyond the literary in their paintings.

Nothing brought the philosophical hunger into better relief than a lofty symposium, published in the December 15, 1948, issue of *Tiger's Eye*, treating the nature of the sublime in art. Obviously, most painters did not leaf through Longinus and Burke in their leisure time, and few were aware of the historical arguments centering on the notion of the sublime. All the same, the use of the word sublime (which had played such an important part in the thinking of nine-teenth-century American artists) did inspire a vague sense of con-firmation. Even assuming that a few studio discussions were specific-ally concerned to define the sublime in art, there were nevertheless a number of artists very eager to have a philosophic envelope in which to evolve. They were favorably disposed to this effort on the part of the intellectually inclined painters Motherwell and Newman to infuse their new society with a lofty sense of purpose and the dignity of philosophic inquiry.

In searching through the documents of those few intense years leading up to and going just beyond 1950, it appears clear that the need for sustaining myths gave rise to an unusual amount of intense philosophizing. By injecting the idea of the sublime into the discourse at that moment, *Tiger's Eye* was answering a distinct need. The use of the term was somewhat careless, it is true, but it nonetheless served to open still other avenues of discourse. It helped to expand the views and inform the intelligences of those who, in building a heterogeneous but quite visible milieu during the late forties, sought to implant the visual arts as a legitimate field of study for cultured Americans.

Curiously, the six contributors to the symposium 'What is Sublime in Art?'—Kurt Seligmann, Robert Motherwell, Barnett Newman, David Sylvester, Nicolas Calas, and John Stephan—never referred to its rather elaborate American precedents in the nineteenth century, but concentrated instead on bending the concept of the sublime to the purposes of modern art. There is also considerable confusion in the texts as to *whose* notion of the sublime they are discussing. Motherwell returns to the treatise of that anonymous Roman writer conveniently called Longinus, and speaks of the exalted, the lofty, 'The echo of a great mind.' Newman also refers to Longinus but seems to take his interpretation of Longinus from Edmund Burke, whom he obviously prefers. Calas also moves away from Longinus toward the Burkean preoccupation with *terribilità* as the best expression of the sublime. None of the authors was scholarly enough, nor was it finally important to their cause, to check the translations of Longinus: to note that the treatise is fragmentary and that large, important sections are missing; or to understand that Longinus was dealing specifically with literature as a sharp and analytic critic, and that his observations were almost never disassociated from specific literary experiences. Longinus served only in a symbolic sense, and his real statements were not important to these excited writers looking for the philosophic touchstone of their moment.

Except for Motherwell, who speaks with marked yearning of the painting that 'becomes sublime when the artist transcends his personal anguish, when he projects in the midst of a shrieking world an expression of living and its end that is silent and ordered,' most of the writers advance in history to the sublime *terribilità* of Nietzsche. Clearly Newman distorts Longinus when he declares that 'to him the feeling of exaltation became synonymous with the perfect statement—an objective rhetoric,' but the distortion served to bolster his essential argument that 'here in America' he and his friends were getting

41. The surrealist capacity for family pleasure continued well into the nineteen-fifties. In this still from the chess film *8 × 8*, Nicolas Calas (left) played knight while Richard Huelsenbeck, Marcel Duchamp, and Enrico Donati took other chess rôles.

rid of obsolete props in order to make sublime art 'out of ourselves, out of our own feelings.' The Longinus treatise, as we know it, makes a point of insisting on the correct expression of specific feelings, and not false rhetoric and specific literary figures. Furthermore, it makes very clear that the perfect statement is not at all likely to be a repository of sublimity: we must ask ourselves, Longinus says, which is superior, 'grandeur accompanied by a few flaws, or mediocre correctness, entirely sound and free from error though it may be.' And he firmly answers that the grand manner is much more likely to be flawed since the mediocre never aim at heights. Throughout the treatise, Longinus calls in examples to show how much the sublime is dependent on strong emotions, and above all, on the imaginative synthesis of emotional and intellectual elements. The passage to which most writers seem to revert is only in the introduction, 'First Thoughts on Sublimity,' and even then, if read carefully, does not support Newman's interpretation. Longinus writes to a certain Terentianus, who as a man of some erudition, would understand without a long preamble that

sublimity consists in a certain excellence and distinction in expression. . . . For the effect of elevated language is, not to persuade the hearers, but to entrance them; and at all times, and in every way, what transports us with wonder is more telling than what merely persuades or gratifies us.

What interested these painters who briefly scanned the philosophic horizons for the myth of the sublime is that which would 'transport with wonder.' The exalted and awesome matched their emotions and was sufficiently ambiguous in definition to serve as an inspiring myth.

The Eighth-street Club

The artists, who recognized again the importance of expressing their ideas, changed their attitude toward the literati to some degree. Where before there was a well-developed suspicion on both sides, during the late forties there were attempts to bring about a rapprochement. Painters, always somewhat sceptical of literary interpretations of their art, nevertheless bemoaned the lack of communication with their intellectual peers. The idea that a real movement, such as the cubist movement in Paris, was always originated by a cast of brilliant protagonists from various branches of the arts, lingered in their thoughts. Although most painters disavowed an interest in building an American movement to rival European precedents, they were very much excited by the prospect, as numerous accounts of contemporary conversations attest.

The artists had labored under the tacit belief that there could be no true American culture for a long time. This belief they shared with the postwar generation of writers who, like the painters, began again to search for the American element in American letters. Norman Podhoretz, educated during the nineteen-forties, summarizes the attitude that prevailed in universities at that time:

I did not think of culture as anything *national*, and in any case American culture had no real status in the eyes of anyone in the 1940s; even if it had, an immersion in it would have left me feeling more, not less, alienated from the national life than before—would have left me feeling, in fact, that the country was hopelessly in the grip of forces of commerce and that there was no place in it for a man of sensibility and taste.[1]

Other writers expressed the sense of alienation from national life, and from each other, by turning to what they hoped was a unique, indigenous American tradition. The anarchic American wild men

193

of letters such as Dahlberg, Henry Miller, Kenneth Rexroth, and Kenneth Patchen enjoyed new underground fame because, as Isaac Rosenfeld remarked, 'the American nightmare has taken the place of the American dream and it is as sentimental as its predecessor, as popular and widely believed in.'[2] Rosenfeld identified the quickening interest in the American alienated genius that was to lead to the phenomenon of the 'beat' generation. As early as 1945 he had remarked on Henry Miller's vogue among students and on Miller's own enthusiasm for Kenneth Patchen:

He fastens on that which is anti-cultural, anti-traditional, anti-intellectual, which subverts form and allows the writer to emerge as the permanent center and concern of all writing . . .[3]

The perpetual conflict between the need for a refined culture and the need to reject tradition and intellectual assumptions, was very marked in the late forties. Henry Miller's existence side by side with the new schools of academically trained, highly intellectual literary critics, was an inherent paradox of the time. A stubborn desire to avoid academicizing was at least as strong as the will to acquire a cultural position in America. Willem de Kooning obliquely reflected this conflict when he alluded to literature in one of his famous titles, *Light in August*; at the same time, he identified with the half-breed hero of the novel, the alienated and fatally expendable Joe Christmas. De Kooning told an interviewer:

There are these two men talking in a barn, and off to one side in the doorway is standing that half-breed Joe Christmas dressed in what I imagined to be a kind of zoot suit . . . I'd like to paint Joe Christmas one of these days.[4]

Writers and painters alike experienced a two-way conflict. They felt they were on the verge of being incorporated, no matter how crassly, into the mainstream of society, and they felt more isolated and lonelier than ever. If they were ensconced in the newly developed academic refuge, they reinforced their isolation by a studied sense of detachment. Simone de Beauvoir on her tour of universities was disheartened to find highly specialized academics in the literature departments: 'Literary people are considered esthetes; they themselves derive a certain glory from this distinction, and they isolate themselves.'[5] On the other hand, she found that isolation was, indeed, the hallmark of American culture. She visited the workshop founded by the refugee director Erwin Piscator, whose fame and success in Europe had been enormous, and noted that 'in America, such

efforts are almost always made in austere solitude. There is no bridge between obscurity and success; the artist works away neglected or amidst the crowd's acclaim. You need luck to make the leap and strength to avoid disaster.' The painters, especially those under financial pressure in the early fifties, would have agreed completely with this assessment of their situation. The problem of success still seemed the canker in the soul of the rebellious American artists and writers. Mme de Beauvoir spoke of visiting a group of editors of a small left-wing literary review who complained that they had less than 6,000 readers and that a writer has

no moral compensations, no friendships with other writers; each is alone; there is no influence to be gained with the public, which is only aware of financial success. But success itself does not always open society's doors to a writer: his reputation is always less and is more transitory than that of a movie star.

Such basic insecurity characterized even the most optimistic statements of an impending new era of artistic appreciation. No artist and very few writers felt at all certain that his position was really changing, despite more university departments of art and writing, more museums, private galleries and traveling exhibitions, wider press coverage, and new artistic reviews. Moreover, by 1949, when Robert Goldwater ran a symposium in the *Magazine of Art* questioning whether there was an art of sufficiently marked character to be called American, and whether there were relationships between contemporary art and literature, all correspondents agreed, as James Thrall Soby put it, that 'the almost total divorce between living literature and living art is a painful American phenomenon.' Another correspondent, Lionel Trilling, dutifully denigrated the idea of nationalism and remarked on the strict *social* isolation in which the two groups live, an isolation, he wrote, that is very nearly hostile. (The painters were almost certainly hostile to Trilling, who represented the new caste of critics dominating the literary reviews; but they were certainly not hostile to Harold Rosenberg, who had long before established himself, as 'one of the boys,' to use his own words, and whose respect for painters was boundless.)

The social isolation to which Trilling referred was to be gradually diminished as both sides began to sense the importance of solidarity. The need for public assertion of an American culture was strong enough to rally even the most confirmed anti-intellectual to the chaotic but purposeful rapprochement, and this occurred not only in the avant-garde literary and artistic reviews, but also in the formation

of a larger and larger community of artists determined to meet each other regularly. The evolution of the legendary 'Club' has been described by various participating members, most of whom disagree in details, but all of whom recognized its value in establishing a sense of the importance of the artist in America. The dynamics of this American kind of movement-building differ sharply from the dynamics that shaped European movements. For one thing, those who gradually began to find that talk could be of great moment to the contemporary artists quite naturally made their discussions public and open to divergent points of view. Whereas in France the discussion that made art movements was usually among artists who shared assumptions, in New York the dialogue took place within a heterogeneous and shifting population of impatient individualists whose only assumption was that something unusual was happening. When public sessions were held, everyone turned up expecting chaotic, excited, and often ridiculous exchanges among recognized antagonists, and they revelled in talk itself as a mode of self-affirmation. To answer the American vernacular greeting 'What's going on?' these New York aspirants to an American movement could only answer that something *was* going on, and that they willed it to go on for the good of America, the individual artists, and the survival of the old bohemian values.

A number of those individuals intimately involved with the public exploration of the situation of the American artist were artists who had long been interested in forging a rhetoric and in finding a philosophy that could reflect their own experience. Sharp-minded and with extremely broad artistic cultures, such men as David Hare, Robert Motherwell, Barnett Newman, Mark Rothko, Willem de Kooning, Ad Reinhardt, and the veteran Harold Rosenberg, could urge their contemporaries to draw closer to the other arts and sciences, and form common cause. When in 1948, Baziotes, Hare, Motherwell, Rothko, and Still planned their art school at 35 East Eighth Street, they called it 'The Subjects of the Artist' because, they said, a student would gain more if he knew 'what modern artists paint about as well as how they paint.' It was what they painted *about* that these artists wished to explore, and that, they defiantly insisted, was what differentiated them from other plastic explorers in the modern tradition. In order to be sure that the students became as aware as they were of the forces of modern life about which they painted, they instituted Friday-evening lectures, open to the public, usually given by fellow artists. During the first year, the studio came to be a gathering

42. By 1949 the need for discussions and lectures was apparent not only at the Club, but also in the summer haunts of the New York artists. This Provincetown forum had been established by Weldon Kees (fourth from left), a jazz expert, poet, and painter who later disappeared; and the poet Cecil Hemley, in a co-operative gallery. Artists met weekly to hear painters, psychiatrists, architects, and poets. To Kees' left are Karl Knaths, Adolph Gottlieb, and George McNeil. Photo: courtesy Adolph Gottlieb

place for each artist who was aware that something was moving in the New York attitude about painting. Thanks to both Motherwell and Newman, the lectures were extremely broad in scope and often derived from literature. When the studio was taken over the following year by some professors from New York University, the Friday evenings continued, and intellectuals such as Hannah Arendt, Richard Huelsenbeck, John Cage, and Harold Rosenberg dealt with questions that broadened the base of the painters' discourse. At the same time, the group at the old Waldorf Cafeteria, which had grown too large, gravitated toward Studio 35. Eventually, they banded together and formed the Eighth-Street Club, which served for several years as the focal point of New York School talk. The coalescence of these informal groupings ensured the heterogeneity of the Club and guaranteed that no creed, no esthetic movement would ever emerge whole.

From its commencement the Club functioned, as all its members agreed, as a surrogate Parisian café. It was where they went to have a drink or coffee, to bring a woman, and to reassure themselves that someone else was there, in the same situation as they were—with the same doubts, loneliness, and fears of the new mechanisms of success. At the same time, in an undefined way, the Club represented a definite attempt to bind together a community, thereby ensuring the position of the American painter in his bewildering postwar society. While the arts used the headquarters to relax and stay in intimate contact with one another, they also used it to confirm their widening audience among the educated strata of the society and to establish the visual artist as a member of the intelligentsia on equal footing with writers and composers. No amount of nostalgic disclaiming can disguise the interest the visual artists displayed in attracting the other intellectuals to their bailiwick, and putting them in their place, so to speak. It was with considerable pride that they scheduled such speakers as Hannah Arendt, Lionel Abel, and E. E. Cummings. Though David Hare or Ad Reinhardt, or sometimes de Kooning, would occasionally heckle the august intellectuals who appeared Friday nights at the Club, they were the first to encourage invitations to poets, philosophers, psychiatrists, and critics. The impetus to storm the gates of American culture was inherent in the large gatherings of artists and their fellow travelers during those hectic years. The overflow into the studio quarter, and into such meeting places as the Cedar Tavern, became legendary. Many a youthful provincial heard about the Club and about the Cedar, and

came to New York to have a chance to drink with the big boys, to call out 'Hi, Jack,' or 'Hi, Bill,' or 'Hi, Franz,' and to feel a part of something not yet defined that was happening in the arts. The heated conversations and arguments that took place at the Club, and even the arcane intellectual lectures, stimulated ever-increasing numbers of aspirants to the bohemian tradition to imagine themselves a part of something roughly similar to a movement. Even the hard drinkers (the participants on panels almost always had paper cups filled with bourbon or scotch) seemed to many a young arrival a hallmark of a special and defined milieu.

That the formulation of a visible milieu was deemed indispensable emerges clearly in the most authoritative account of the three-day symposium held in 1950 at Studio 35 from April 21 to 23. A good portion of the proceedings were published in 1951 by Wittenborn and Schultz in *Modern Artists in America*, another of their adventurous publications that never got beyond the first issue. But that one is, as it was conceived to be, an invaluable historical document, edited by Robert Motherwell and Ad Reinhardt and the Museum of Modern Art's librarian, Bernard Karpel. The intention was to take history out of the hands of historians, to endow the modern movement with the quick insights of the artists themselves, and to 'convey the sense of modern art as it happened.' The collaboration of Reinhardt, already known as a resident moralist in the movement, and Motherwell was in itself an indication of how strong the will to create a defined American movement was. Reinhardt's numerous critiques, delivered with a candor his audiences had learned to expect at the Club, did not prevent his taking part in this serious and purposeful attempt to get a clear view of the broadening cultural landscape. It was tacitly agreed, no matter how fierce the weekly quarrels were, that the enunciation of a milieu was more important in the long run.

In the published sections of the three-day meeting, which was in itself an indication of how intensely interested the artists were in projecting themselves as a group, the intention to declare an entity is apparent even in the fact of their having invited a notable art historian, Alfred H. Barr, to participate. Again and again the question of community is raised and repeatedly evaded. The ambivalence that marked the attitudes of these by-now veterans in the struggle with American philistinism emerges forcefully in their desire for community and their fear of being absorbed and neutralized if they appeared to be a defined group. On the first day Richard Lippold, who served

o

as moderator, urged the group to speak about 'creativity,' but Barnett Newman immediately inserted the crucial question: Do we artists really have a community? David Hare, with characteristic acerbity, answered that he saw no need for a community, that artists always function beyond or ahead of their society, and he summed up his romantic argument by asserting: 'I think this group activity, this gathering together is a symptom of fear. Possibly you could connect this with the question of mass production, in the sense that in this country there is a feeling that unless you have a large public you are a failure.' To which the other arch individualist Ad Reinhardt replied that all the same, why couldn't the group find out what their community is and what their differences are? Motherwell agreed with Reinhardt and the discussion continued but at every turn shied away from defining the community. When Alfred Barr tried to steer the discussion in the direction of finding a name 'for our direction or movement,' the artists, with understandable caution, retreated. The vague sense of community that had drawn them together, even in something as formal as a symposium which was carefully recorded, was not enough to warrant capitulation to the traditional enemy, the art historian. Even the clear understanding that a phalanx formation would lead them more quickly to the promised land of acknowledgment could not allay the romantic instinct for solitary realization. The last word, literally and figuratively, was had by de Kooning who declared, 'It is disastrous to name ourselves.'

The second offering in *Modern Artists in America* was an account of a round-table discussion of modern art in San Francisco organized by Douglas MacAgy, who was then the director of the California School of Fine Arts. The inclusion of this discussion, which had taken place in 1949 from April 8 to 10, indicates how important the continental span was to the New York artists editing this yearbook. Since the end of the war the west coast had kept in close contact with the east, and efforts were made to find common cause. It was in everyone's interest to keep the lines open and to sponsor the idea that what was happening in American painting was a transcontinental event of importance. In this Douglas MacAgy and his wife, Germayne, who was then a curator at the California Palace of the Legion of Honor, were energetic and reliable agents. MacAgy, a Canadian who had spent 'so many years being over-educated' at the Barnes Foundation and the Courtauld Institute, had come to San Francisco in 1941 at the bidding of Dr Grace Morley, the markedly progressive director of the San Francisco Museum. There he plunged into a

43. During the early nineteen-fifties news of the New York School was eagerly sought in the relatively new art departments all over the country. At this symposium (c. 1953) at the University of North Carolina the visiting dignitaries are, left to right: Philip Guston, Jack Tworkov, George McNeil, the art dealer Charles Egan, and Franz Kline. Photo: courtesy Charles Egan

museum schedule of tremendous intensity, dealing with some two hundred exhibitions a year and many special events designed to reach out into the community. MacAgy's interest in vanguard painting was always alive and cosmopolitan, and led him to make the acquaintance of many New York artists, among them Arshile Gorky, who exhibited at the San Francisco Museum in 1941. His duties at the museum were interrupted by the war, which drew him into a new profession as propaganda analyst for the Office of War Information. When the war was over, he found himself embarking on still another profession: that of director of the California School of Fine Arts which had all but ceased to function.

MacAgy quickly put the school on its feet with a new program designed to shatter the premises of all previous art schools in America. He was aided by the returning GIs, who were mostly serious and

somewhat older than the average student population, and whose avid interest in the new currents in American art helped MacAgy to build up an unusual faculty. At all times he kept in touch with New York, as did one of his star teachers, Clyfford Still, who had joined the faculty shortly after his trip to New York during which he had arranged for his first exhibition at Peggy Guggenheim's gallery. Still was by all accounts a figure of tremendous charisma. 'He preached the gospel in terms of baseball analogies, and hammered into his students his ideas about the responsibilities of the artists,' MacAgy recounts.[6] Both Still and MacAgy made frequent sorties to New York, where MacAgy studied the work of the New York painters and wrote occasional articles. It was for them very natural to engage their counterparts for teaching jobs, and in 1947 Mark Rothko went to teach at a summer semester. Rothko proved to be a very inspiring teacher whose 'elusive talk' MacAgy compares to the curling smoke of his ubiquitous cigarette. Other New York artists took on visiting assignments during the five years of MacAgy's stewardship, the last of them being Ad Reinhardt. Throughout his sojourn the artists in San Francisco experienced the same sense of movement, the same upsurge of enthusiasm and confidence that the artists in New York were experiencing. The west coast, as MacAgy stresses, was 'a wide open situation' in which anything was possible, including the leap into fame of an obscure schoolteacher-painter such as Clyfford Still. The stance of such New York luminaries as Pollock, de Kooning, Rothko, and Reinhardt was understood and approved by students and faculty alike, and by a very small but growing number of San Francisco *aficionados*.

As an educator MacAgy was exceptionally daring, and he made the California School of Fine Arts one of the few art schools in the country where young people could come into contact with the essential forces in American painting. His intention was to expose them to the underlying philosophy of the avant-garde as it emerged. 'Artists in coping with assumptions by which we live through the dimensional idiom space–time are attacking another level,' he wrote in a school prospectus in 1948, and he mounted elaborate diagrams and constructions in the school illustrating the space–time continuum, in order to reveal to students 'the new measure of life, as opposed to the Renaissance.' MacAgy liked to talk about 'non-rational truths,' and in general supported the romantic and occasionally metaphysical ideas of a small selection of New York School painters. When it came to organizing the round-table discussion, MacAgy stressed the deep

44. In the late nineteen-forties Ad Reinhardt functioned both as an organizer of important activities to expand the New York School, and as a self-appointed scourge. Despite his acerbity, he was highly esteemed by his peers. Photo by Maurice Berezov, courtesy Rita Reinhardt

45. The tough iconoclasm of Clyfford Still's 'Painting, 1951' brought him
into prominence of the early nineteen-fifties. Coll: The Museum of Modern
Art, Blanchette Rockefeller Fund

seriousness of modern American painting by inviting indisputable authorities from other disciplines to participate. Two visual artists, Marcel Duchamp and Mark Tobey, were joined by a philosopher, George Boas; an anthropologist, Gregory Bateson; a literary critic, Kenneth Burke; art critics Alfred Frankenstein and Robert Goldwater; curator Andrew Ritchie; composers Darius Milhaud and Arnold Schoenberg (who sent his statement in typescript); and architect Frank Lloyd Wright. Because of the heterogeneity of the group, the discussion was generally abstract and stayed close to the problem of culture in a radically changing society. In a sense, the non-artist participants were an idealized audience, not intimately concerned with modern American art, though newly aware of their duty to be so. Kenneth Burke, for instance, felt compelled to explain his interest:

And basically, the reason that I watch modern art with such avidity and earnestness is: Here is an area where the motives of our world are being enunciated profoundly. . . . That's why we should take modern expression so seriously—because it is concerned with the basic motives of life, with the things over which men will lurk, and mull, and linger, and for which they will seek new statements.

Burke's willingness to take the modern artist seriously must have had considerable psychological value to the artists sharing this unusual exchange through the printed word. Rarely before had a distinguished literary figure lent so much authority to the seriousness of their enterprise, and rarely had such a group been gathered for the express purpose of praising modern art (although Frank Lloyd Wright didn't seem to realize it). The group as a whole did not share either knowledge or opinion on the subject, but it did acknowledge the visual arts as a crucial cultural factor; and the proceedings were considered significant enough to document. As Goldwater himself pointed out in the course of the discussion, 'One of the characteristics of nineteenth- and twentieth-century civilization has been its sense of historicity, and the critic, as well as the contemporary artist, cannot avoid that sense of history.'

He was quite right. The book itself in which his statement is published is a direct effect of the sense of historicity that pervaded even the most anarchic groupings in the art world. Motherwell and Reinhardt consciously sought to make their own decisions concerning significant history in the book, including an important section that they called 'Art in the World of Events.' Faithful to the precepts of the nineteen-thirties, the editors assumed that the art they were

46. The Vernissage, before 1960, was still a pleasing pretext for artists to meet and converse. Here Mark Rothko talks with Adja Yunkers.

documenting had emerged in certain historical circumstances—and that those circumstances were as much a part of art's history as the individual works of art. The editorial note preceding the section stated that

Isolation of the significant statements and prejudices of the year, as expressed in the written words on art, would serve to intensify whatever pattern underlay the sequence of happenings. The success of such a method of exposition presupposes—as with the work of art itself—that communication is the result of a process of active participation.

The editors set the tone of this section with two quotations, one by Mark Tobey, in which he defends his penchant for experimentation by declaring that he thrusts forward into space just as scientists do because, as he asks rhetorically, 'shall any member of the body exist independently of the rest?'; and one by James Thrall Soby, who re-iterated the preoccupation of the postwar commentators with what was once called art for art's sake. 'In an age steadily becoming more collective,' he wrote, 'art remains one of the few means through which the individual will can assert itself. . . .'

By contrast, the documents Reinhardt and Motherwell gathered together are nearly all testimonies of the repressive atmosphere in which this freedom of individual assertion has to occur. Clearly they were alarmed and clearly they intended to alarm their readers. How, they seem to be asking, can the artist be free to experiment and assert his individuality in the face of mounting obstacles in the 'world of events?' Such obstacles are naturally enough largely political. When the U.S. State Department withdrew 'Advancing American Art' from its European tour and unceremoniously turned over the paintings to the War Assets Administration for sale as surplus property in 1947, artists and their supporters rightly saw the unpleasant consequences to come. By 1949 the floor of the United States Congress served as a forum for all the gathering forces of reaction, spearheaded by Representative Dondero. His line of attack was all too familiar to those aware of the history of repression in the arts. He suggested, without bothering too much with factual evidence, that all of American advanced art was 'shackled to communism,' and proposed measures to expunge communism from 'the heart of American art.' His bid for notoriety as defender of Americanism in culture was for a time successful enough to agitate the art world thoroughly. Countless editorials appeared to refute him in the professional journals and in a few newspapers. But, as the documents in *Modern Art in America* attest, the enemies of advanced art also took heart and renewed their complaints of unintelligibility and their hints that such advanced modes were ineffably linked with leftism. Not even articles pointing out how reactionary the Soviet régime was in relation to culture were able to offset a wave of populist demagoguery aimed principally at the vanguard painters. The editors included several examples, which are obviously representative of a host of other instances. One of the most disheartening documents came from Los Angeles, where screen writers had already felt the effects of a harsh resurgence of persecution. It concerns the 1950 Annual Exhibition of Artists of Los Angeles and Vicinity held at the Los Angeles County Museum, against which a host of 'Americanists,' including the American Legion and the Chamber of Commerce, launched a massive attack, demanding that the director of the museum and the jurors be 'interrogated' by the County Board of Supervisors. Among other things, their published petition stated: 'We object also to public monies being allotted for prizes for mediocre art and the importing of eastern 'intellectuals' to judge Californian art.' The 'eastern' intellectuals who threatened the good California

defenders of the American 'way of life,' as they put it, had long been a source of irritation. That the cultural milieu which had been struggling to form itself for almost four decades had finally succeeded in being recognized is apparent in all these frenetic attacks. Modern art and modern literature had finally come of age—at least enough to provoke the philistines to battle. The artists may have wondered if, in fact, they constituted a community, but in the eyes of Representative Dondero, the American Legion, and scores of similar defenders of the faith, there was no question about it.

'Instantaneous tradition'

A significant session at the Club in 1954 bore the title: 'Has the Situation Changed?' The question was merely rhetorical. Everyone knew it had. In posing the question, the painters were joining other artists who, toward the mid-fifties, began to cast an analytical eye on the shifting cultural assumptions. The entire cultural apparatus from the little magazines to the glossies was busy assessing the new and peculiar situation of the arts in America. Since the onset of the Cold War around 1948, there had been a compulsive tendency among the artists and their critics to scan American institutions for new keys to identity. Universities introduced the new field of American Studies; newspapers conducted inquiries into the recent past; weeklies focused on postwar arts and letters as though the new situation was unprecedented. The 'alienated' artist began to wonder just how alienated he really was.

It was more or less accepted that the social disengagement characterizing the artists' passage from the thirties to the forties was permanent. The general withdrawal from political preoccupations was considered healthy, and a sign of a new art-for-art's-sake era. The painters joined the larger cultural establishment in agreeing that the social commitment of the nineteen-thirties had been a futile detour. There were frequent allusions to the common sociological past at the Club, but rarely did a speaker address himself to the political implications of the Cold War. Oblique references abounded, but the fifties were not hospitable to art discussions with political orientation. An articulate summary of this new position was offered by Adolph Gottlieb in 1954 when he spoke on 'The Artist and Society' at the annual College Art Association meeting.[1] Gottlieb emphatically abjured the position of the 'alienated' artist, although in his opening

remarks he said that by the age of eighteen he had understood 'that the artist in our society cannot make a living from art; must live in the midst of a hostile environment; cannot communicate through his art with more than a few people; and if his work is significant, cannot achieve recognition until the end of his life if he is lucky, and more likely posthumously.' Although he said his attitude had been modified somewhat by events, even now he was surprised if someone liked a painting well enough to buy it.

Gottlieb stressed that with the rise of a new sense of confidence in the forties, the painters could no longer use 'alienation' as an alibi for their own uncreativeness. In his own case, he reported, he discovered that the situation for the American artist had improved in many areas. He insisted that the painter in relation to his society would only find his situation improved if he himself improved it:

> However, there is a sentimental attitude that longs for a reconciliation between artist and public in the false hope that the artist can, in some nebulous fashion, be in touch with the grass roots of human aspirations. . . . The notion of an organic society, within which the artist could exist harmoniously, is a Utopian fantasy.

Although many artists would have disagreed with Gottlieb's assessment of improvement in the artist's situation (which, of course, meant economical improvement above all), his definitive rejection of Utopian nostalgia; his denials that the dreams of the thirties could be valid for artists; and his determined attitude of self-reliance pretty much represented the attitudes emanating from the New York School. They would have agreed with him that 'the modern artist does not paint in relation to public needs or social needs—he paints only in relation to his own needs.' Very few painters would have argued against Gottlieb's essentially art-for-art's sake position in 1954, or if they had, they would have done so with restraint, since the whole thrust of the abstract expressionist generation was away from the entangling and frustrating social rhetoric that had filled up their youthful days.

If the painters had come to realize that by the mid-fifties something had changed drastically in their milieu, it was not only a question of how they themselves had changed in their maturity. Not only they, but also their community had altered. Despite the deep-seated suspicion of success on the part of the New York School, success was insidiously attacking their unity. The genuine community of impoverished bohemians, all of whom had shared economic deprivation

during the Depression, was disintegrating as prosperity swept post-war America into a different economic frame of reference. It is not easy to hold together even a rudimentary sub-group when the larger group makes room. 'The fellowship of suffering lasts only so long as none of the sufferers can escape,' writes Auden. 'Open a door through which many but probably not all can escape one at a time and the neighborly community may disintegrate. . . .'[2]

One by one, a few of the New York School painters were escaping from the egalitarian condition of poverty. Pollock could say in 1950 that things were a little easier, and that he could begin to think about living on his paintings. Rothko, while still obliged to teach, could look forward to occasional windfalls, as the rise in his prices indicates: in 1946 his show at the Betty Parsons Gallery had top prices of $150; in 1948 they ranged from $300 to $600, and by 1949 there was a price of $1,000 on one large canvas. His 1950 exhibition, where prices ranged from $650 to $1,300, resulted in the sale of six paintings. His friend Clyfford Still followed a similar course and by 1950 his paintings ranged in price from $650 to $2,200. Barnett Newman, who had only recently emerged as a painter, had his first one-man exhibition at Parsons in 1950, when prices ranged from $750 to $1,200, and by 1951 there was a painting for $2,500. Five years later Philip Johnson bought an early (1949) work by Newman for $3,000. Given the price of eggs during that time, these painters were commanding very high prices. They could no longer be considered impoverished 'loft-rats,' and the question of their permanent alienation from society began to appear somewhat academic. Even though nothing had changed in the deepest sense, the fact that a few American buyers were willing to spend fairly large sums for American vanguard painting could not be totally ignored. The solidarity of poverty was under attack.

Among the few relatively 'successful' painters who were beginning to sell their work, there were increasing pressures. Although some, such as de Kooning and Kline, continued to live downtown as they always had, enjoying the camaraderie of communal drinking and sessions at the Club, they faced new complications that decisively altered the 'situation.' They and a few others from the inner circle of nineteen-thirties veterans were able to hold together to some degree, but it became increasingly difficult to do so as they were besieged by hundreds of newcomers eager to participate in the nameless surge of activity. Often the older artists found themselves torn between a desire to extend their positions through young acolytes and a need to escape from the clamor. Those who, like Kline, de Kooning,

Vicente, and Guston, continued to live in the Tenth-Street district and to frequent the Cedar Tavern often exchanged amenities with the new contingents, but by the late fifties they were poised for flight. The increasingly public nature of the activities surrounding the New York School became unendurable.

Not only was the older generation crowded by the stream of youths pouring into New York at that time, but they were also beginning to experience the inevitable displacement of interest the new generation brought in. Although the older painters had only just begun to get used to their new-found esteem, they were sensitive to the intimations of abandonment already present in the latter half of the decade. The old American problem of novelty and fleeting loyalties was still there. A new breed of art dealer appeared, making news in the Cedar by buying out the whole studio of some young artist and conscientiously propagandizing his find. Suddenly the magazines were filled with news of the new generation, although the old generation had scarcely had time to be inscribed in history. The nature of the new art, moreover, was clearly a critique of the abstract-expressionist attitude. Certainly the most gifted of the new arrivals were clear about that. When Robert Rauschenberg hit his stride in the mid-fifties, he exhibited such objects as *Bed* (1955), a shocking upright 'combine' of a real quilt and pillow smeared with oil paints; and in 1958 *Coca-Cola*, with its American-eagle wings and the three empty Coke bottles enshrined. The introduction of actual objects, often with direct popular connotations such as the Coke bottles, was interpreted as a riposte to the high-flown discourse of the older abstract expressionists. Rauschenberg specifically rejected the idealistic aspirations they represented, and assumed an ironic stance which enabled him to criticize obliquely their spiritual ardor. To paint, he said, is no more important than anything else in life. His appearances in art journals were almost always accompanied by statements such as the frequently quoted 'Painting relates to both art and life. Neither can be made (I try to act in that gap between the two).'[3]

Not only were there rebellious younger artists such as Rauschenberg and Jasper Johns, but there were also a great many converts to the abstract-expressionist idiom, particularly that associated with the expressionistic brushwork of de Kooning. With profusion came surfeit. Even the warmest adherents to New York School psychology became disaffected. When, in 1958, Alfred Barr, Harold Rosenberg, and Thomas Hess participated in a panel at the Club, they all showed signs of irritation with the widespread adaptation of New York

School mannerisms. Barr specifically called for 'revolution' and deplored what he called the 'young academy.' He was waiting for the inevitable 'rejection,' he said, waiting for the new generation to 'make its statement.' Many other critics had already acknowledged the 'rejection' and were hastening to find its proper sobriquet, as the proliferation of 'movements' during the nineteen-sixties bore out. In Britain and Europe, critics were talking about 'culture heroes,' and the new importance of mass media and popular subject matter. Attention was obviously deflected from the main figures of abstract expressionism as the fifties drew to a close, and the painters were becoming aware of the ephemeral nature of fame in the arts. All the same, the fifties saw a constant increase in group activity fundamentally inspired by the presence of the abstract-expressionist group. Everyone, even the most wary mature painters, seemed intent on expanding the vanguard at all costs. The cooperative gallery movement, which originated in the Tenth-Street area and was spearheaded by the Tanager Gallery just next door to de Kooning's studio, was generously supported by older artists who, in spite of everything, sensed the importance of enlarging the community. The thronged streets during evening openings seemed to confirm the existence of the new cultural group. Such crowds helped to encircle the artist, to insulate him from the old worrisome problems of external society, and to save him from the dilemmas that once intervened between his conscience and his work. The bulwark of human bodies paradoxically helped the artist to nourish his perennial sense of isolation and to confirm him in his belief that the individual gesture was finally his only defense against hostile society.

Hostility was always expected. It was taken for granted that when any of the important figures in the New York School exhibited there would be a pained outcry in the average press and sales would be relatively sparse. Willem de Kooning more than fulfilled such expectations with his third one-man exhibition at the Sidney Janis Gallery in March 1953. Having been identified as a pioneer of the new abstraction, de Kooning caught both his admirers and detractors off-balance by producing an exhibition almost exclusively composed of furiously painted, determinedly figurative studies of women. *Time* magazine roared about *Big City Dames* on April 6, 1953, and the art journals zealously pursued the new departure in de Kooning's work as though it were to be the final direction of the New York School. As Thomas Hess has remarked,[4] *The Women* made a traumatic impression on the public, and although the Museum of

Modern Art bought *Woman I* from the show (which Hess said was the most widely reproduced painting in the world during the fifties) there were very few sales until 1956 when, according to Hess, 'wealthy collectors in America and Europe became seriously interested in de Kooning's paintings.' Hess himself had followed de Kooning's long and serious struggle with the problem of introducing the human image:

The painting's energetic and lucid surfaces, its resoundingly affirmative presence gives little indication of a vacillating, Hamlet-like history. *Woman* appears inevitable like a myth that needed but a quick name to become universally applicable. But like any myth, its emergence was long, difficult and (to use one of the artist's favorite adjectives) mysterious.

As inevitable as it seemed to Hess, de Kooning's mythic woman soon dissolved again into ever more complex abstractions which once again incited speculation in the press that he had run his course and reached the dead end of abstract expressionism. At about the same time, Pollock was exhibiting the post-drip abstractions in which the haunting eyes and heads that had once peopled his sketches seemed to emerge again. As was expected, the hostile critics, who had always known that the linear dripped-painting led nowhere, responded exultantly. Even artists were puzzled by the feints of their leaders. Pollock, who had so often complained that 'they put you up so that they can cut you down,' found his suspicions confirmed. With grim satisfaction the stellar figures of the New York School were obliged to recognize their perennial isolation. Despite growing audiences and increasing sales, America, as the old axiom had it, had a very short memory. Even Jean Cocteau scolded in the fifties:

Your ideal would be an *instantaneous tradition*. The new is immediately attached to a school. Its life is over at the time. You classify and name it, and since you don't allow an artist to experiment, you demand that he repeat himself and you replace him when he tires you. In that way you kill the flies.[5]

The progress of the New York School as a whole was no easier than it was for its acknowledged leaders. Each year saw redoubled efforts to display to the world that a community of vanguard artists really existed. It began with the 1951 group exhibition that had been organized by a committee of artists who rented an empty store. Known as 'The Ninth Street Show,' the exhibition included most important New York artists and a great many younger talents, and it stimulated a surge of discussion. Although the show received a great

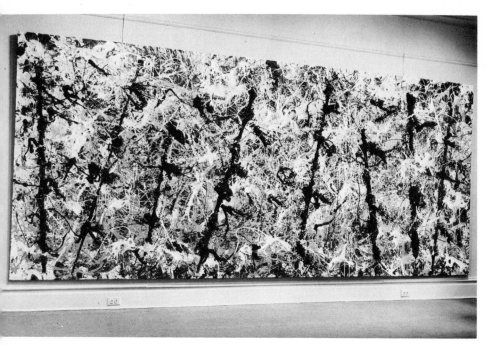

47. Pollock's 'Blue Poles' of 1952 was a centerpiece in the first Stable show. Photo by Oliver Baker, coll: Ben Heller

deal of attention, there were no sales. Yet, by taking the nineteenth-century tradition of the artists' salon and turning it to good account, the artists gave the impression of a new momentum in the New York School. A year and a half later, when Eleanore Ward had opened a gallery in an old, heavy-timbered stable which still smelled agreeably of hay and leather, a second artists' show ('The First Stable Annual,' February 1954) was compiled by a committee of artists. It exhibited the work of 150 painters, including Pollock's *Blue Poles*, and important works by de Kooning, Kline, Motherwell, Brooks, Tworkov, Baziotes, Graham, and many others. Of the older artists, only Still and Rothko did not participate. Again, although there was increased attention in the press, according to Mrs Ward there were no sales. At the following annual, however, business picked up a little, and the 'situation' change was sensed even by the normally hostile papers. The difference was spelled out the following year when Mrs Ward turned over the gallery to Thomas B. Hess, who selected the work of twenty-one artists in order to illustrate some new directions in American art. Hess' remarks in the catalog were significant of the

P

changes in attitude characterizing the later fifties. 'Today's painters,' he wrote, 'are unhappy with the phrase avant-garde and deprecate its connotations of bohemia, revolution, shock for shock's sake.' The newcomers, it appeared, were not eager to dissociate themselves from potential success, as had their elders. A gesture such as Rothko's refusal to participate in a Whitney Annual for the sake of 'the life my pictures will lead in the world' seemed to them unnecessary, if not ridiculous. It was hard enough as it was to find an audience, without assuming the heroic old stance of voluntary isolation. Group action and the force of numbers were more effective.

The end of an era

Lurking behind increased group activity and redoubled efforts to enlarge and strengthen the milieu that had engendered the New York School were numerous complex motivations—at least one of which was the need to close ranks before the stealthy enemy. Only by accruing large numbers of devotees to the principles of individual salvation could the arts hope to make a stand against the ever more subtle attacks on the part of organized society. These attacks were not limited to the art journals. As the Cold War developed, the role of the government became increasingly disturbing. The crude assaults of Congressman Dondero were not repeated; the government had found more sophisticated means of propaganda. In the haunted fifties, silence rather than volubility was the rule. Artists and writers all too often found the means to maintain their silence by simply not informing themselves. While it was not essential for an artist to take a political stance, it was important for him to know how he might be affected by the political positions of others; but during that period, he tended not to want to know. The government functioned quietly on an international scale without informing its public. For a time an equilibrium was established. Few were aware that the many United States Information Service stations abroad were heavily censored. In Rome in 1955 the head of the U.S.I.S. privately lamented the restrictions imposed by Washington. There was no possibility of having a Ben Shahn exhibition as he couldn't get 'clearance,' and other vanguard artists would not submit to the 'test' for clearance. Even Hemingway had only recently received clearance, and that was only because he had won the Nobel Prize.

Occasionally an important intellectual such as R. P. Blackmur was considered 'clear' enough to be sent abroad to lecture. He has bitterly

described his experience as a representative of America in Europe and in Japan, where a U.S.I.S. official telephoned him to be sure he would 'take it easy' in his radio broadcast. The intellectual Blackmur wrote, 'can be a writer, an artist, a professor, a scientist and gain modest prestige from society and considerable patronage from foundations; but to do this he must as a rule forego any of the dubious, uncommitted roles of the mind in action.'[1]

Rather than truckle to the agencies that inhibited his mind in action, the artist most often preferred to turn inward, to live within the self-sustaining community prescribed by his culture and his market-place. To many, it seemed that society was more cordial to their entrance, and that at last America was beginning to recognize a need for culture. Intellectuals who had long since turned away from politics could now speculate that America had somehow changed, and that alienation was no longer the condition of the artist. Much of this was wishful thinking, as later experiences have proved, but during the fifties there were many intellectuals, especially writers, who could muse upon the comfortable situation that they found themselves enjoying and assume that America, and not they, had changed.

Nothing made this clearer than a widely heralded symposium in *Partisan Review* in 1952, with the astonishing title 'Our Country and Our Culture.' It was later published in book form with the more sober title *America and the Intellectuals.*[2] The very same intellectuals who had once nurtured the idea of alienation were now able to talk of 'our country' and 'our culture.' They, of course, were in a better position than the artists to revise their attitudes. They were closer to 'their' country, in that it offered them many more possibilities for success during the fifties than ever it provided for painters. Publishing had vastly enlarged their public, and the universities, where the writers' position was comfortable, had taken them in. Painters were not yet that much in demand, and remarkably few had ever been able to subsist on their work. Hess, in speaking of America in 1961 could still say that 'no society . . . has been as cruel and as viciously indifferent to its best artists as ours'; adding, 'I reckon that today there are about 25 Abstract Expressionist artists making what any forty-year old college graduate would call "a living" in New York.'[3] For the rest, it was impossible to make 'a living' in their own profession. It was not surprising, then, that the editors of *Partisan Review* could state in their introduction to the symposium that many writers felt closer to their country and their culture:

We have obviously come a long way from the earlier rejection of America as spiritually barren, from the attack of Mencken on the 'booboisie,' and the Marxist picture of America in the thirties as a land of capitalist reaction.

This is partly because, they hopefully suggested, Europe was no longer a sanctuary, and 'now America has become the protector of Western civilization, at least in the military and economic sense.'

The editors then went on to the ultimate heresy, at least for a so-called radical magazine, of stating that there was now recognition that American democracy has an intrinsic, positive value, and that 'it is not merely a capitalist myth but a reality which must be defended against Russian totalitarianism. . . . For better or for worse, most writers no longer accept alienation as the artist's fate in America; on the contrary, they want very much to be a part of American life.'

How very much they wanted to be part of American life can be gauged by the absence of reference throughout the symposium to the questionable war in Korea. One of America's intellectuals, Podhoretz, even wrote in his autobiographical book that, in general, in his circle, American foreign policy was regarded as right and the Korean war 'just.' In fact, the 'just' war which seemed of so little moment to the intellectuals represented by *Partisan Review* remains a phantom. The 1971 World Almanac, for instance, doesn't bother to mention it at all, although there are three dense columns about Korean history and geography and economy. What concerned the editors of the journal, and most of their correspondents, was the encroachment of 'mass culture' on the artist. Most of the writers temporized about the 'new' acceptance of the intellectual, but warned each other about the dangers of the increased power of the mass media. There were few dissenters from the position of *Partisan Review*'s editors, but among them was Delmore Schwartz's sharply underlined statement of the need for a critical, nonconformist minority in the great tradition of Thoreau and Veblen. He castigated his fellow intellectuals for their will to conform, which, he wrote, 'is now the chief prevailing fashion among intellectuals.' The will to conformism, he said, is a flight from the influx, chaos and uncertainty of the present, a forced and false affirmation of stability in the face of immense and continually mounting instability. Schwartz was joined by one other strong voice—that of Norman Mailer. Four years earlier Mailer had published his war novel *The Naked and the Dead* at the age of twenty-five. It had been well received and widely read by a public that had only recently been able to buy paperbacks at reasonable prices.

Mailer's book, first published in 1948, appeared in paperback in 1951. Its warning against the mounting power of bigotry was contained in numerous passages in which enlisted men discuss politics in much the same way as did their officers. Their attacks on Negroes, Jews, and Communists abound, indicating that Mailer saw the war as an instrument of reaction. His exhausted soldiers envision coming home to an America free of all the disturbing forces that had prevailed in the Depression. In one flashback, a soldier muses,

We're gonna do a lot of cleaning up, I hear they got some niggers down in Washington, that's a fact, I was readin' it in the newspapers they got a nigger down there tellin' white men what to do. War's gonna fix all that.

On a different educational level is the second lieutenant who ponders his relationship to a general. He remembers that the general had told him about an employee in the War Department who had been discharged after some Communist documents had been planted in his desk. 'I'm surprised that it worked,' the lieutenant says. 'You say everybody knew the man was harmless.' The general replies:

Those things always work, Robert. You can't begin to imagine how effective the Big Lie is. Your average man never dares suspect that the men in power have all the nasty impulses he has, except they're more effective about carrying them out.

Mailer's anxieties about the uses of the Big Lie proved well founded during the next few years. By the time he answered *Partisan Review*'s inquiry, he was understandably wrathful. He declared at the outset that he was in almost total disagreement with the assumptions of the symposium, and found it shocking:

Everywhere the American writer is being dunned to become healthy, to grow up, to accept the American reality, to integrate himself, to eschew diseases, to re-value institutions. Is there nothing to remind us that the writer does not need to be integrated into his society, and often works best in opposition to it? I would propose that the artist feels more alienated when he loses his sharp sense of what he is alienated from.

Mailer then reminded his colleagues that they seemed to have forgotten the history of the twentieth century and ceased to reflect on modern war. He reproached them for not discussing in print 'that total war and the total-war economy predicate a total regimentation of thought. . . . It has become as fashionable to sneer at economics and emphasize the 'human dilemma' as it was fashionable to do the reverse in the thirties!' He concluded by reminding his readers that the great artists—certainly the moderns—are 'almost always in

48. David Smith had settled in Bolton Landing on Lake George in the early nineteen-forties, but he still made sorties to New York, during which he could be seen at the festive openings that characterized the mid-nineteen-fifties. With him in this picture is Dore Ashton. Photo by Steve Ashton

opposition to their society, and that integration, acceptance, non-alienation, etc., etc., has been more conducive to propaganda than art.'

The resistance Mailer called for was becoming increasingly difficult as the fifties wore on, but the artists of the New York School struggled to hold on to what Mailer called 'the sharp sense of what he is alienated from.' By the very nature of the existentialist platform on which they had first appeared, the New York painters declared their independence from all institutionalized concepts of the artist's role in society. By becoming models of self-motivated individuals,

49. This compendium of art-world allusions by Ad Reinhardt appeared in the journal *Transformation* (L/3, 1952), another undertaking of the adventurous booksellers Wittenborn and Schultz. Reinhardt's barbs were always democratic, finding their mark on artists as well as critics, dealers, and museum officials. Photocopy by David Manders

who were well able to sustain their creative course over long periods of time, even without affirmation from society at large, the artists were better able to resist the blandishments of a benign and neutralizing cultural establishment. Instinctively, they opened their ranks to dissidents of every shade, amplifying the milieu and buttressing their own position. Crossed paths occurred more frequently during this period, especially between 1950 and 1955. In the downtown gatherings the representatives of the old bohemian tradition still called the tune, and they were always interested in allies, so that artists from other fields were absorbed and made comrades-in-arms in the unending battle with conformism. One of them was the composer, John Cage, who drew a record crowd when he gave his 'Lecture on Nothing' at the Club. Cage's musical soirées in his Grand Street loft on the lower East Side were frequently attended by artists. They recognized and appreciated in him the unshakeable determination to pursue his own individuality. 'At Cage's musicales down on Grand Street,' his younger colleague, Morton Feldman, recalls, 'it was personality that counted. It was like a vote of confidence. A lot of artists turned up: Kiesler, Kline, Ferren, Pollock, and of course de Kooning, and a lot of literary people were interested in him, too.'[4] Feldman himself was, in turn, attracted to the artists because of the 'permissions' inherent in their position. His experience with the music world had been unsatisfactory because 'there was nothing happening in American music. Avant-garde was in the ivory tower. It paralleled the New Criticism. It was the academy. It was work that was about music.'

Both Cage and Feldman seemed to feel that the painters were not yet immured within the benign bastions of the academic world and that something in the general movement of the downtown scene could be characterized as authentically vanguard. They cultivated an audience among the artists, and tended to gravitate to the same places. For example, both Feldman's teacher, the composer Stefan Wolpe, and John Cage had done several stints at Black Mountain College, an early experiment in an open educational system in the Blue Ridge Mountains of North Carolina. Black Mountain had opened in 1933 and had been particularly hospitable to Europeans fleeing from Hitler. Josef Albers headed the art department from 1933 to 1949, and had invited many painters, including de Kooning, for summer sessions. De Kooning and Cage were both there in 1948. Along with such notables as Gropius, Zadkine, Feininger, Ozenfant, and Krenek, artists from the New York School, among them Kline,

Tworkov, and Vicente, sporadically held workshops. Invariably these contacts enriched the activities back in New York and enlarged the vanguard circle.

Cage's ideas were taken seriously by many painters. They could easily comprehend his emphasis on the separateness of musical 'events,' having themselves rejected the classical canons of composition. The idea of the 'event' itself was sympathetic, since the diction of vanguard criticism was at that very moment describing aspects of abstract expressionist painting as 'events' on the canvas. Harold Rosenberg's criticism had already sounded the note of the isolated event, the 'moment' in the ongoing flux of life; very soon afterwards, he suggested that the new painting had erased the boundaries between art and life—a position that young Robert Rauschenberg, once a student at Black Mountain College, was to assume and enact in his work. Rauschenberg even more than the older artists could find affinities with Cage's unorthodox treatment of his materials —the prepared piano, with its strings muted by bits of debris, or the found objects (such as the jawbone of an ass) suitable for producing sounds analogous to the continuum of sound in everyday life. Rauschenberg's attention to Cage's ideas can be gauged in a letter he wrote to Betty Parsons about his first one-man exhibition in 1951, in which he spoke of 'an organic silence' and 'the plastic fulness of nothing.' Cage's Zen Buddhist rhetoric found its way into the vocabularies of many initiates in New York.

Cage's value as an artist was matched by his value as a model of individualism. The circle of the New York School, widening continually in the fifties, always welcomed renegades from an increasingly visible system. While the word 'establishment' was not yet fashionable, the components of the establishment were already known: renegades were necessary. A number of literary figures, who did not quite fit the new universitarian roles available, turned up among the artists. When Dylan Thomas appeared—dishevelled, distraught, full of misgivings and despair—he was quickly surrounded by counterparts in New York, and not a few painters shared raucous evenings with him at the White Horse Tavern. He was a precursor of the furore that was soon to erupt when the literary establishment got wind of San Francisco's riotous 'beats.' When these wild men came east, they found the New York School ready to welcome and shelter them. Allen Ginsberg was often at the Club, exhorting his informal audience to read Shelley, while they toasted him with paper cups full of the crudest bourbon available.

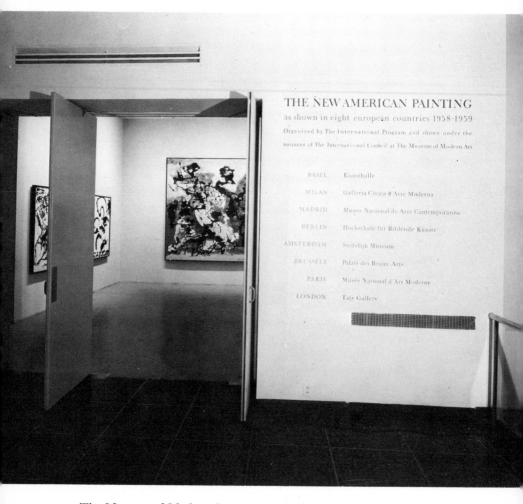

50. The Museum of Modern Art was proud of the international reception accorded 'The New American Painting' exhibition when it traveled to eight European countries in 1958–59. Photo by Sunami, courtesy The Museum of Modern Art

The way had been prepared by the resident young poets of the New York School such as Frank O'Hara and Kenneth Koch, who had chosen the artists' milieu as a shield from the growing academicism in the world of poets. The painters found easy affinities with these young descendants of the French romantic tradition, with their innate bohemianism. Both O'Hara and Koch had been steeped in the traditions of Laforgue, Apollinaire, and Jacob. They picked up the irony and burlesque inherent in the tradition and added a rich farrago of American vernacular. Their poetry was understood and enjoyed by the New York School painters and, later, O'Hara became one of the most acute commentators on their work. Finally he was made a curator at the Museum of Modern Art—this being the first authentic evidence of a rapprochement between poets and painters.

As fresh and unconventional as the local poets were, they were never as extravagantly alienated as the West Coast writers who began to appear regularly among the New York artists shortly after the publication of Ginsberg's 'Howl' in 1956. Kerouac particularly, and to a lesser degree Ginsberg, sought out the painters. It was not unusual to see Kerouac and Kline with a group of younger artists drinking at the Cedar and finishing up the night at Kline's studio. Whenever there was a party at the Club the Beats turned up, sometimes high on marijuana, sitting in the rear of the loft while the artists—still faithful to liquor—danced and bellowed loudly.

Ginsberg was the more influential poet to fraternize with the New York School because he, more than any other, had made it clear what he was alienated from. His very presence reinforced the instinctive rebellion of the painters. His admiration for those alienated and magically inclined precursors—Rimbaud, Yeats, Céline, and of course Whitman—paralleled the artists' predilections. Moreover, he was interested in painting and had at one time made a close study of Cézanne in order to draw parallels for his own art. He claimed that he had developed a method of writing poetry in which he tried to juxtapose one word against another without perspective lines, in the way Cézanne juxtaposed one tone with another.

When Ginsberg first gave a reading of 'Howl,' it took place, appropriately enough, in a small artists' cooperative gallery in San Francisco. Both the vanguard art and literary communities were present. Significantly, Ginsberg commented later that it was an ideal evening because he and the others wound up 'with a sense of "at last a community."' [5] The longing for community that marked the New York

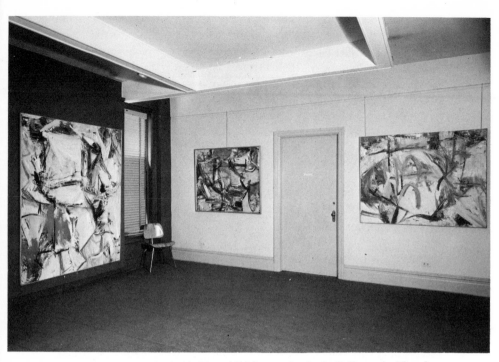

51. By 1956, when he held this exhibition at the Janis Gallery, de Kooning had again turned away from the woman *motif* toward landscape-like abstractions. At this time, his works began to command attention and good prices on an international scale. Photo: courtesy Sidney Janis Gallery

School was matched by a continental longing on the part of artists who felt alienated.

There were other reasons for Ginsberg's welcome in the artists' community. His frank attack in 'Howl' on the vices of McCarthy's America came as a relief to many who had endured the silences too long. They had turned, as had 'the best minds' of Ginsberg's generation, to other traditions. They had also known those minds 'who studied Plotinus Poe St. John of the Cross telepathy and bop/ kaballa because the cosmos instinctively vibrated at their feet in Kansas'. In the fifties the cry against heedless materialism was welcome to those who were beginning to feel the pressures of money in the studios: 'Moloch! Moloch! Robot apartments! Invisible suburbs! . . .' The painters knew only too well the 'Breakthroughs! over the river! Flips and crucifixions! gone down the flood! Highs! Epiphanies! Despairs! . . .' Like Ginsberg, the artist could recognize

the Whitmanesque truth of the great plaint: 'America I've given you all and now I'm nothing . . . America when will you be angelic?'[6]

Even the Beats, though, found a place in the searing limelight of New York. Their *succès de scandale* resembled the earlier successes of painters such as Pollock and de Kooning, and it left them with the same bitter aftertaste. The possibility of community was controverted quickly enough by the forces that brought so many to New York seeking a sense of community but finding always that the community had been colonized. Instability was the norm in New York, and community was a dream that very few artists could seriously entertain as the fifties drew to a close. By 1960 there was almost nothing left of the camaraderie that small numbers can sustain. The New York School was already a legend. In the spring of 1961 a great party was given by three of the most celebrated New York School painters. It represented the end of an era. The art world turned out in full force and went through the motions—it was more like an embassy reception than the spontaneous revels of old bohemia—and awoke the next day with an uncomfortable feeling of finality.

This party took place in a loft, but a loft with parquet floors, spotless walls, and a majestic colonnade running its length. Many of the old restless spirits were present, but then, so were some 800 others, including collectors, dealers, museum officials, and assorted functional members of a greatly enlarged art world. They were there by written invitation and checked carefully at the door by armed Pinkerton men. Once upon a time, a famous poet remarked, Pinkerton men had been used to chase disreputable elements such as artists. Now the artists do the chasing. It is not easy to understand what had happened. How had this extravaganza come to be, and why? Partly the answers were circumstantial. Ten years before there had been only about thirty respectable art galleries in New York. By 1961 there were more than 300 managing between them to stage close on 4,000 exhibitions a year. This unprecedented growth had blurred the outlines of an art community and caused confusion in the ranks. It was no longer possible to be sure of meeting someone you knew at a bar. Strangers were everywhere. It was no longer possible to assume that a few basic attitudes were shared, since the volume of activity had brought new experiments and also a new climate of acceptance for outmoded styles. The international success of the New York School had brought immediate reaction at home, ranging from serious second-generation departures to outright rejections. The press,

229

which by now understood the news value of art marketing, spurred its readers to expect constant shifts and novelties. By 1960 it had dropped even derisive references to abstract expressionism and was exploring new fields for hyperbole. What Kiesler had called the victory dance, the 'continuous carmagnole' that had sustained the New York School for about ten years while it conquered the world aesthetically, was over. Others were dancing to other tunes in the sixties. The New York School as such had vanished, and what emerged, as they had always known it would, was a scattering of isolated individualists who continued to paint.

Afterword

I have tried to locate the New York School in terms of both its background and the collective history of the exceptional individuals it embraced. But as an article of faith I have to admit that I believe there is a point at which history, environment, and cultural patterns recede. Art then takes over, if only briefly, and shines forth with inexplicable apartness. I believe that in the late nineteen-forties and early fifties, the momentum of the New York School reached that mysterious point in time and place: Art took over—the work of a few individual artists seemed to exist beyond and independent of its conditioning contexts. It was brief enough, to be sure, for by 1960 it had passed. New stimulants made inroads on the collective psyche of artists, and new generations appeared, in the modern tradition, to overthrow the myth of the immediate past. Myth had gone far to sustain that older generation, and one aspect of the myth was that the individual artist had to function outside of a system. Myth itself has a structure, and that was system enough.

The passing of the New York School myth was relatively rapid, and I attribute its meteoric behavior to the violence of social change in America. Europe had its convulsive wars in the twentieth century, but never experienced such rapid alterations of values as did the United States. The Civil War, for instance, ushered in a brief era of radical change during the black reconstruction period, but within a matter of months that was completely reversed. There was violent hysteria in the nineteen-twenties, just as there was violent change in the thirties; and then a complete reversal in the forties. Since there was no stability whatsoever in the value systems within which the artist worked in twentieth-century America, it is not difficult to understand how impossible a genuine movement in the arts would be.

Q

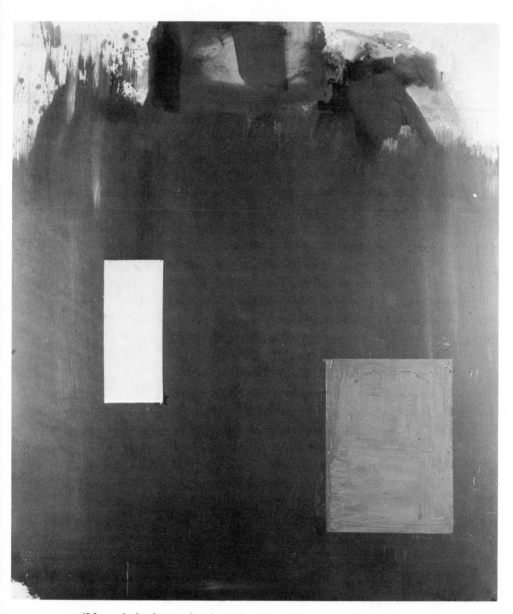

52. 'Memoria in Aeterne' painted by Hans Hofmann in 1962, mourns his fellow artists Arthur B. Carles, Arshile Gorky, Jackson Pollock, Bradley Walker Tomlin, and Franz Kline. Photo: courtesy The Museum of Modern Art

Certainly one of the contributing factors in the volatility of the arts in our society was America's advanced encounter with technology. Ever since the Civil War the swift development in technology fostered the idea that Art was a commodity. The consumer society was born in the United States, and generated problems for culture long before Europe had to face such anguishing conflicts. The American artist early learned to resist mass culture—that artificial product of the technological society—and early experienced his punishment for such resistance Rothko and Still ranted against art appreciation and art museums, while Rosenberg and Greenberg upheld the idea of 'high art' in a defiance of mass culture. Both of them, for instance, felt compelled to deal with the idea of 'kitsch' more than once, and implicit in their condescending attitude toward 'kitsch' (which later critics defended as 'popular art') was their fear of the encroachments that technological marketing devices made upon the image of art.

In view of the present situation, it seems to me their fears were well founded. The myth of the romantic New York School was essentially construed from the old *art pour l'art* sources. Originally, the art-for-art's-sake movement was a revolutionary, anti-bourgeois manifestation of artistic independence. Its supporters insisted on the absolute freedom of the artist, both from the demands for intelligibility by vulgarians and from the demands of sociability by propagandists. Victor Hugo could declare that he, for one, did not know in what consisted the limits of art, and he was echoed by many subsequent artists who insisted on the autonomy of their works and on their freedom to follow their inspiration. The long life of the romantic tradition and the art-for-art's-sake attitudes it sponsored can be linked to the historical circumstances in which, until quite recently, imperialism and aggressive capitalism functioned. Its apparent eclipse can be explained by the vast cultural changes that have occurred during the past decade or so. But the myth of the artist as *disaffiliated*, with all the inherent contradictions I have tried to outline, seems vital enough to be reborn out of the cyclical purifying fires. The existence of the *idea* of a New York School bears this out.

References

Introduction

1. The statements by Morton Feldman were made in a conversation with the author.
2. Edwin Denby. *The 1930's: Painting in New York* (New York: Poindexter Gallery, 1957).
3. John Singleton Copley, letter of November 24, 1770, from *Letters and Papers of John Singleton Copley and Henry Pelham* (New York: AMS Press, 1970 reprint of 1914 edition).
4. Thomas Cole, quoted in Barbara Novak, *American Painting of the 19th Century* (New York: Praeger Publishers, 1969).
5. Randall Jarrell, *A Sad Heart at the Supermarket* (New York: Atheneum; London: Eyre & Spottiswoode, 1962).
6. Adelyn Breeskin, *The Roots of Abstract Art in America 1910–1930* (Washington, D.C.: Smithsonian Institution, 1965).
7. Henry Bamford Parkes, *The American Experience* (New York: Alfred A. Knopf, 1947).

Chapter 1 Greenwich Village—and Depression

1. Murdock Pemberton in *Arts Magazine* (New York), October 1955.
2. Malcolm Cowley, *Exile's Return* (New York: The Viking Press; London: The Bodley Head, 1951).
3. Isamu Noguchi, *A Sculptor's World* (New York: Harper & Row, 1968).
4. Mary Heaton Vorse, 'A School for Bums,' *The New Republic* (New York), April 29, 1931.

Chapter 2 'Hell, It's Not Just About Painting!'

1. Editorial (unsigned), *View* (New York), no. 1, series III, 1943.
2. William C. Seitz, *Arshile Gorky, Paintings, Drawings, Studies* (New York: The Museum of Modern Art, 1962).
3. From David Smith's journal in the *Journal of the Archives of American Art* (New York), 81, no. 2, April 1968.

4. Dorothy Dehner, Foreword in John Graham's *System and Dialectics of Art* (Baltimore: Johns Hopkins University Press, 1971).
5. Arshile Gorky, quoted in Julien Levy's *Arshile Gorky* (New York: Harry N. Abrams, 1966).
6. Arshile Gorky, 'Stuart Davis,' *Creative Art* (New York), September 9, 1931.
7. Frederick J. Kiesler, *Contemporary Art Applied to the Store and Its Display* (New York: Brentano, 1930).
8. The statements by Lee Krasner were made in a conversation with the author.
9. Edmund Wilson, *A Literary Chronicle 1920–1950* (New York: Doubleday, 1956).
10. Edward Dahlberg, *Alms for Oblivion* (Minneapolis: University of Minnesota Press, 1964).
11. Matthew Josephson, *Life Among the Surrealists* (New York: Holt, Rinehart & Winston, 1962).
12. The statements by Clyfford Still were made in a conversation with the author in the late nineteen-fifties.
13. Sam Kootz, *Modern American Painters* (New York: Brewer & Warren, 1930).
14. Sam Kootz, *New Frontiers in American Painting* (New York: Hastings House, 1943).
15. Ben Shahn, *The Biography of a Painting* (New York: Grossman, 1966).
16. Matthew Josephson, *op. cit.*
17. Jose Clemente Orozco, 'New World, New Races and New Art,' *Creative Art* (New York), 6, no. 1.
18. John Ferren, Introduction to *Yun Gee* catalog (New York: Schoelkopf Gallery, 1968).
19. Lillian Hellman, *An Unfinished Woman* (Boston: Little, Brown, 1969).
20. Charles Chaplin, *My Autobiography* (New York: Simon & Schuster; London: The Bodley Head, 1964).
21. Antonio Rodriguez, *A History of Mexican Mural Painting* (New York: Putnam; London: Thames & Hudson, 1969).
22. The statements by Herman Cherry were made in a conversation with the author.
23. Paul Burlin, quoted in Ralph M. Pearson, *The Modern Renaissance in American Art* (New York: Harper Brothers, 1954).

Chapter 3 *Artists and the New Deal*

1. Barnett Newman, quoted in Thomas B. Hess: *Barnett Newman* (New York: Walker & Co., 1969).
2. Henry Billings, interview in the *Journal of the Archives of American Art* (New York), no. 25, November 1964.
3. William F. McDonald, *Federal Relief Administration and the Arts* (Columbus: Ohio State University Press, 1969).
4. George Biddle, Letter to Franklin Delano Roosevelt, May 9, 1933, reprinted in William F. McDonald, *op. cit.*
5. Edward Bruce, quoted in William F. McDonald, *op. cit.*

6. John I. H. Baur, *Revolution and Tradition in Modern American Art* (Cambridge: Harvard University Press, 1951).
7. Holger Cahill, *Art in America in Modern Times* (New York: Reynal & Hitchcock, 1934).
8. William F. McDonald, *op. cit.*
9. Ben Cunningham, *WPA Then and Now* (Essex County, New Jersey: YM–YWHA, 1967).

Chapter 4 *A Farrago of Theories*

1. Alfred Kazin, *Starting Out in the Thirties* (Boston: Little, Brown, 1962).
2. Harold Rosenberg, 'Breton—A Dialogue,' *View* (New York), series II, 1942–43.
3. Raphael Soyer, *Self-Revealment: A Memoir* (New York: Random House, 1967).
4. Meyer Schapiro, 'The Social Bases of Art,' a paper delivered at the First Closed Session of the Artists' Congress at the New School for Social Research, New York, February 1936.
5. Stuart Davis, in *Stuart Davis*, edited by Diane Kelder (New York: Praeger Publishers, 1971).
6. Antonio Rodriguez, *op. cit.*
7. Francis V. O'Connor, *Jackson Pollock* (New York: The Museum of Modern Art, 1967).
8. John Graham, *System and Dialectics of Art* (Baltimore: Johns Hopkins University Press, 1971 reprint of 1937 edition).
9. Thomas B. Hess, *Barnett Newman* (New York: Walker & Co., 1969).
10. Barnett Newman, Foreword to Igor Kropotkin: *Memoirs of a Revolutionist* (New York: Horizon Press, 1968).

Chapter 5 *Studio Talk*

1. From the Carl Holty papers in the Archives of American Art, New York.
2. Mark Rothko, *Milton Avery* (Greenwich, Conn.: New York Graphic Society, 1969).
3. Hans Hofmann, Symposium at the Riverside Museum, New York, 1941.
4. Larry Rivers, quoted in Sam Hunter: *Hans Hofmann* (New York: Harry N. Abrams, 1969).
5. This and the following quotations are from Hans Hofmann: *Search for the Real and Other Essays*, edited by Sarah T. Weeks and Bartlett Hayes, Jr. (Cambridge, Mass.: MIT Press, 1967).

Chapter 6 *The Advent of Surrealism*

1. Walker Evans, Foreword to James Agee: *Let Us All Now Praise Famous Men* (Boston: Houghton Mifflin, 1960).
2. Paul Eluard, in *La Revolution Surrealiste* (Paris), December 1926.
3. Julien Levy, *Arshile Gorky* (New York: Harry N. Abrams, 1966).
4. The statements by Tworkov were made in a conversation with the author.

5. Bradley Walker Tomlin, quoted in John I. H. Baur's introduction to *Bradley Walker Tomlin* (New York: Whitney Museum of American Art, 1957).

Chapter 7 *Voices from Europe*

1. Meyer Schapiro, *op. cit.*
2. From the Carl Holty papers in the Archives of American Art, New York.
3. Pablo Picasso, 'Message to American Artists,' *Picasso on Art*, edited by Dore Ashton (New York: The Viking Press, 1972).
4. André Malraux, quoted in Alfred Kazin: *Starting Out in the Thirties* (Boston: Little, Brown, 1962).
5. Stephen Spender, 'T. S. Eliot,' *The New York Review of Books* (New York), September 25, 1969.
6. Edmund Wilson, *op. cit.*
7. Edmund Wilson, *The Intent of the Critic* (Princeton: Princeton University Press, 1941).
8. Alfred Kazin, *op. cit.*
9. W. H. Auden, 'September 1, 1939,' in *Selected Poetry* (New York: Random House, 1959).

Chapter 8 *Myth and Metamorphosis*

1. Barnett Newman, quoted in the Pollock Symposium, *Art News* (New York), April 1967.
2. Peggy Guggenheim, *Confessions of an Art Addict* (New York: Macmillan, 1960).
3. Laura Fermi, *Illustrious Immigrants* (Chicago: University of Chicago Press, 1968).
4. Carl C. Jung, quoted in Morris Philipson: *Outline of Jungian Esthetics* (Evanston, Ill.: Northwestern University Press, 1963)
5. *Ibid.*
6. Irving Sandler, *The Triumph of American Painting* (New York: Praeger Publishers, 1970).
7. Wolfgang Paalen, *Form and Sense* (New York: Wittenborn and Schultz, 1945).

Chapter 9 *American Culture or Mass Culture?*

1. Wallace Stevens, *The Necessary Angel* (New York: Alfred A. Knopf, 1951).
2. W. H. Auden, in *20th-Century Authors*, First Supplement, edited by Stanley J. Kunitz (New York: H. W. Wilson, 1955).
3. Granville Hicks, in *The Strenuous Decade*, edited by Daniel Aaron and Robert Dendiner (New York: Doubleday, 1970).
4. John Peale Bishop, Lecture at Kenyon College reprinted in *Kenyon Review*, 3, Spring 1941.
5. Laura Fermi, *op. cit.*

6. Simone de Beauvoir, *America Day by Day* (New York: Grove Press, 1953).
7. Lincoln Kirstein, quoted in George Amberg: *Ballet in America* (New York: Duell, Sloane & Pearce, 1949).
8. Edwin Denby, *Looking at the Dance* (New York: Pellegrini & Cudahy, 1949).
9. George Amberg, *Ballet in America* (New York: Duell, Sloane & Pearce, 1949).
10. Martha Graham, quoted in Margaret Lloyd: *The Borzoi Book of Modern Dance* (New York: Alfred A. Knopf, 1949).
11. *Ibid.*
12. Edwin Denby, *op. cit.*
13. The statements by Marian Willard were made in a conversation with the author.
14. Arshile Gorky, Central School of Art, catalogue.
15. James Agee, *The Nation* (New York), May 1, 1943.
16. Lillian Hellman, *op. cit.*
17. John Huston, quoted in Lillian Hellman, *op. cit.*
18. Walter Benjamin, *Illuminations* (New York: Harcourt, Brace & World, 1968).
19. Jacques Maritain, *Reflections on America* (New York: Scribner, 1958).
20. Lenny Bruce, *How to Talk Dirty and Influence People* (Chicago: Playboy Press, 1963).

Chapter 10 *Abstract Expressionism*

1. Peggy Guggenheim, *op. cit.*
2. Elaine de Kooning, *Art News* (New York), April 1967.
3. Ethel K. Schwabacher, *Arshile Gorky* (New York: Macmillan, 1957).
4. Clement Greenberg, in *The Nation* (New York), March 24, 1945.
5. Harold Rosenberg and Robert Motherwell, *Possibilities* (New York), Fall 1947.

Chapter 11 *Artists and Dealers*

1. Clement Greenberg, *Partisan Review* (New York), April 1948.
2. Sam Kootz, in an interview with Dorothy Seckler, April 13, 1964.
3. *Life*, October 11, 1968.

Chapter 12 *Existentialism*

1. Theodore Solotaroff, Introduction to Isaac Rosenfeld: *An Age of Enormity* (New York: World, 1962).
2. René d'Harnoncourt, 'Challenge and Promise: Modern Art and Modern Society,' *Magazine of Art* (New York), November 1948.
3. Willem de Kooning, 'Symposium,' *Bulletin of the Museum of Modern Art* (New York), Spring 1951.
4. W. H. Auden, *Age of Anxiety* (New York: Random House, 1965).
5. *Partisan Review* (New York), March–April 1947.

6. Parker Tyler, *Magazine of Art* (New York), March 1950.
7. Franz Kline, Interview with David Sylvester, *Living Arts* (London), Spring 1963.
8. Philip Guston, *It Is* (New York), no. 1, Spring 1958.
9. Jean-Paul Sartre, *Existentialism and Humanism* (London: Methuen, 1948).
10. Adja Yunkers, *Tiger's Eye* (New York), no. 8, June 1949.

Chapter 13 *The Eighth-Street Club*

1. Norman Podhoretz, *Making It* (New York: Random House, 1967).
2. Isaac Rosenfeld, *Partisan Review* (New York), Summer 1946.
3. Isaac Rosenfeld, *The New Republic* (New York), December 3, 1945.
4. Willem de Kooning, *Newsweek* (New York), November 20, 1967.
5. Simone de Beauvoir, *op. cit.*
6. This statement by Douglas MacAgy was made in a conversation with the author.

Chapter 14 *'Instantaneous Tradition'*

1. Adolph Gottlieb, 'The Artist and Society,' *College Art Journal* (New York), Winter 1955.
2. W. H. Auden, *The Dyer's Hand and Other Essays* (New York: Random House, 1962).
3. Robert Rauschenberg, quoted in *Sixteen Americans*, edited by Dorothy Miller (New York: The Museum of Modern Art, 1959).
4. Thomas B. Hess, *Willem de Kooning* (New York: Braziller, 1959).
5. Jean Cocteau, *The Journals of Jean Cocteau*, translated by Wallace Fowlie (New York: Criterion Press, 1956).

Chapter 15 *The End of an Era*

1. R. P. Blackmur, *The Logos in the Catacomb* (*A Primer of Ignorance*) (New York: Harcourt, Brace & World, 1967).
2. 'Our Country and Our Culture,' *America and the Intellectuals* (Partisan Review Press, 1953).
3. Thomas B. Hess, quoted in Fred W. McDarrah: *The Artist's World* (New York: Dutton, 1961).
4. The statements by Morton Feldman were made in a conversation with the author.
5. Allen Ginsberg, quoted in Jane Kramer: *Allen Ginsberg in America* (New York: Random House, 1968).
6. Allen Ginsberg, *Howl and Other Poems* (San Francisco: City Lights, 1956).

Index

241

Gascoyne, David, 85
Gatch, Lee, 78, 98
Gauguin, Paul, 100
Gee, Yun, 40
Gérôme, Jean Léon, 12
Gide, André, 25
Ginsberg, Allen, 225, 228
Glarner, Fritz, 76, 118
Gogol, Nikolai, 106
Goldwater, Robert, 1–2, 158, 195, 205
Goodman, Paul, 184
Goodyear, A. Conger, 100
Gorky, Arshile, 1, 2, 3, 16, 20, 22–3, 24, 25, 27, 31, 47, 61, 68, 75, 94, 96, 98, 99, 101, 109, 113, 119, 123, 124, 147–8, 155, 159, 164, 166, 173
Gorky, Maxim, 22
Gottlieb, Adolph, 1, 20, 34, 35, 64, 68, 72, 77–8, 99, 118, 119, 122, 126, 127, 128–9, 132, 147, 160, 168, 169, 170, 171, 173, 184, 187, 209–10
Graham, John, 17, 24–7, 28, 31, 35, 64, 68, 69–70, 71, 75, 78, 94, 98, 119, 122, 126, 166, 215
Graham, Martha, 142–3, 145
Graves, Morris, 35, 157
Greene, Balcomb, 127
Greenberg, Clement, 79, 82, 153, 155, 157–61, 164–6, 171, 184, 233
Gris, Juan, 27
Gropius, Walter, 224
Gropper, William, 22, 63
Grosz, George, 79
Guggenheim, Peggy, 118, 126, 153, 154, 155, 168, 202
Guggenheim, Solomon, 109, 112
Guston, Philip, 1, 4, 38, 42, 109, 164, 181, 212

Hammett, Dashiell, 41
Hare, David, 119, 122, 124, 173, 178, 196, 198, 200
Harris, Louis, 78, 127
Hartley, Marsden, 36, 101
Hartung, Hans, 101
Hauptmann, Gerhart, 17
Hawthorne, Nathaniel, 143
Heap, Jane, 27
Hearst, Randolph, 48, 50, 64
Heathfield, John, 102
Hegel, G. W. F., 92
Heidegger, Martin, 178
Heine, Heinrich, 86

Hellman, Lillian, 40, 149–50
Hemingway, Ernest, 217
Henn, Robert, 22
Herbst, Josephine, 63
Hess, Thomas B., 72, 73, 158, 166, 212, 213–14, 215–16, 218
Hicks, Granville, 137
Hindemith, Paul, 140
Hiss, Alger, 175
Hitler, Adolf, 41, 65, 115, 139
Hofmann, Hans, 1, 3, 13, 79–84, 122, 125, 133, 158–9
Holty, Carl, 13, 35, 64, 75, 76, 101, 146, 168, 184
Homer, Winslow, 12
Hoover, Herbert, 44
Hopkins, Harry, 45, 50, 137
Horney, Karen, 123
Howard, Richard, 139
Huelsenbeck, Richard, 198
Hugnet, George, 114
Hugo, Victor, 233
Huston, John, 150
Huxley, Aldous, 173

Ingres, Jean Auguste Dominique, 4, 69, 162

James, Henry, 34, 140
James, William, 9, 10
Janowitz (Janis), Harriet, 23
Jarrell, Randall, 8
Jewell, Edward Alden, 127, 147
Joergenson, Joergen, 140
Johns, Jasper, 212
Johnson, Philip, 101, 211
Josephson, Matthew, 33, 37
Joyce, James, 22, 37, 90, 106, 178
Jung, C. G., 123–4

Kadish, Reuben, 38
Kafka, Franz, 92, 106–7, 178
Kahn, Frederick, 77
Kainen, Jacob, 78
Kandinsky, Wassily, 27, 30, 69, 76, 81, 82, 83, 110, 113, 123, 124, 135, 159
Kant, Immanuel, 126
Karpel, Bernard, 199
Kazin, Alfred, 54, 108
Kerouac, Jack, 227
Kierkegaard, Sören, 136
Kiesler, Frederick J., 17, 23, 24, 25, 27–8, 30, 31, 36, 98, 119, 121, 224, 230